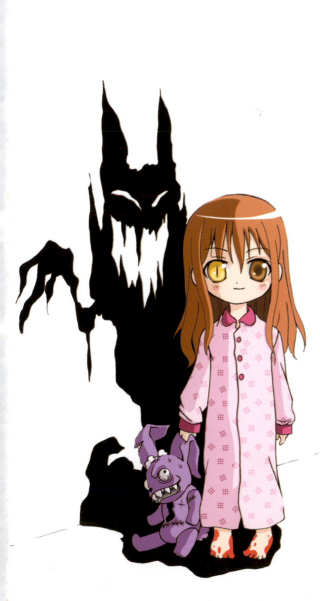

MANGA
FOR THE BEGINNER
midnight monsters

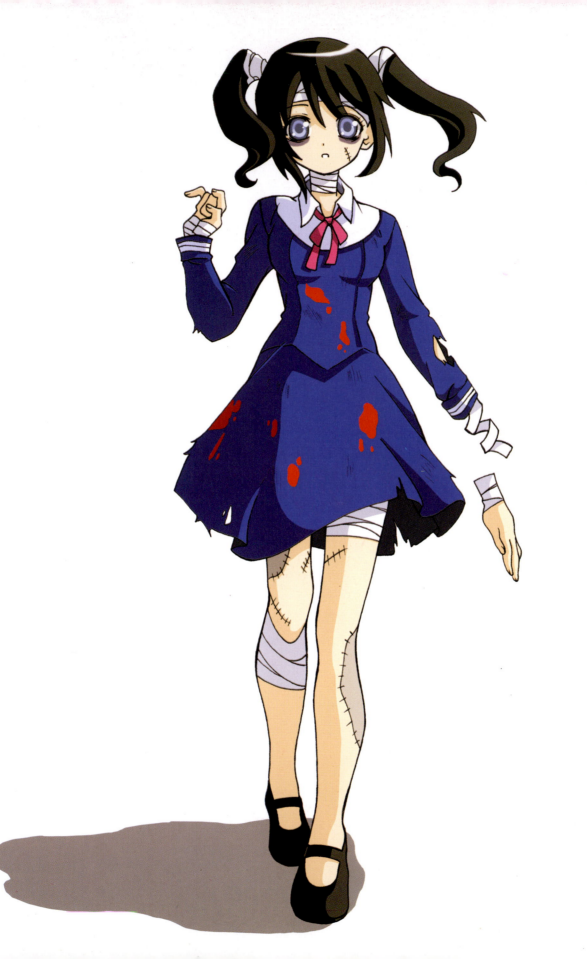

MANGA
FOR THE BEGINNER

midnight monsters

How to Draw Zombies, Vampires, and Other Delightfully Devious Characters of Japanese Comics

CHRISTOPHER HART

WATSON-GUPTILL PUBLICATIONS / NEW YORK

CONTRIBUTING ARTISTS

Anzu
Tabby Kink
Rhea Silvan
Roberta Pares
Tina Francisco

Published in the United States by Watson-Guptill Publications,
an imprint of the Crown Publishing Group, a division of Random
House, Inc., New York.
www.crownpublishing.com
www.watsonguptill.com

WATSON-GUPTILL and the WG and Horse designs are
registered trademarks of Random House, Inc.

Library of Congress Cataloging-in-Publication Data
Hart, Christopher, 1957-
 Manga for the beginner midnight monsters : how to draw
zombies, vamipres, and other delightfully devious characters of
japanese comics / Christopher Hart. — First edition.
 p. cm
 Includes index.
1. Comic books, strips, etc.—Japan—Technique. 2. Figure
drawing—Technique. 3. Goth culture (Subculture) I. Title.
 NC1764.5.J3H3692873 2013
 741.5'1—dc23
 2012035609

ISBN 978-0-8230-0710-3
eISBN 978-0-8230-0711-0

Printed in China

Text design by Matt Davis

Cover design by Matt Davis

Cover art by Tabby Kink and Roberta Pares

10 9 8 7 6

First Edition

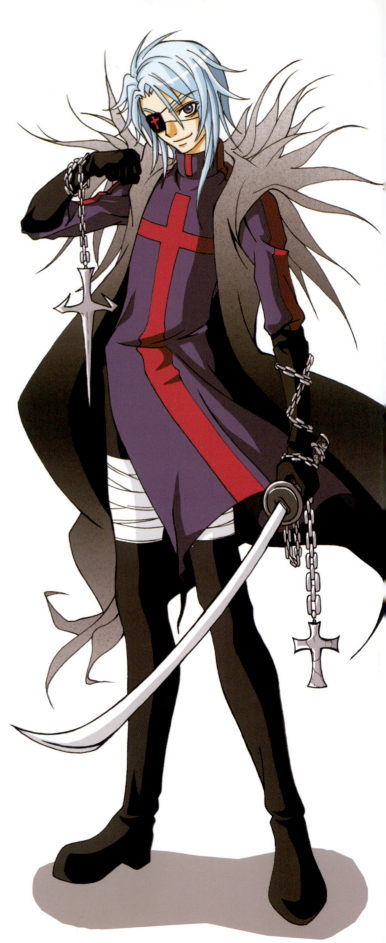

CONTENTS

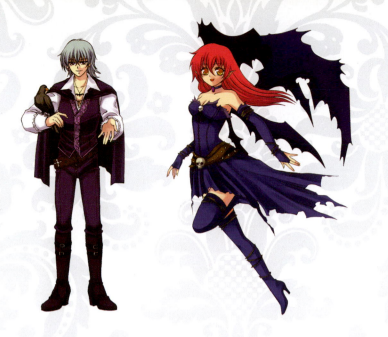

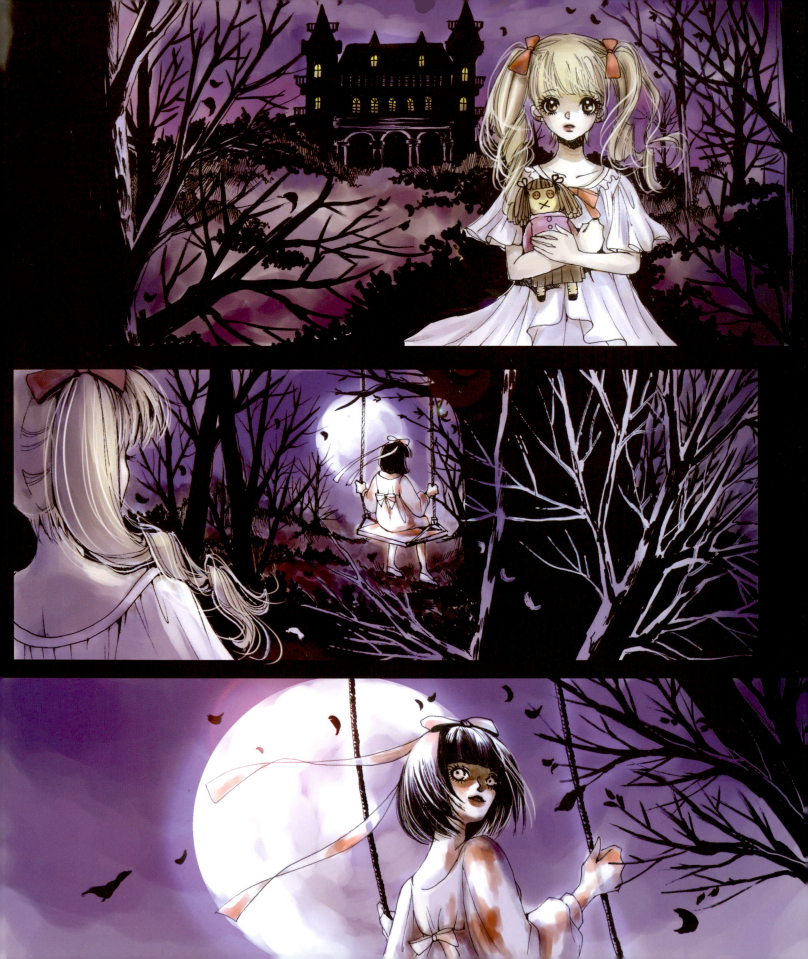

INTRODUCTION

Welcome to the glimmering world of elegant darkness, where handsome vampires are irresistibly seductive; pretty little girls have soulless eyes; and teens are confused by forces beyond their control. The realm of monsters and the supernatural is visually striking. It stirs our deepest fears with characters that are deceptively beautiful and yet deadly. At the same time, these characters are often tragic heroes, born to a world where they don't belong. It's compelling stuff. And now, with this book, learning to draw in the hottest style of manga is as simple as following the step-by-step illustrations and hints, which are carefully crafted to speed up the aspiring artist's learning curve.

Within these covers lie the frightening characters that viewers can't look away from. Their bewitching charm and sinister slinkiness captivate manga fans. The shelves in bookstores and the listings online overflow with spooky stories about dashing vampires, dangerous temptresses, zombies, and other perennial supernatural favorites.

In addition to providing a complete overview of how to draw popular monstrous character types, I also include sections on drawing moody backgrounds, using color, and more.

You'll learn the newest trends in making manga monsters. Among these is the technique of mixing genres. I'll demonstrate how to create characters by marrying one popular style with another to produce something completely new and fresh. For example, when goth style is combined with the look of schoolgirls, it results in "shoujo-goth," a haunting style.

This book belongs on the shelf of anyone who enjoys drawing manga. Because of the widespread appeal of the supernatural, artists simply can't afford not to learn how to draw its monstrous inhabitants. This timeless style is represented by some of today's most popular graphic novels, including *Vampire Knights* and *Bleach*, to name but a couple.

Are you ready to embark on a deliciously evil adventure in drawing? If so, then let's get started.

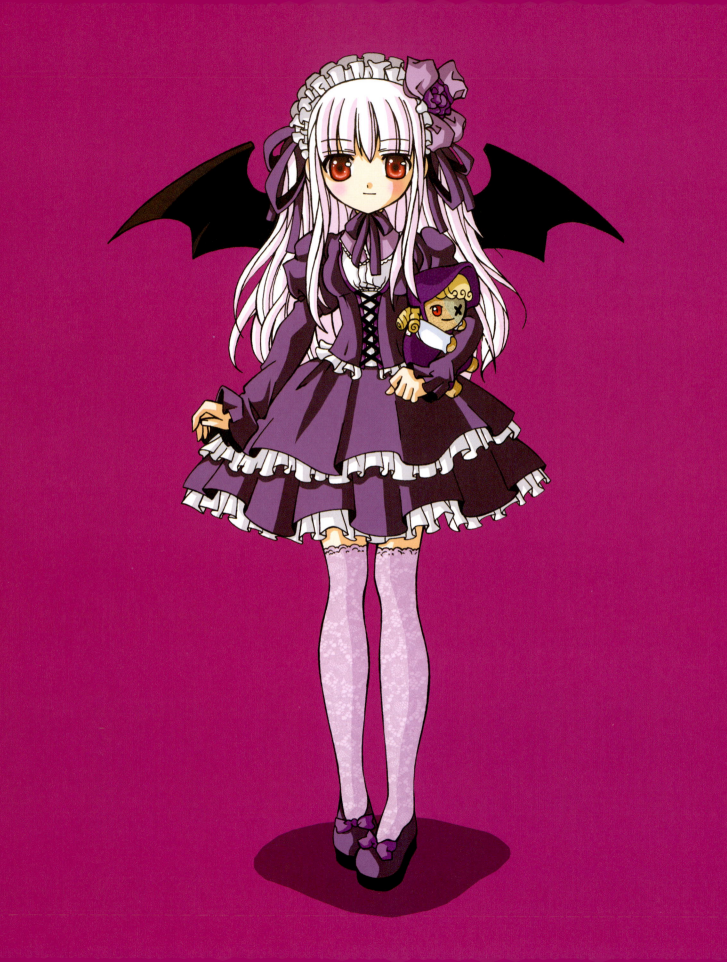

THE BASICS

The world of midnight monsters is one where the good are bad, and the bad are even worse. It features darkly charismatic characters. Here deceit and seduction are as commonplace as Sailor Moon look-alikes at a manga convention.

But before you begin to draw these glamorous and wicked characters, let me give you a brief overview of some of the more popular denizens of darkness, doom, dread, and any other gloomy terms that start with the letter *D*. With this foundation in place, I'll lead you to a fantastic world of drawing tutorials. Scared? I'd tell you not to be, but then I'd be lying. So grab a pencil, a clove of garlic, and a wooden stake, and let's begin.

MAJOR CHARACTER TYPES

What makes a monster a monster? Is it the way these characters avoid the sunshine like the plague, sleep all day, and do their work only at night? Not really, because that would describe every college kid in America. Is it the way a monster has to deceive and trick people in order to live? Maybe, but that also applies to lawyers. What about the fact that many monsters live their lives in fear of being impaled by a stake through the heart, their flesh being seared by a cross, or melting if they should ever come into contact with water? Bingo.

Style is an important aspect of art. Although the goth style is grounded in solid drawing techniques, it's also highly atmospheric and stylish. The look is smooth, devious, but also refined, cultured, even sumptuous. It is critical for manga artists to be able to capture this look in their drawings. And that's why this book marries technique with style in all of its tutorials.

THE EVOLUTION OF A STYLE: FROM GOOD GIRL TO GOTH GIRL

Meet the typical good girl. She's happy and neatly dressed. Not someone you might mistake for the living dead.

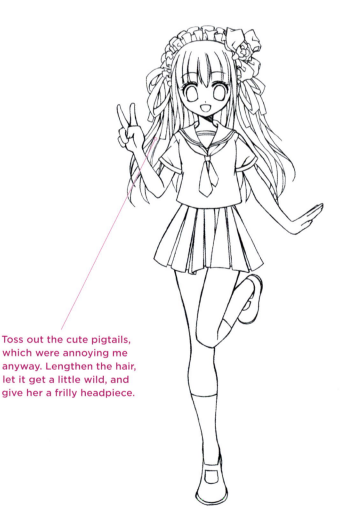

Toss out the cute pigtails, which were annoying me anyway. Lengthen the hair, let it get a little wild, and give her a frilly headpiece.

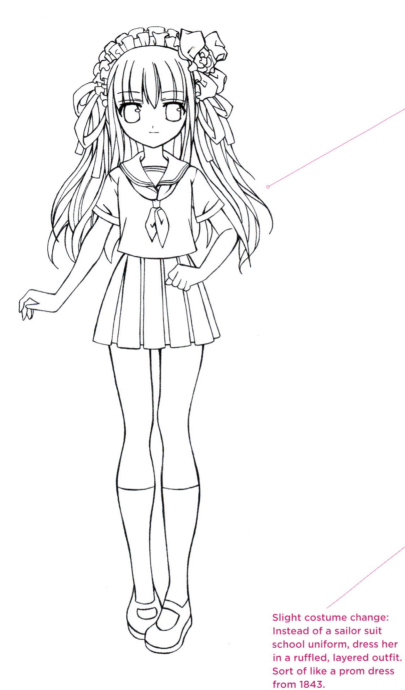

Notice that her pose becomes more introverted.

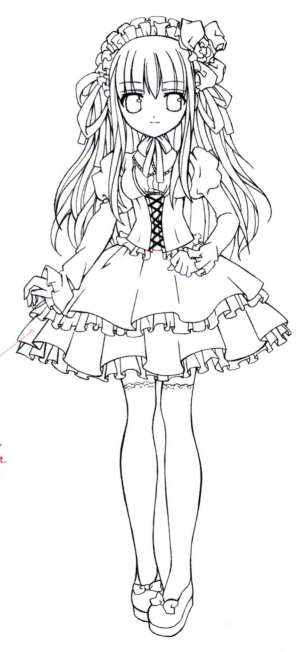

Slight costume change: Instead of a sailor suit school uniform, dress her in a ruffled, layered outfit. Sort of like a prom dress from 1843.

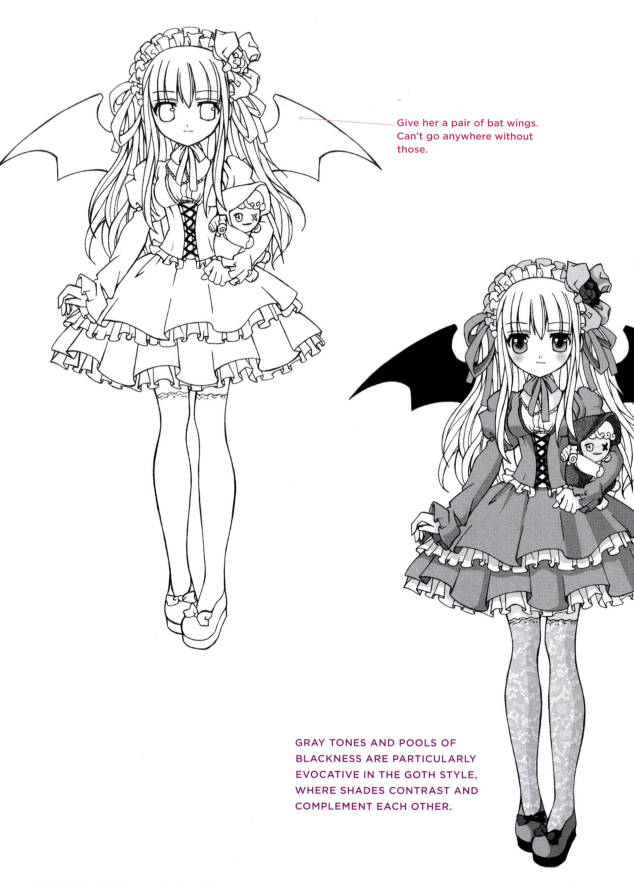

Give her a pair of bat wings. Can't go anywhere without those.

GRAY TONES AND POOLS OF BLACKNESS ARE PARTICULARLY EVOCATIVE IN THE GOTH STYLE, WHERE SHADES CONTRAST AND COMPLEMENT EACH OTHER.

WINGS AND FLOUNCES

Goth style contains both overt and subtle icons of evil. Bat wings are overt. The red eyes are subtle, but just as effective.

THIS GOTH GIRL WEARS THE COLORS OF NIGHT. THAT DOESN'T MEAN "DREARY"; IT MEANS "EERIE."

CHILDREN OF THE DAMNED

Parents: Don't let your kids attend any birthday parties for these two. Possessed children are super-ominous. And we're talking about young children. Children who play with sand buckets, yo-yos, and, yes, tarantulas. If you really want to creep out your audience, make them twins. Twins are a common motif running through Japanese comics in all genres. Sometimes they convey silliness and fun, like when they play "Hide and Seek." These two are more likely to play "Hide the Femur."

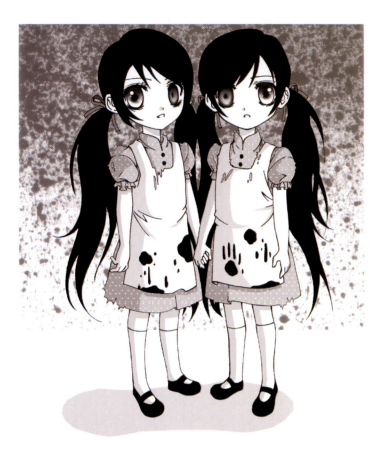

YOUNG TEEN GOTH

Goths aren't always vampires. Often, they are drawn as social outcasts and misfits who are attractive or handsome, but in a dark and mysterious way. They can make cool combos when mixed with schoolgirl clothing as in this example of casual boots and a bow in the hair combined with a Victorian dress, colored in a cheerful shade of black.

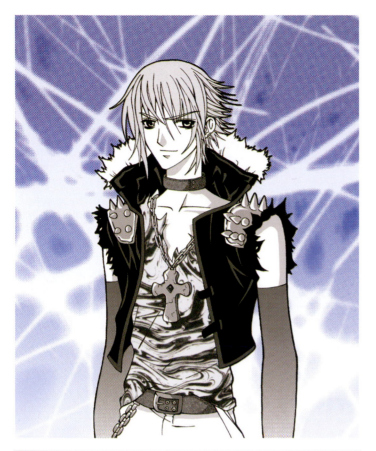

GOTH GUY

Girls, do not date a guy who dresses like this, whether or not he's made the honor roll. This poster boy for "bad news" is the quintessential rebel. He's self-absorbed, indifferent, and dangerous. In other words, he's way cool. He's everything your mom fears in a boy.

Note the ripped tank top, chains, spikes, and punky-glamorous fur-lined vest. Not exactly dressing for a job interview, is he?

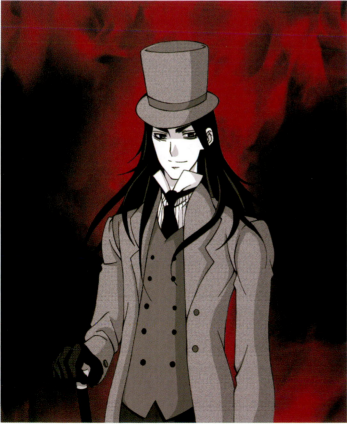

VICTORIAN VAMPIRE

In the supernatural realm, it's always midnight in London. It seems the Gilded Age never died. Out of the mist comes a pleasant-looking stranger with an anemic complexion. How anemic? He'd need to live in a tanning booth for two weeks just to be called "pale." He has a lean and hungry look, yet his cultured and well-to-do visage puts others at ease. The elegant fashion conceals a primal thirst for blood.

GLAMOROUS VAMPIRE

This type lures his prey with dashing good looks, stylish attire, and expensive taste. He can usually be found living in a mansion, castle, or gigantic penthouse apartment overlooking the city lights. But remember: These are only suggestions. You're the artist. You can decide where he lives and which toys to give him and whether or not to name him "Fred." Actually, I take that back. Never name a vampire "Fred."

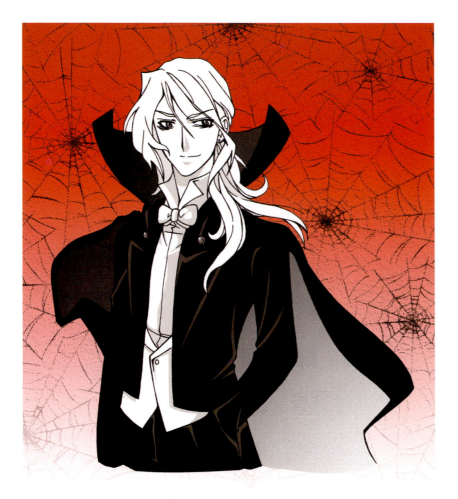

ADDING GLAMOUR

Manga artists have a big advantage over screenwriters when it comes to budget. Anytime a screenwriter calls for an expensive prop or location, the producer starts to worry about what it might cost to pull it off. As a result, loads of great scenes get eliminated from many scripts, and, therefore, never make it onto the screen.

But a manga artist, drawing a graphic novel, has an unlimited budget. It costs no more to draw two people talking in a fancy castle than it does to draw the same two people talking on a sidewalk in Pittsburgh.

VAMPIRE WOMAN

She's very seductive and very bad. And I don't mean rolled-through-the-stop-sign bad. She's just about the most seductive character type in the genre. Although her outfit or costume may vary greatly, typically, these clothes have something in common: They are flirtatiously revealing and composed of only a few dark colors, or black, rather than a wider palette. Her dark smile radiates confidence. She has had boyfriends, but somehow, they never seem to make it past the first kiss.

DRAWING VAMPIRE WOMEN

Many popular vampire women aren't drawn in the youthful, shoujo style of manga. No oversized head, no giant glistening eyes, no cutesy body shape or frilly outfit. She's got the look of an older teen or young adult. That means that, relative to her body, her head is a more normal size than the oversized heads of younger characters. Her eyes are more almond-shaped than spherical. And she has a slinky figure.

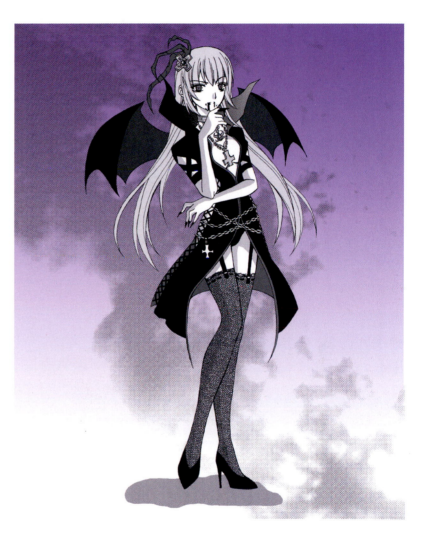

DRAWING HEADS

Get out your pencils for some wickedly fun character drawing. The rule about drawing supernatural character heads is that there is no rule. (Although, if the rule is that there are no rules, isn't that a rule? Hey, it's no coincidence that I pulled off a B– in philosophy.) You can make a cute character look as foreboding as a creepy one. It's all in the execution—of the idea, that is.

However, most star characters of the supernatural genre are good-looking. So keep an eye on the treatment of the hair, eyes, expressions, and colors as you follow the steps in this chapter.

POWERFUL MALE GOTH

Characters from the Dark Side may appear elegant and refined, but they also possess tremendous physical powers. At any moment, they can unleash a torrent of fury. No one likes to face a torrent. Have you ever heard anyone say, "More torrent, please?" Of course not.

The elegant face of this cultured monster is sleek and tapered. But a powerful neck and wide shoulders give away his physical prowess. No wussy guy is built like that. Notice how thick his neck is and how square his shoulders are.

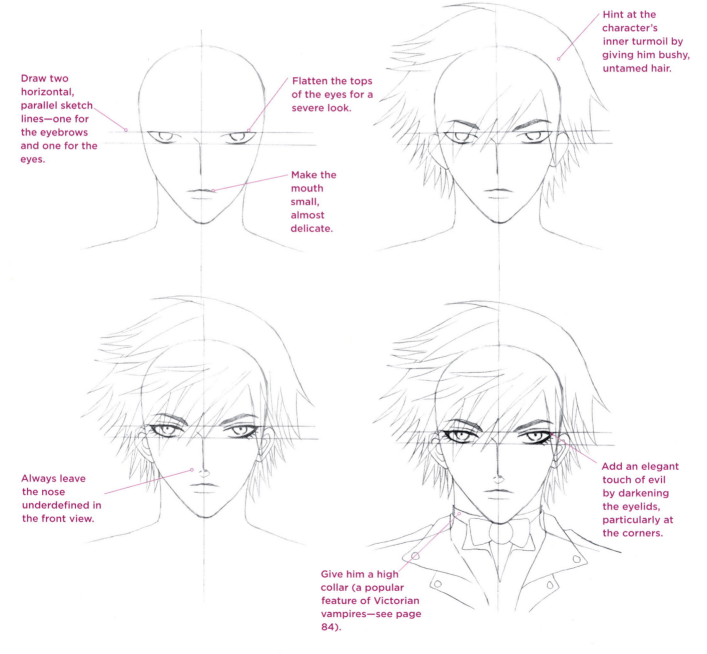

Draw two horizontal, parallel sketch lines—one for the eyebrows and one for the eyes.

Flatten the tops of the eyes for a severe look.

Make the mouth small, almost delicate.

Hint at the character's inner turmoil by giving him bushy, untamed hair.

Always leave the nose underdefined in the front view.

Add an elegant touch of evil by darkening the eyelids, particularly at the corners.

Give him a high collar (a popular feature of Victorian vampires—see page 84).

Don't allow too much hair to fall in front of the eyes, or he might end up missing his victim and biting a lamppost instead.

Whether you go over your drawing with a marker or simply trace your rough to achieve a clean pencil line, your goal is the same: Create a thin, refined, unwavering line.

DRAWING THE NOSE

Reduce the emphasis on the nose by using a minimal amount of lines.

TIP

The sleekness of a gaunt chin adds to a character's evil elegance.

THE COLORS USED FOR THIS TYPE OF CHARACTER ARE GENERALLY COOL COLORS (SEE PAGE 154). I DON'T MEAN "COOL" AS IN "WOW, COOL RACING STRIPES, DUDE!" I MEAN IT AS IN COLOR THEORY. COOLER COLORS INCLUDE ICE-BLUE, PURPLES, AND MAGENTAS. IN THIS GENRE, PALE SHADES WORK BEST.

VICTIM

Where there's a villain, there's a victim. In the horror genre, the victim is often an innocent, pretty girl. Being a victim is different from being an opponent.

An opponent fights back. A victim succumbs. Note the large, innocent eyes, delicate nose, and curls in her hair.

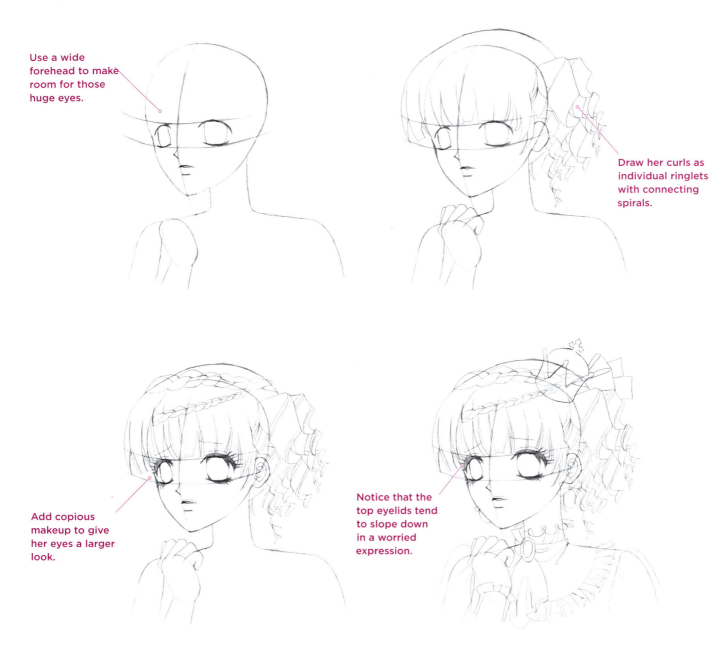

Use a wide forehead to make room for those huge eyes.

Draw her curls as individual ringlets with connecting spirals.

Add copious makeup to give her eyes a larger look.

Notice that the top eyelids tend to slope down in a worried expression.

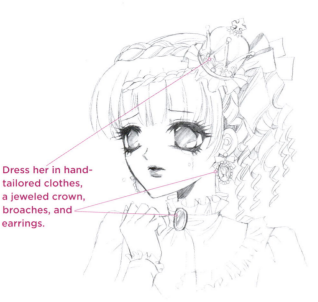

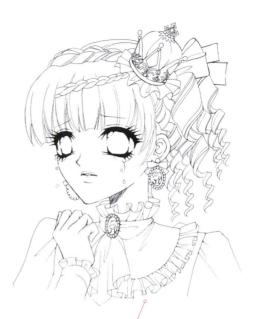

Dress her in hand-tailored clothes, a jeweled crown, broaches, and earrings.

Use flounces, or crimped trimming, to make the edges of her dress look fancier.

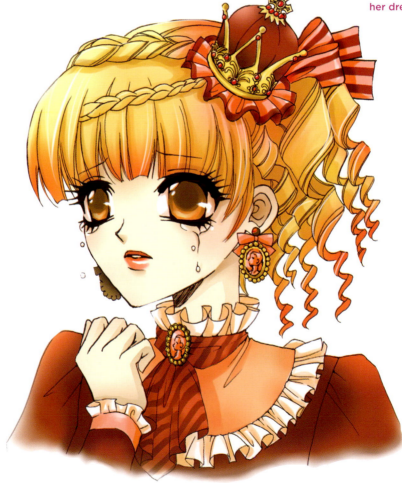

BEING HUMAN, RATHER THAN UNDEAD, HER COLORING IS YELLOW AND ORANGE, WHICH ARE WARM, LIVELY COLORS. IT'S ONE OF THE PERKS THAT COME WITH RED CORPUSCLES.

THE WILD ONE

Can you spot it in his eyes? There's a recklessness seen only in vampires and teenage drivers. At first, he may look like a choirboy who uses a color-blind hairdresser. But in reality, he's a cold-blooded vampire.

You'd have to either be an idiot or in love to exchange saliva with this guy. But somehow, he always gets the girl, while the math majors can't find a date to the prom. Go figure.

Make sure to give him large, horizontal eyes.

Use a light touch on his eyebrows. Too much angle creates a frown. Just a touch of it creates a sinister look.

Once again, look at how thick yet sleek his upper eyelids are.

Remember: The more evil the character, the thicker the lower eyelids become.

THE CHOICE OF A BOLD, UNNATURAL HAIR COLOR, SUCH AS PINK, GREEN, BLUE, OR WHITE, MAY INDICATE AN OTHERWORLDLY CHARACTER. PALE BLUE HAIR INDICATES A GRANDMOTHER FROM ORLANDO.

THE SEDUCTRESS

This popular type is a mature woman in her mid-five-hundreds. (The undead live a long time.)

The seductress derives her supernatural powers from spells, curses, tarot cards, potions, crystals, and eye of newt. Not too much newt. Like garlic, a little newt goes a long way. She may also be cast as a vampire. Her look is so intriguing that it has lured men to their deaths. She may feel regret, but what can she do about it? She already tried a therapist. And he was delicious.

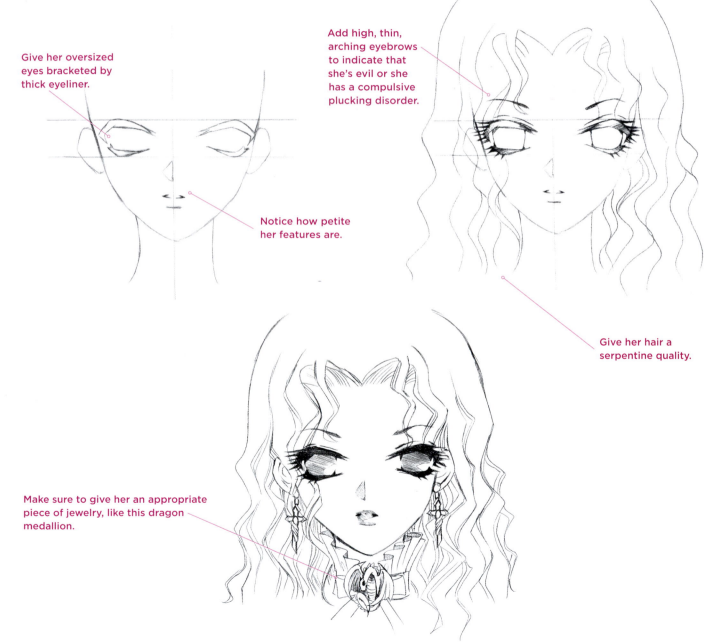

Give her oversized eyes bracketed by thick eyeliner.

Notice how petite her features are.

Add high, thin, arching eyebrows to indicate that she's evil or she has a compulsive plucking disorder.

Give her hair a serpentine quality.

Make sure to give her an appropriate piece of jewelry, like this dragon medallion.

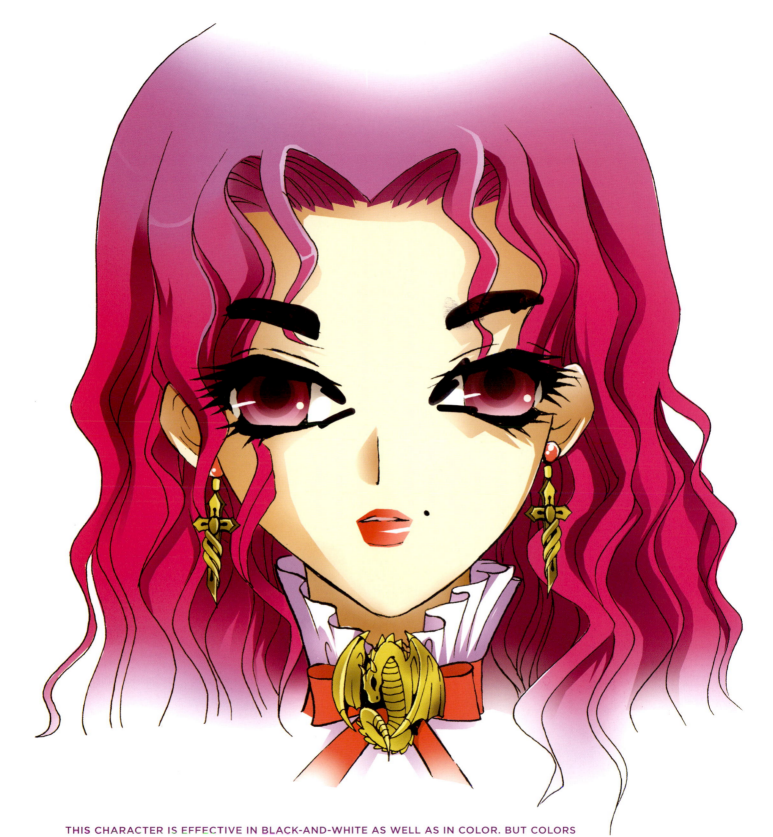

THIS CHARACTER IS EFFECTIVE IN BLACK-AND-WHITE AS WELL AS IN COLOR. BUT COLORS ARE BEST AS GOOD COMBOS WITH BLACK, DUE TO THE DARKNESS OF THE EYES.

YOUNG TEEN GOTH: MALE

The young vampire is often beset by strange dreams that clue him into his true identity, of which he is unaware. They beg questions too terrible to even think about: Is he really a vampire, and therefore different from all the other children? Is his destiny preordained? Is someone keying his car?

Although he has the bright-eyed look of youth, already there are troubling signs on the horizon: the hallmark blackness around his eyes, the wild hair of a different color, and delicate features. These are not the looks of a volunteer hall monitor.

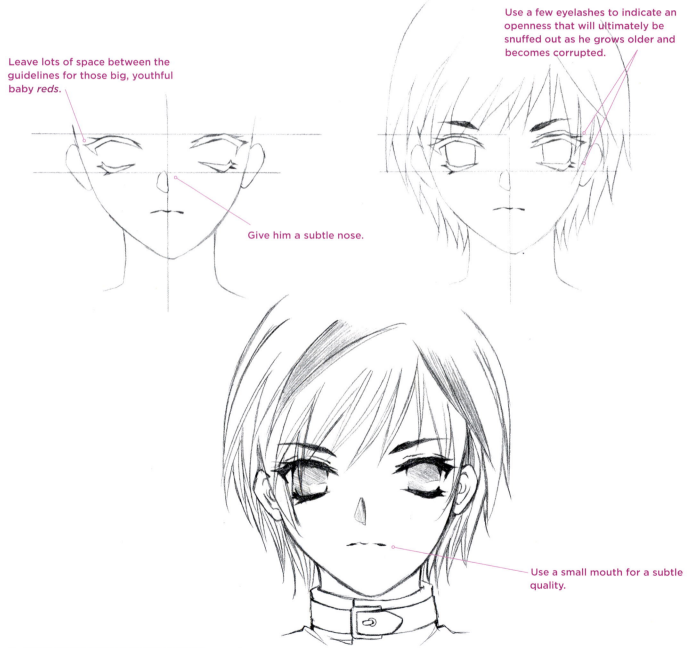

Leave lots of space between the guidelines for those big, youthful baby *reds*.

Give him a subtle nose.

Use a few eyelashes to indicate an openness that will ultimately be snuffed out as he grows older and becomes corrupted.

Use a small mouth for a subtle quality.

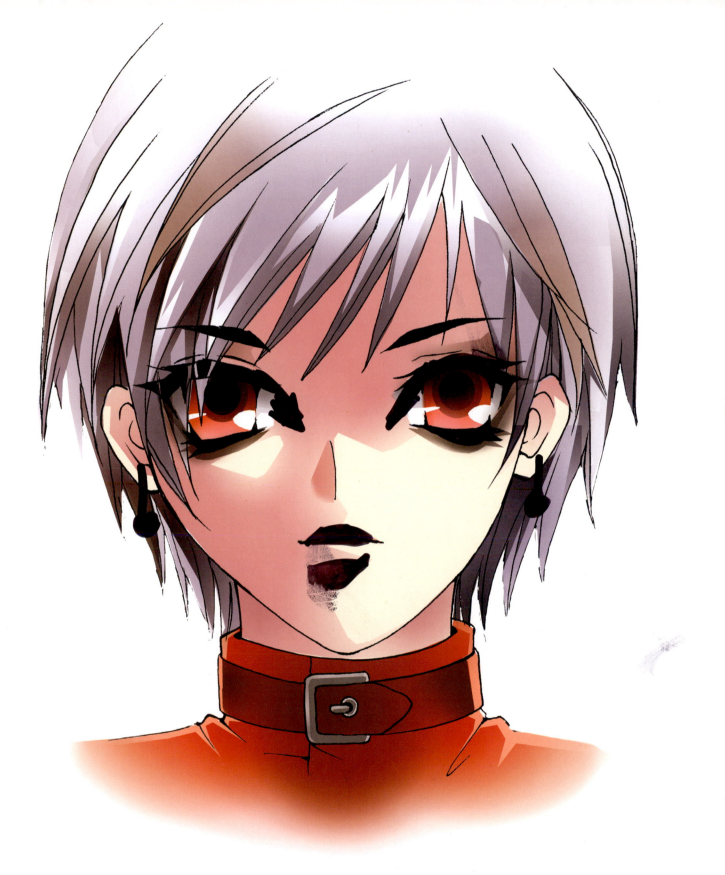

USE INTENSE COLORS FOR AN INTENSE KID.

YOUNG TEEN GOTH: FEMALE

Quite surprisingly, it's the girls and children of the goth world who can be the most effective at creating a disturbing image. This young lady may look like sugar and spice and everything nice, but still, you've gotta wonder why her favorite flavor is "Type O." But there I go, jumping to conclusions.

Not very many visual clues give away her gothic nature, except for the intensely spiked eyelashes, wide-eyed, aimless stare, and white hair. But that's visible in close-up only. In a full shot, her outfit would bring more dark elements to the fore. This type will appear later in this book.

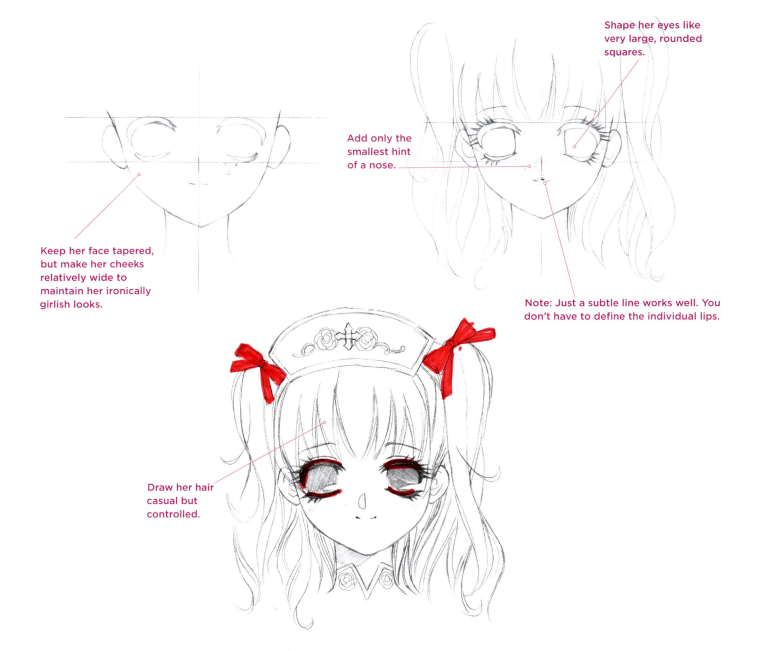

Keep her face tapered, but make her cheeks relatively wide to maintain her ironically girlish looks.

Shape her eyes like very large, rounded squares.

Add only the smallest hint of a nose.

Note: Just a subtle line works well. You don't have to define the individual lips.

Draw her hair casual but controlled.

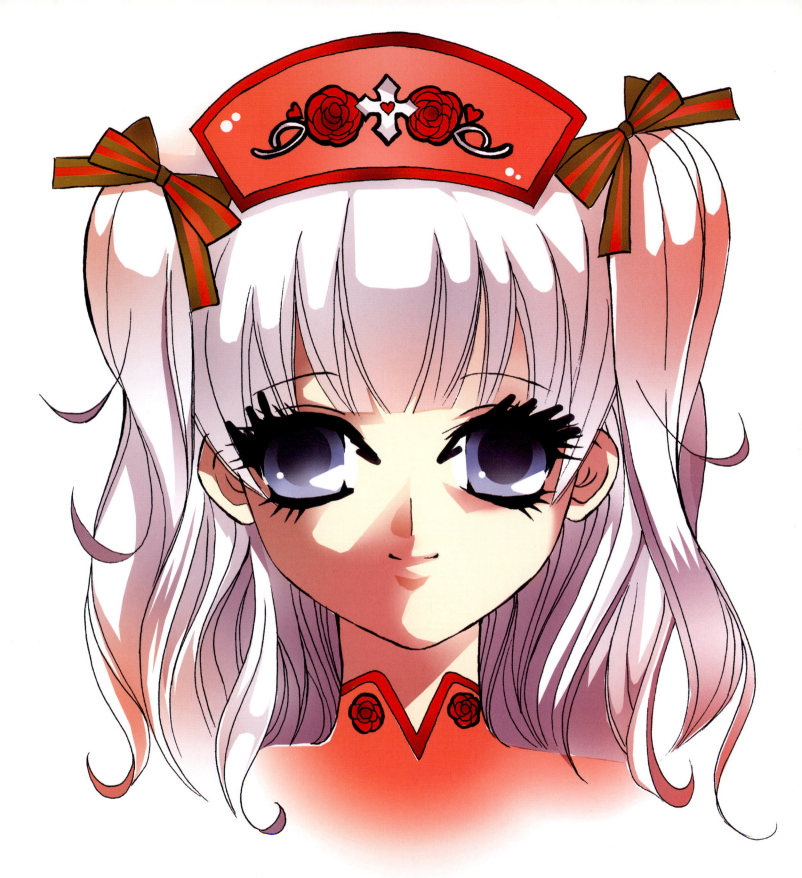

TOO CUTE TO BE EVIL? METHINKS NOT. DEEP DOWN, BENEATH
THAT CUTE EXTERIOR, LIES A DANGEROUS VAMPIRE.

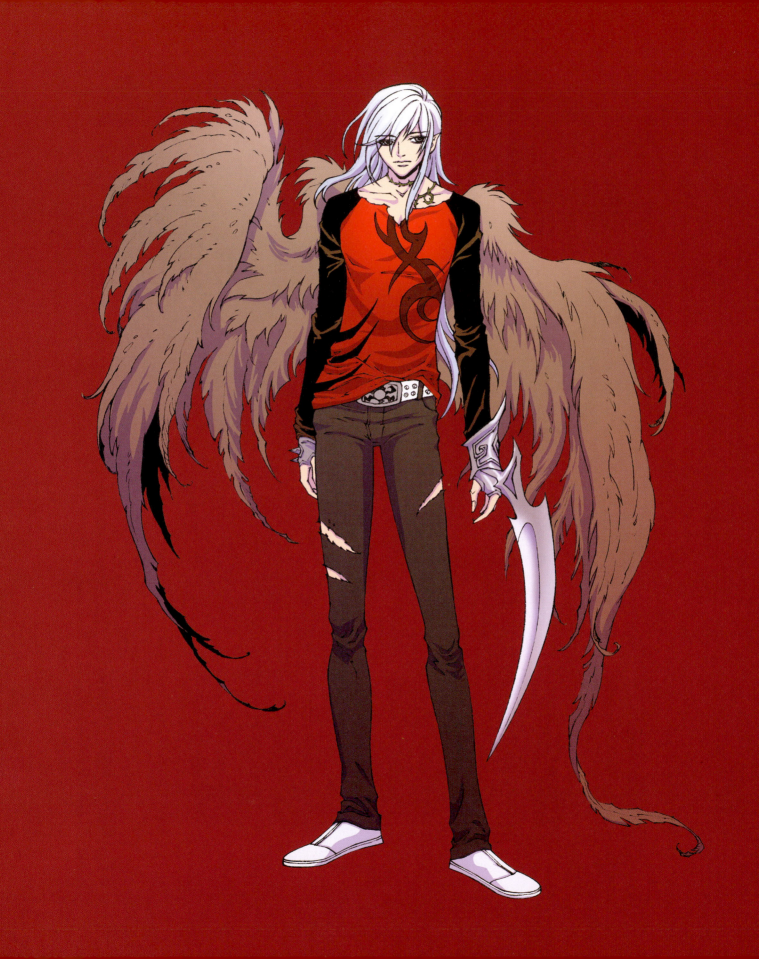

DRAWING BODIES

The key words to remember when drawing the adult supernatural body type are *willowy* and *slinky*. The delicately elongated body of the goth makes the character appear haunting and darkly poetic. And unlike heroic figures, which have upright posture, supernatural characters often have inward-leaning postures, to signify a brooding quality. In women, this often produces a bewitching allure. These character types usually have long arms and legs, adding to their lean appearance.

FRONT VIEW BASICS: MALE

Long arms, long legs, thin torso, and—wide shoulders? Yep, that's right. He's rather thin and delicate in appearance, but with an important contradiction: His wide shoulders hint at his power. Although outwardly he may appear to be slightly gentler than a yoga instructor holding an orphaned bunny, he can become instantly fierce and dangerous, like a man holding a deadly bunny.

The strongest characteristics of supernatural types are their acute feelings of anguish, self-doubt, sensitivity, and isolation. His somewhat sunken chest puts into visual form the character's state of mind—inward reflection.

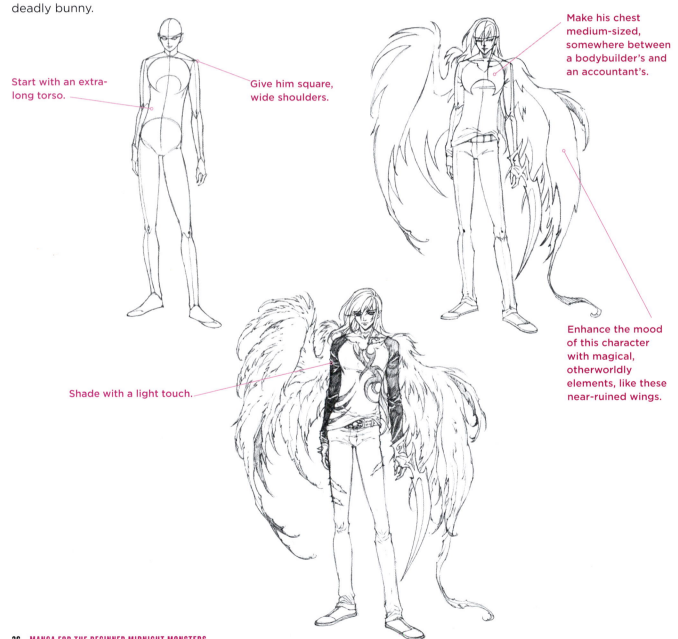

Start with an extra-long torso.

Give him square, wide shoulders.

Make his chest medium-sized, somewhere between a bodybuilder's and an accountant's.

Shade with a light touch.

Enhance the mood of this character with magical, otherworldly elements, like these near-ruined wings.

THE BLACK-AND-WHITE VERSION
RETAINS A SENSE OF ELEGANCE DUE
TO THE USE OF A FINE-TIP PEN AND A
STEADY HAND. IN THE COLOR VERSION,
THE BLACK TONES ARE OFFSET BY A
BOLD RED.

TIP

Subtle and delicate
lines are needed for
areas such as the
feathers and the hair.

ACCESSORIES

Accessories are always a welcome
device. What's an accessory? Anything
on a character that is not clothing. Think
rings, bracelets, buckles, necklaces,
pins, and the like. All characters have
them, goths and nongoths alike. For
example, an ordinary teen might wear a
wristwatch, while a goth character wears
a razor-wristband.

IMPORTANT ANGLES OF THE MALE BODY

In addition to the front view, there are also the important side view (profile), 3/4 view, and rear view. The 3/4 view is used most often in comics and graphic novels, followed by the front view, side view, and rear view. Note the simplicity of the constructions. The poses at every angle are the same, for easy comparison.

Focus on the masses of the rib cage and the hips, as well as the overall outline. Be cognizant of drawing long, smooth lines, punctuated by the joints. If you go back to your drawing after a break, it will give you perspective to spot your mistakes and correct them. And then, if someone still spots a mistake, simply say, "I meant to do that."

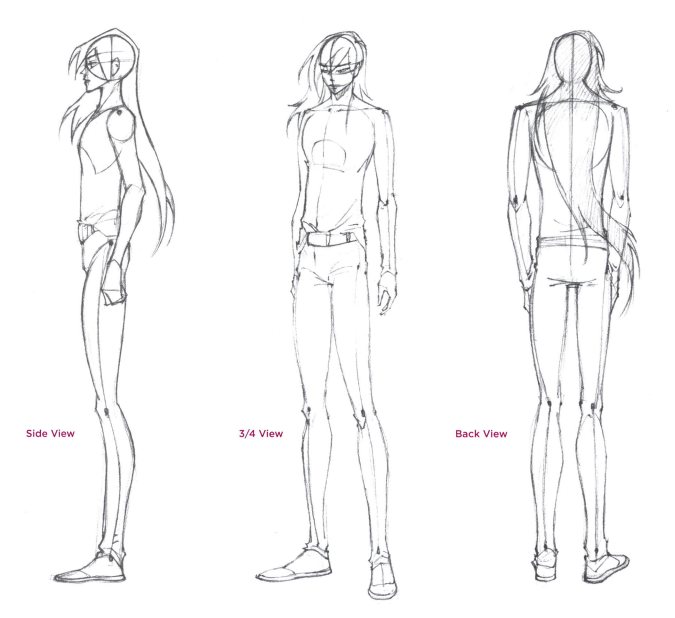

Side View

3/4 View

Back View

FRONT VIEW BASICS: FEMALE

The female goth is more than just a pretty face. Many female goths are clever schemers, who use guile and their physical attributes to entice their hapless victims.

However, the attractive image you see may not even be the goth's "true" self, but an illusion that hides her hideous appearance. Talk about disappointment.

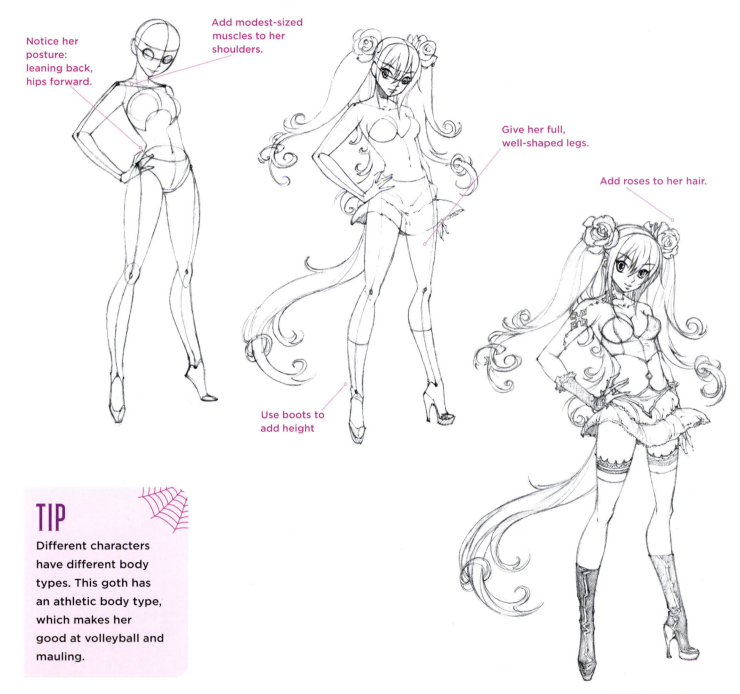

Notice her posture: leaning back, hips forward.

Add modest-sized muscles to her shoulders.

Give her full, well-shaped legs.

Add roses to her hair.

Use boots to add height

TIP

Different characters have different body types. This goth has an athletic body type, which makes her good at volleyball and mauling.

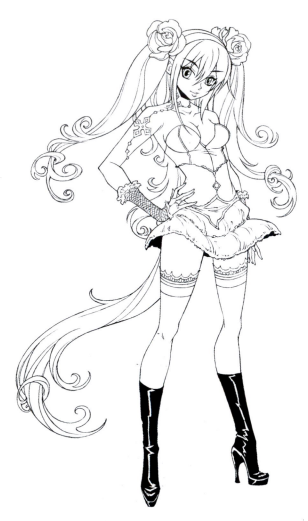

BEING CUTE DOESN'T MEAN SHE CAN'T ALSO BE BAD. SHE'S LIKE THE GIRL NEXT DOOR. THAT IS, IF YOUR NEIGHBOR HAPPENS TO BE A VAMPIRE.

COLOR RANGE

Some artists rely on only a few dark hues, combined with pools of blackness, to color their goth characters. While that's effective, you can also use a wider chromatic range. But you have to take care not to allow the colors to make the character look cheery and good-natured, like a college girl who spends her free time picketing against corporations, while majoring in business.

Colors for goth characters are most effective when they are dark, muted, pale, or mixed with gray. Bold colors work in certain conditions; for example, as accents, or to brighten up a character. But apply these sparingly.

EMBELLISHMENTS

Embellishments that are both good and evil create an uncomfortable ambiguity that enhances the mood and keeps the audience on edge. Flowers are a good example. In the shoujo genre, they're used to connote love and joy. In the goth style, they're often used to emphasize their blood-red color and prickly thorns. Sometimes the roses are black.

IMPORTANT ANGLES OF THE FEMALE BODY

Let's look at how she's built from three major angles. Note the subtle exaggeration used to create a glamorous physique: The neck is elongated, the torso is shortened, and the legs are lengthened. This combination makes the character appear tall but also feminine. On a young woman, super-long hair, the type you see here, spells glamour. On an older woman, super-long hair means she probably sings to her plants and considers her cats to be her children.

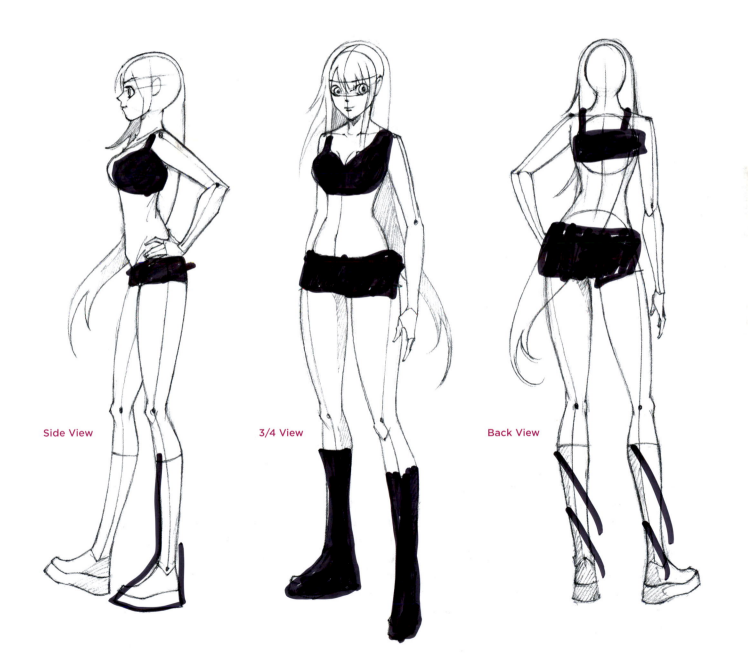

Side View

3/4 View

Back View

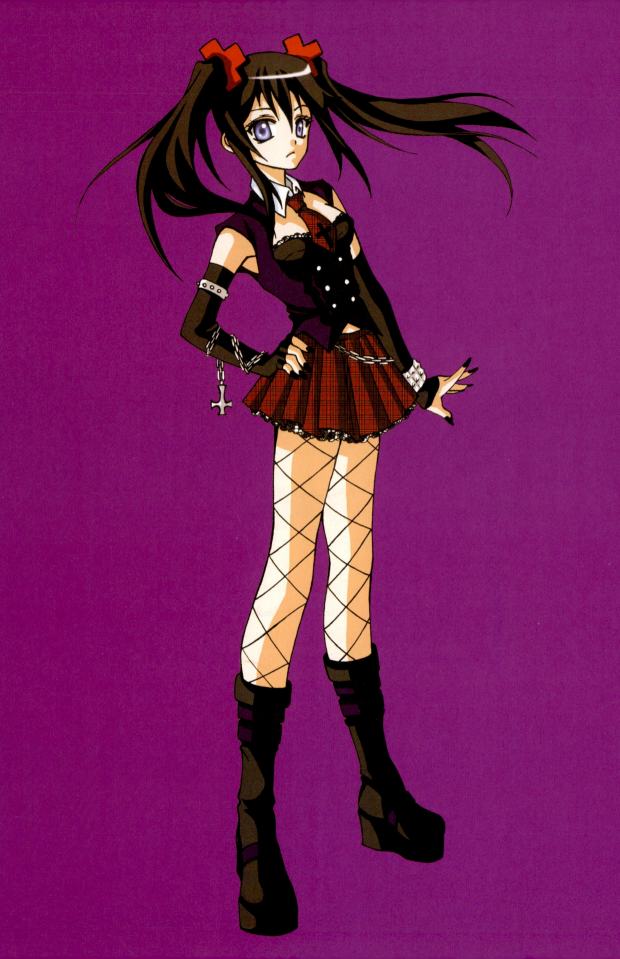

GIRLS FROM THE DARK SIDE

Zombies, vampires, goths, Lolitas, and the possessed—these are but a few of the high-profile female characters of the Dark Side. Not only are they spine-tinglingly eerie, they are also striking to look at and curiously disarming. What is it about an evil female that makes the male of the species overlook the terrible dangers of pursuing her? Maybe it's that certain something in her mascara-laden eyes. Or the way she lets her hair gently decompose in the wind. Perhaps it's how she moves—that is, before rigor mortis sets in.

GOTHIC AND LOLITA-STYLE FEMALE

The gothic and Lolita style is not only popular in graphic novels but also as a subculture in Japan. Aristocratic but elegantly macabre costumes from the Victorian era represent the gothic part. The other half of the equation is the Lolita style. That is the cute flair with which you draw and pose these characters. The combination produces characters that look both innocent and wicked at the same time. These characters require extra attention to capture their softer, subtler charm and darkly glamorous outfits.

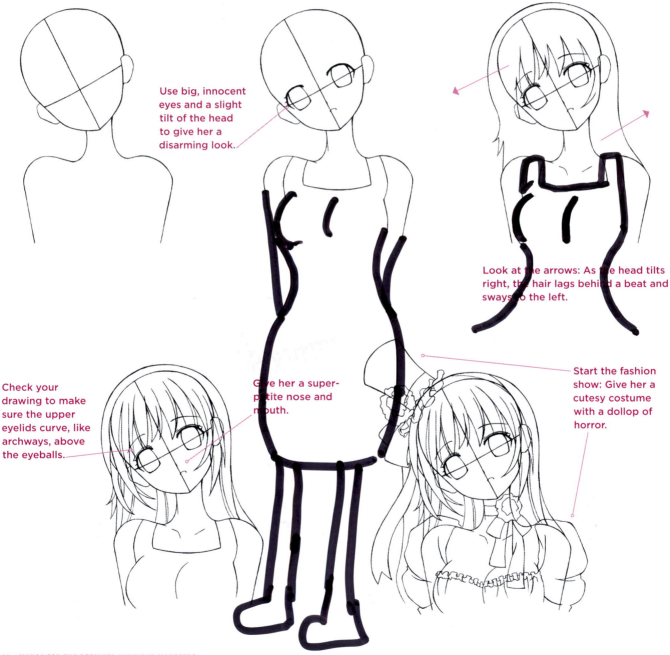

Use big, innocent eyes and a slight tilt of the head to give her a disarming look.

Look at the arrows: As the head tilts right, the hair lags behind a beat and sways to the left.

Start the fashion show: Give her a cutesy costume with a dollop of horror.

Check your drawing to make sure the upper eyelids curve, like archways, above the eyeballs.

Give her a super-petite nose and mouth.

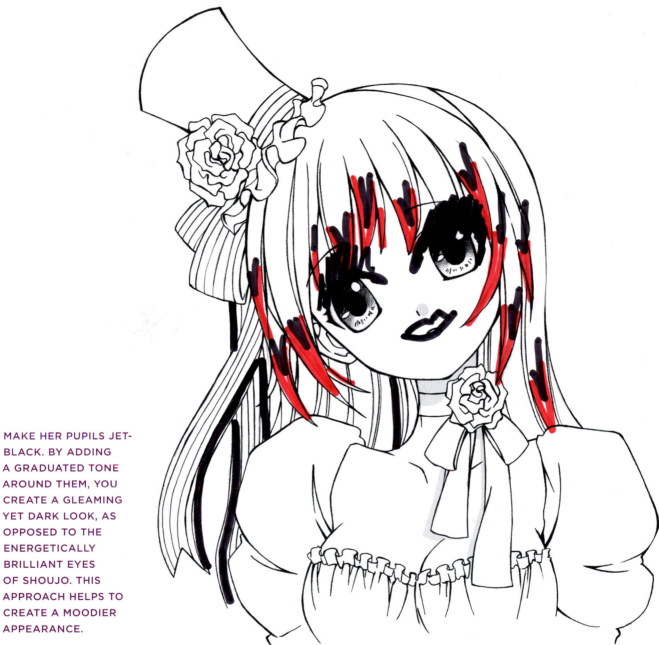

MAKE HER PUPILS JET-BLACK. BY ADDING A GRADUATED TONE AROUND THEM, YOU CREATE A GLEAMING YET DARK LOOK, AS OPPOSED TO THE ENERGETICALLY BRILLIANT EYES OF SHOUJO. THIS APPROACH HELPS TO CREATE A MOODIER APPEARANCE.

GORGEOUS, NOT GROTESQUE

Many beginners, and even seasoned manga artists, make attractive female goths look angry, hideous, and repulsive in an attempt to communicate the character's genre. But in my opinion, this approach is counterproductive. It's also unnecessary, and will drive away readers, rather than appeal to them. A goth character drawn as a pretty girl or a charming guy stirs an interesting mix of emotions in the viewer. Think of the goth's good looks as strategic cover, hiding her evil intentions. Evil looks more dangerous when it's wrapped in an appealing, or even innocent, appearance.

FULL BODY

If every outfit this gothic and Lolita-style girl owns is like this one, I'd be scared to look in her closet. The price for tailoring alone could be half the GDP of Guam. Striped stockings? Are those really Victorian?

Sort of . . . okay, okay, they're not really. But you don't have to rigidly adhere to the time period. It's a style, not a history book.

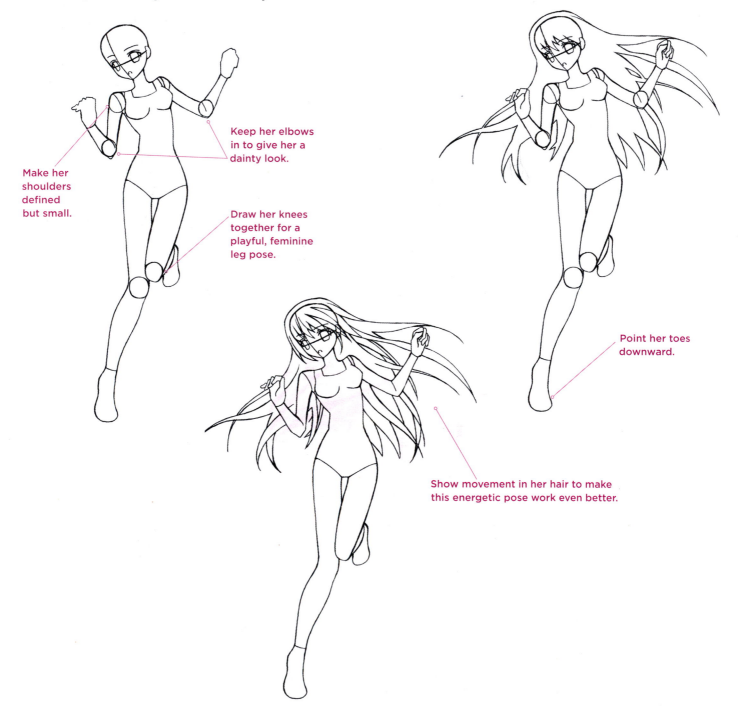

Make her shoulders defined but small.

Keep her elbows in to give her a dainty look.

Draw her knees together for a playful, feminine leg pose.

Point her toes downward.

Show movement in her hair to make this energetic pose work even better.

Notice that as she lands, downward, the dress moves upward, creating a secondary action.

ALTHOUGH THE OUTFIT GIVES AN OVERALL IMPRESSION OF BEING DARK, THERE'S MORE TO IT THAN THAT. THE DARK AREAS ARE PUNCTUATED BY SMALLER AREAS OF LIGHTER HUES, TO PREVENT MONOTONY.

DARK GOTHIC GIRL

This contemporary-girl-meets-Victorian-goth character has some "punk" style rolled into the final package. As a teenager, she plays the role of a popular social outcast. (Is it possible to be an outcast and popular at the same time? Wow. Deep.)

Her mascara is so thick and exaggerated that it looks as if she applied it with a chocolate bar.

For all her nonconformity, she faithfully conforms to the goth "uniform": a color combination predicated on black, spiked or studded bracelets and necklace, frills, corset, and clunky boots. Not quite babysitter material.

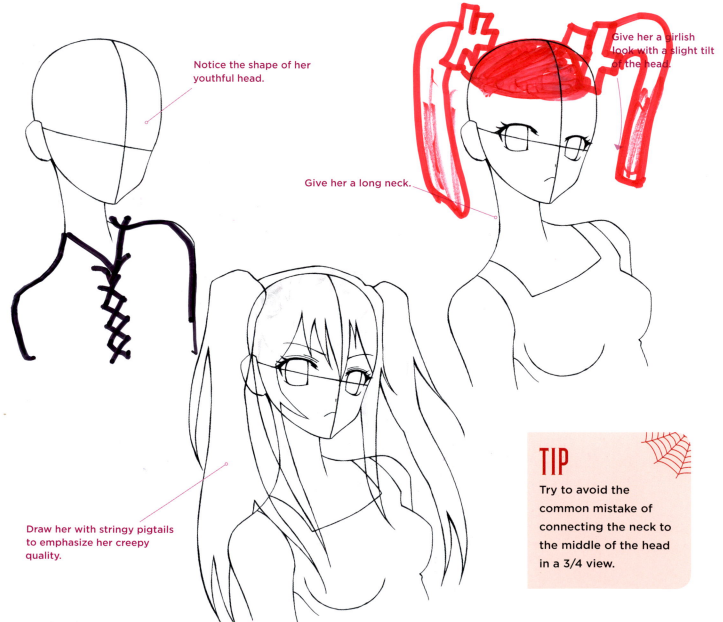

Notice the shape of her youthful head.

Give her a girlish look with a slight tilt of the head.

Give her a long neck.

Draw her with stringy pigtails to emphasize her creepy quality.

TIP

Try to avoid the common mistake of connecting the neck to the middle of the head in a 3/4 view.

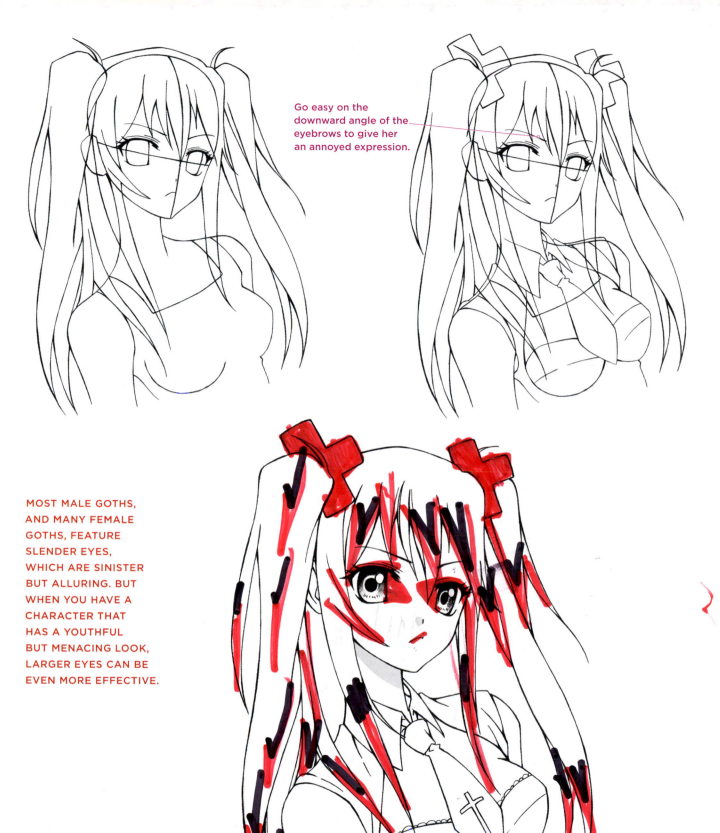

Go easy on the downward angle of the eyebrows to give her an annoyed expression.

MOST MALE GOTHS, AND MANY FEMALE GOTHS, FEATURE SLENDER EYES, WHICH ARE SINISTER BUT ALLURING. BUT WHEN YOU HAVE A CHARACTER THAT HAS A YOUTHFUL BUT MENACING LOOK, LARGER EYES CAN BE EVEN MORE EFFECTIVE.

FULL BODY

Her look says, "Stay away." (I know, because I used to get this look all the time at school dances.) This example demonstrates a practical concept you can use in many of your drawings. Her character type (cute) is the opposite of her costume (scary). This creates an interesting dynamic. The elements work together as a unit. Try to remember that you're not just drawing a character, but a concept. She is an intense, goth loner, who doesn't fit in. Colorful, striped leggings may look cool, in the abstract, or perhaps they're a favorite of yours to draw. But they would brighten this character up too much.

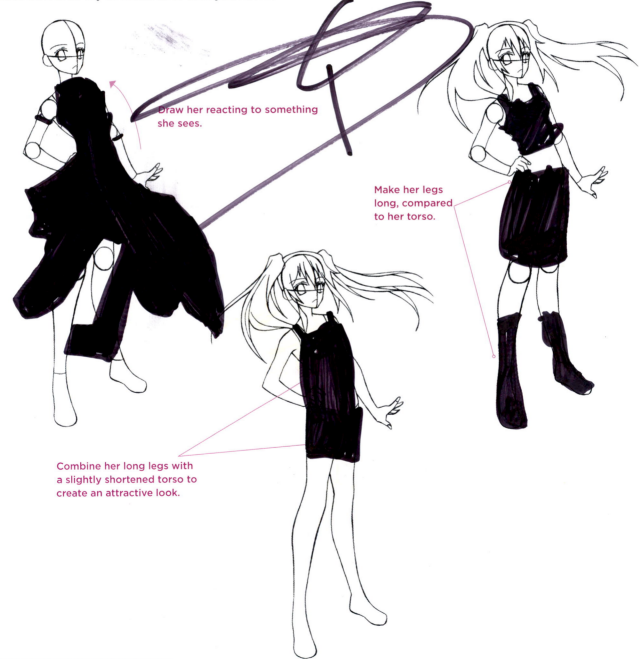

Draw her reacting to something she sees.

Make her legs long, compared to her torso.

Combine her long legs with a slightly shortened torso to create an attractive look.

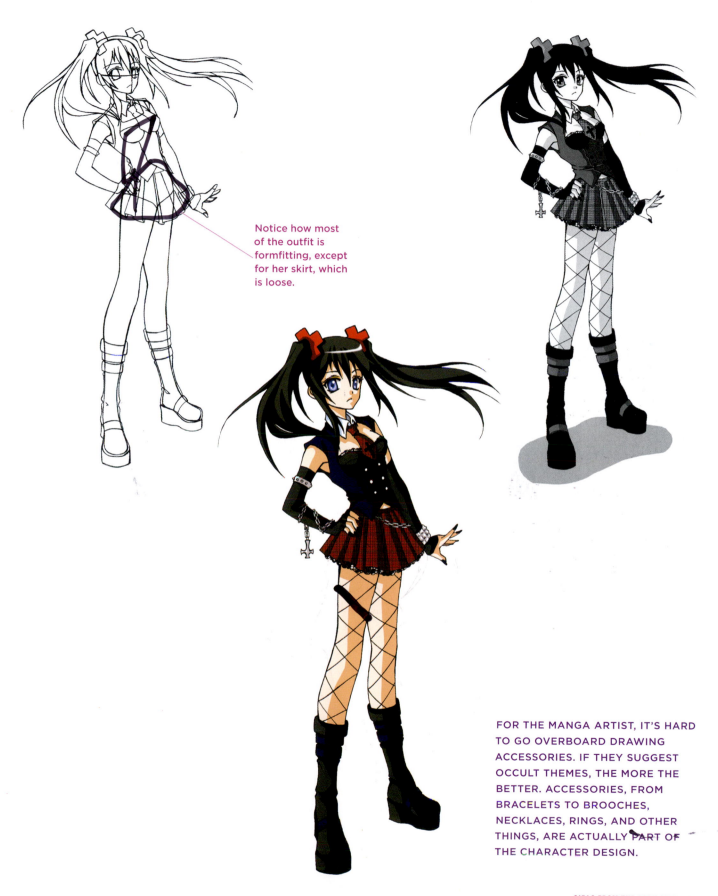

Notice how most of the outfit is formfitting, except for her skirt, which is loose.

FOR THE MANGA ARTIST, IT'S HARD TO GO OVERBOARD DRAWING ACCESSORIES. IF THEY SUGGEST OCCULT THEMES, THE MORE THE BETTER. ACCESSORIES, FROM BRACELETS TO BROOCHES, NECKLACES, RINGS, AND OTHER THINGS, ARE ACTUALLY PART OF THE CHARACTER DESIGN.

POSSESSED CHILD

Possessed children rank high on the supernatural "creep-o-meter."

This character type has a sweet, innocent appearance—except for her eyes. The eyes give away the character's true nature. Sometimes, they're drawn with dark circles. Other times, they stare blankly at nothing, like students in calculus class. In extreme cases, you can give her two totally different-shaped eyes. A blank stare is more ominous than an angry look.

This juxtaposition of charm and wickedness creates an unsettling feeling, which is all to the good. The rule is that any character that causes the viewer distress is successful!

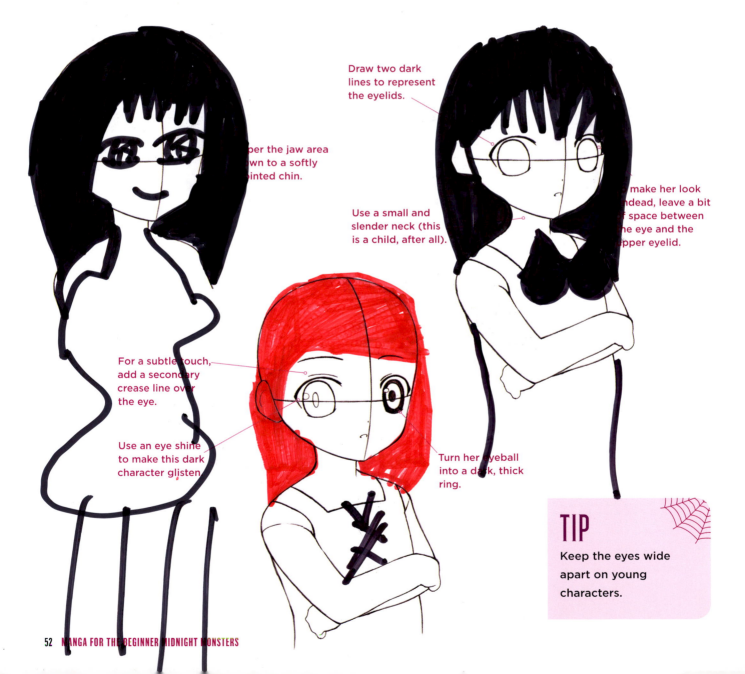

Draw two dark lines to represent the eyelids.

...per the jaw area ...wn to a softly ...inted chin.

Use a small and slender neck (this is a child, after all).

...make her look ...ndead, leave a bit ...f space between ...he eye and the ...pper eyelid.

For a subtle touch, add a secondary crease line over the eye.

Use an eye shine to make this dark character glisten.

Turn her eyeball into a dark, thick ring.

TIP
Keep the eyes wide apart on young characters.

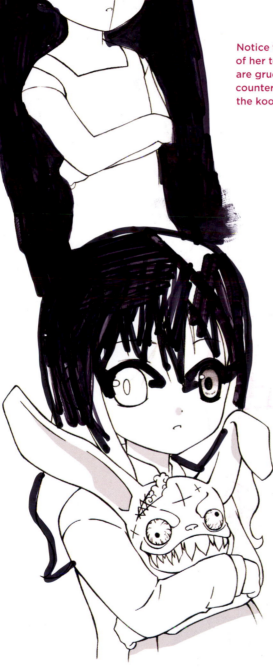

Use a gently sloping arch for the eyebrows.

Notice the incongruity of her toy. The teeth are gruesome, but counterbalanced by the kooky eyes.

Use clothes to add size to the character's body.

NOTE THE HORROR IN HER COZY EMBRACE.

FULL BODY

A character's head should match her body. The head and body should be of the same "type." For example, a character with a cute head needs a cute-style body, not a long, slinky torso and limbs.

To demonstrate this principle, meet "Twinkles." Twinkles appears to have just come out of the basement, where she had a fun time sawing off the babysitter's head. Oh that Twinkles! Is there anything she won't do for a laugh?

Her alter ego, the wall-shadow, spontaneously grows into an even more wicked version of Twinkles. This device is effective only if the shadow is drawn larger than the person who casts it, implying that the cute version of the character is only an illusion.

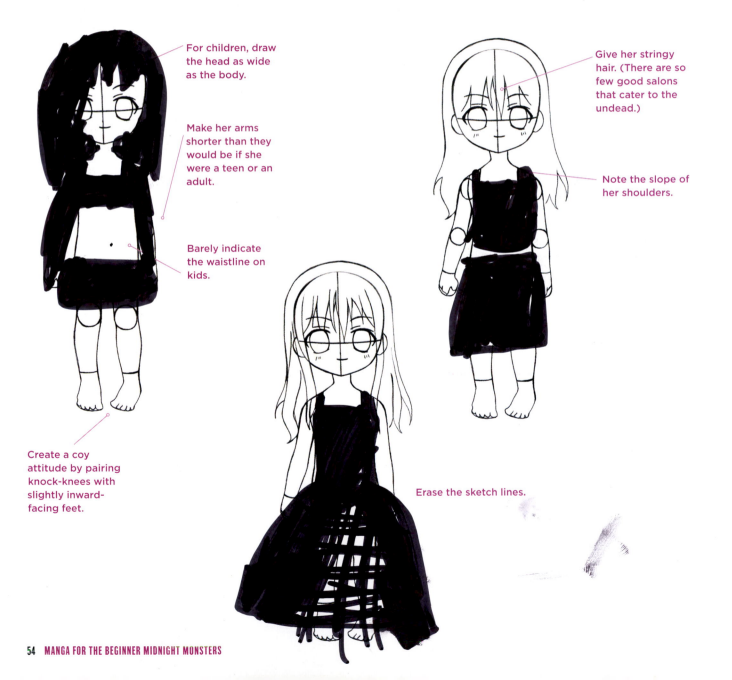

For children, draw the head as wide as the body.

Make her arms shorter than they would be if she were a teen or an adult.

Barely indicate the waistline on kids.

Create a coy attitude by pairing knock-knees with slightly inward-facing feet.

Give her stringy hair. (There are so few good salons that cater to the undead.)

Note the slope of her shoulders.

Erase the sketch lines.

Remember that pajamas are never formfitting.

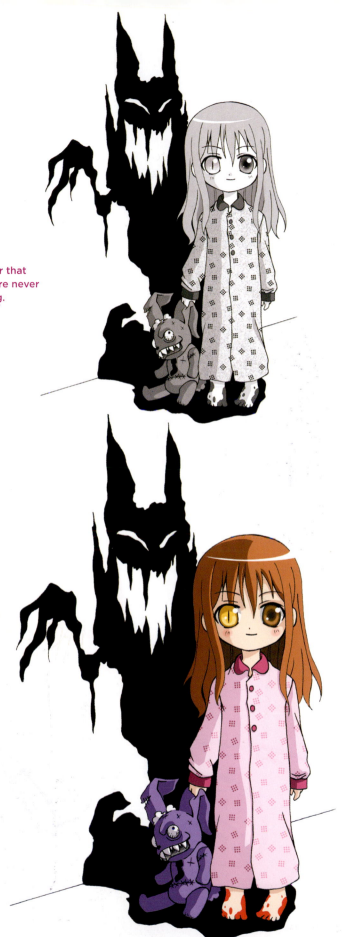

PERSONIFIED SHADOWS

Three emotions are most typically depicted in the form of personified shadows:

* Wicked joy
* Anger or fury
* Fear or shock

DRAW THE FLOOR ON AN ANGLE TO CONVEY UNCERTAINTY AND AGITATION. NOTE THE CONTRAST: A SERENE CHARACTER PAIRED WITH A MENACING ONE. THE MONSTER-SHADOW WORKS BEST IF IT CREEPS ALONG THE FLOOR AND THEN RISES UP ALONG A WALL, AS IF IT IS GROWING STRONGER.

GIRL WITCH

The old hag with warts on her nose, bony arms, and spindly fingers is sooooo yesterday. Gone, too, is her hunched posture. Today's witch wears the signature pointed hat and black, tattered dress. But now her eyes sparkle, so maybe she's a good witch, but her pet toad and serpent make me just a teensy bit suspicious about that. Either way, her eyes are the main attraction, and therefore her nose and mouth should be minimized in terms of size.

"Huh?" you utter quizzically, unable to comprehend what drawing a tiny nose and mouth could possibly have to do with great-looking eyes. Here's why: By downplaying certain features, you pull the focus away from them and allow the larger features—in this case, the eyes—to shine. The nose and mouth are important for drawing attention to her eyes precisely because they're small and subtle. Contrast is key. It makes the eyes look larger by comparison. Please hold any more questions until the next page.

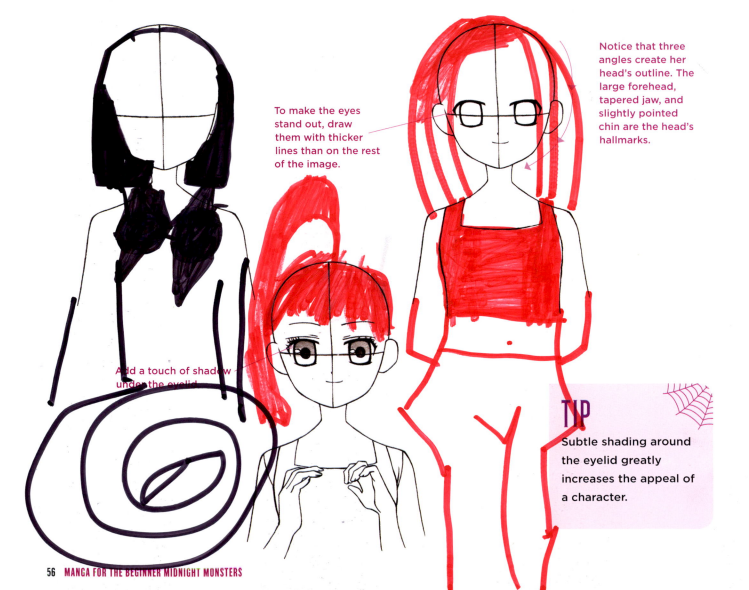

To make the eyes stand out, draw them with thicker lines than on the rest of the image.

Notice that three angles create her head's outline. The large forehead, tapered jaw, and slightly pointed chin are the head's hallmarks.

Add a touch of shadow under the eyelid.

TIP

Subtle shading around the eyelid greatly increases the appeal of a character.

Draw her hat so that only
the underside and tip are
visible.

Observe
how the hat
pushes the
hair down
on top of
her head.

Give her raised
eyebrows.

Place her pigtails beh
the ears.

Add a small crease over
her eyelids. This crease
s almost always added
y the pros because it
dds depth to the eyes.
w your drawings will
re this professional
k!

Notice how her braids
over top of each other.

Give her a pet fr

and this playmate
ty soon, she'll just
mate.

FULL (FLYING) BODY

Sometimes, as artists, we tend to compartmentalize. By this I mean that as we work, we often concentrate on each separate element of a drawing, while we miss the impact of the overall picture. This may lead to a particularly puzzling situation: You've done a pretty darn good job with the drawing. Then you step back and take a look at it. So how come it doesn't look good? Don't be too hard on yourself. Maybe everything has been drawn well. But unless you first rough-sketch the entire pose, focusing on its driving concept (e.g., a flying girl), then no amount of pretty hair and eyes will convey this idea. In other words, don't just draw a very pretty witch, and then stick a broom under her. Instead, draw the girl in an action pose from the start. Once the sketch is in place, finish it by working on the character's appeal.

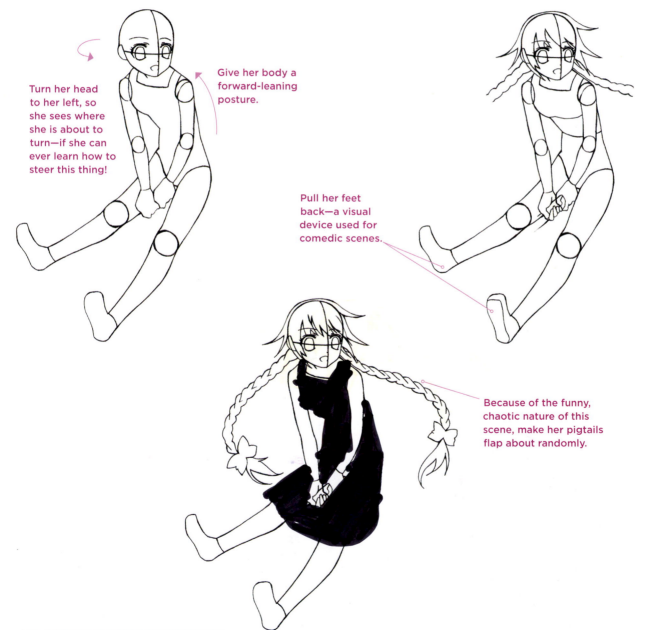

Turn her head to her left, so she sees where she is about to turn—if she can ever learn how to steer this thing!

Give her body a forward-leaning posture.

Pull her feet back—a visual device used for comedic scenes.

Because of the funny, chaotic nature of this scene, make her pigtails flap about randomly.

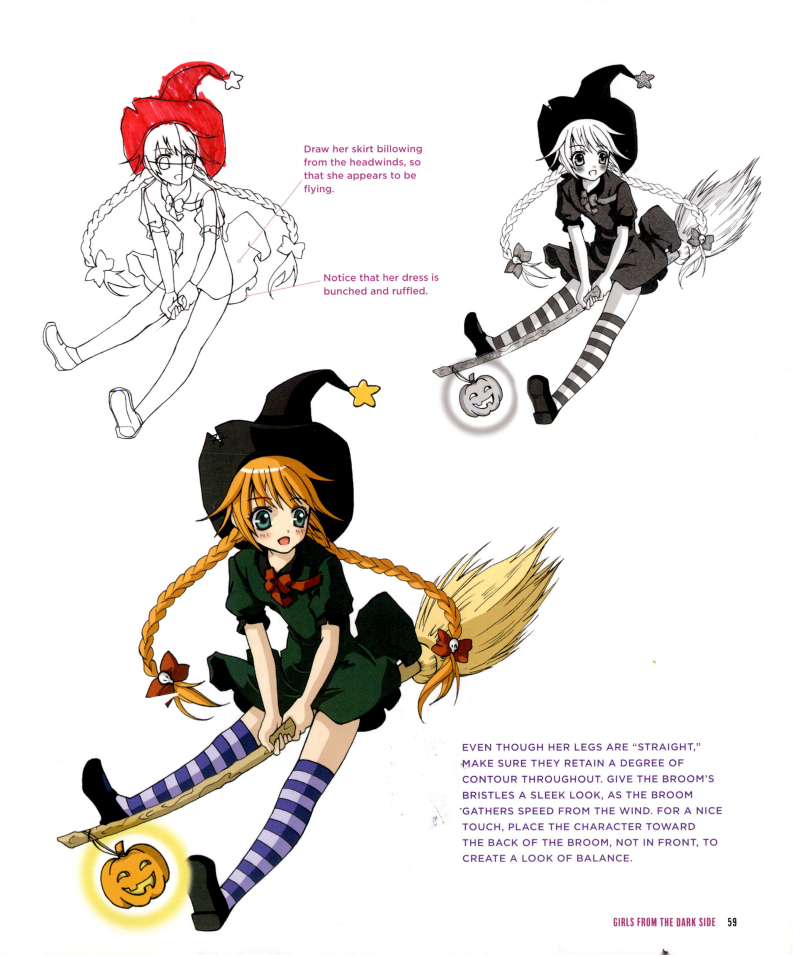

Draw her skirt billowing from the headwinds, so that she appears to be flying.

Notice that her dress is bunched and ruffled.

EVEN THOUGH HER LEGS ARE "STRAIGHT," MAKE SURE THEY RETAIN A DEGREE OF CONTOUR THROUGHOUT. GIVE THE BROOM'S BRISTLES A SLEEK LOOK, AS THE BROOM GATHERS SPEED FROM THE WIND. FOR A NICE TOUCH, PLACE THE CHARACTER TOWARD THE BACK OF THE BROOM, NOT IN FRONT, TO CREATE A LOOK OF BALANCE.

ZOMBIE GIRLFRIEND

Okay, so your blind date didn't work out as well as you had hoped. Mainly because she turned out to be undead. Hey, these things happen. You might want to consider using a different online dating service next time.

Look on the bright side: At least you know what to get her for her birthday—a sewing kit.

Zombies are the quintessential living dead.

Actually, they're more dead than living. Sort of like a customer service rep at a big-box store.

Start off by drawing a pretty zombie. Why pretty? Because if you start off with a somewhat scary character, by the time you're finished adding all the "zombie-fied" elements to her, she will look absolutely repulsive.

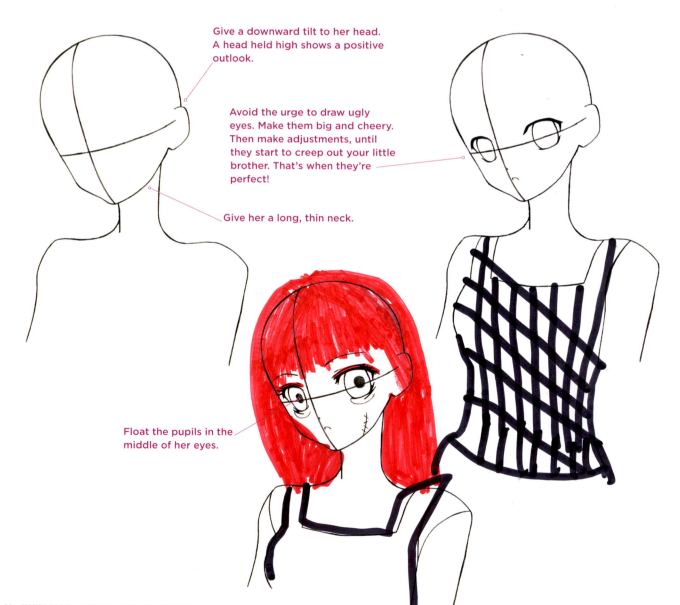

Give a downward tilt to her head. A head held high shows a positive outlook.

Avoid the urge to draw ugly eyes. Make them big and cheery. Then make adjustments, until they start to creep out your little brother. That's when they're perfect!

Give her a long, thin neck.

Float the pupils in the middle of her eyes.

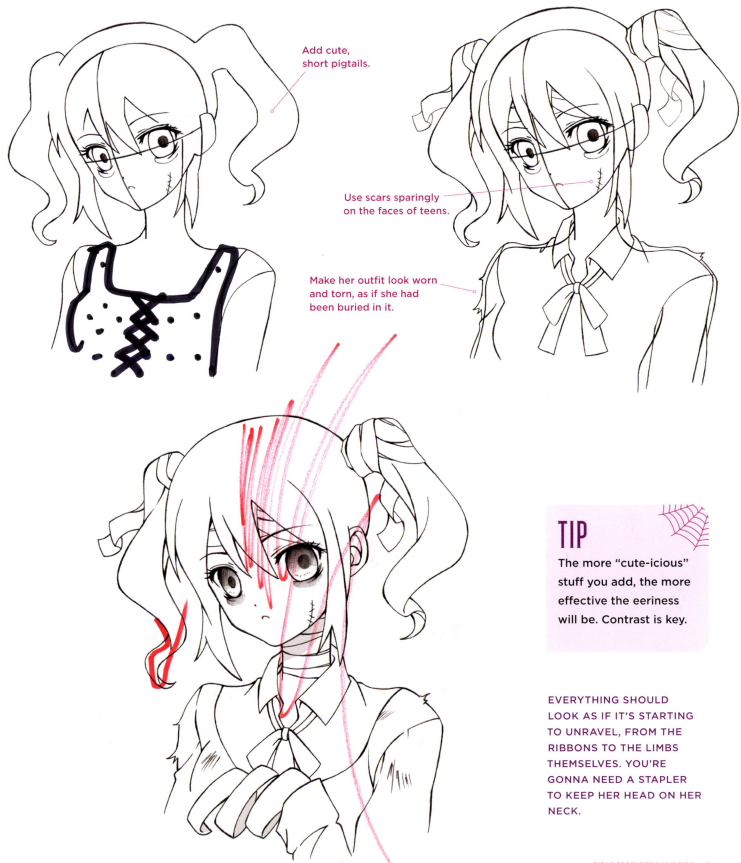

Add cute, short pigtails.

Use scars sparingly on the faces of teens.

Make her outfit look worn and torn, as if she had been buried in it.

TIP

The more "cute-icious" stuff you add, the more effective the eeriness will be. Contrast is key.

EVERYTHING SHOULD LOOK AS IF IT'S STARTING TO UNRAVEL, FROM THE RIBBONS TO THE LIMBS THEMSELVES. YOU'RE GONNA NEED A STAPLER TO KEEP HER HEAD ON HER NECK.

FULL BODY (OR AT LEAST WHAT'S LEFT OF IT)

The phrase *Pull yourself together!* has special resonance among zombies. Although this example shows a zombie in the first stages of putrefaction, some zombies are much further along.

Zombies are fun to draw because they're just about the most stubborn characters in all of manga.

Arm fell off? No problem. She'll just keep moving forward. Legs rotted away? A mere speed bump. She'll just drag herself along the ground until she finds a human victim. Zombies always make me wonder if we humans underestimate just how good we must taste.

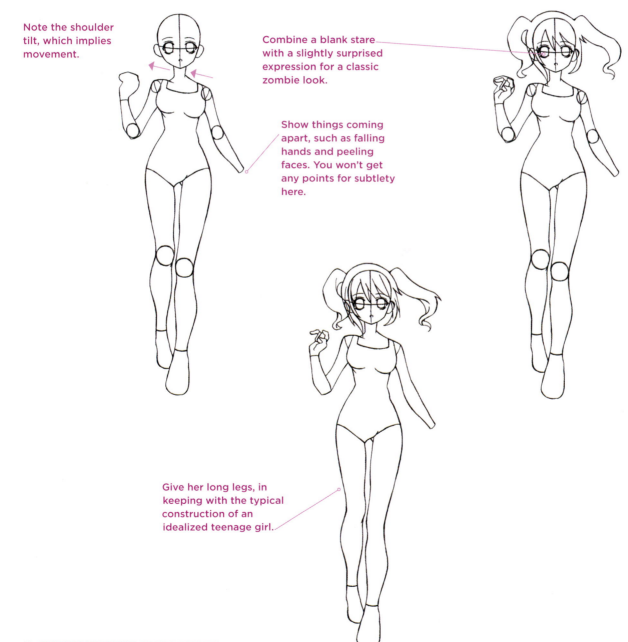

Note the shoulder tilt, which implies movement.

Combine a blank stare with a slightly surprised expression for a classic zombie look.

Show things coming apart, such as falling hands and peeling faces. You won't get any points for subtlety here.

Give her long legs, in keeping with the typical construction of an idealized teenage girl.

Always fray the garments. These are not hand-me-downs; they're "dig-me-ups."

HER BLANK STARE CONVEYS A MINDLESS LOOK. THIS WORKS WELL FOR ZOMBIES, WHICH ARE CHARACTERS WHO HAVE HAD THEIR WILL STOLEN FROM THEM. ALL THEY WANT TO DO IS KILL HUMANS. THEY HAVE NO OTHER HOBBIES— THEY ARE KILLAHOLICS. THE BLOOD SPLATTER ON HER DRESS BELONGS TO SOMEONE ELSE. HERS IS ALREADY COAGULATED. THE DRESS'S COLOR, ONE YOU NORMALLY DON'T SEE WORN BY THE UNDEAD, HAS A BIT OF "BOUNCE" TO IT. IT LIVENS UP THE IMAGE, BUT DOESN'T OVERDO IT. NO ONE WANTS A PERKY ZOMBIE.

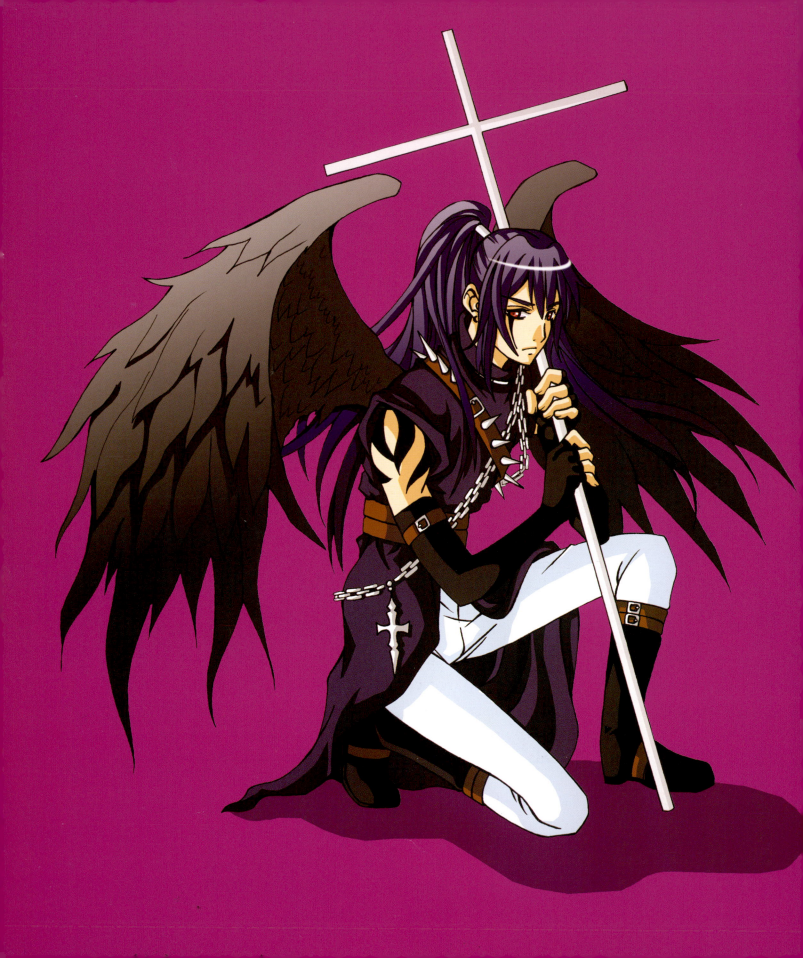

BOYS WITH LOST SOULS

Now turn your attention to another key group of supernatural characters. Soulless boys are emblematic of this age of angst and anger: the teen years in the prison of suburbia. Not only are soulless boys "bad," but they're also the epitome of cool. Striking in their appearance, they are the driving force behind many stories. That's because readers can relate to them—in the sense that they feel different from everyone else. Alone in a world where everyone else seems to belong. Like how you felt in band practice.

But for immortal goth boys, this difference is not all in their heads. Their very existence exemplifies loneliness. They don't build camaraderie with others. The only place they feel at home is at a manga convention.

Let's meet them and learn how to draw them.

VAMPIRE BOY

Vampires are so popular, so crucial to the horror genre, that several sections of a good monster book could be devoted to them. (What a coincidence! This book has several sections devoted to them. See page 83 for a whole chapter dedicated to vampires.) In addition, this character is so vital to the genre that he really ought to lead off any chapter on supernatural boys. (Well, what do you know! This book does that, too!) And, finally, any book that does both those things should definitely win the Nobel Prize in literature. (Oh, please, don't be silly. I'm certainly not going to get my hopes up for that. By the way, just out of curiosity, what does someone wear to the awards ceremony?)

Today's vampires are sensitive—not just emotionally, but in their physical appearance as well. Say bye-bye to repulsive bloodsuckers and hello to killers-as-teen-idols. Is this a great culture or what? Although they have immense powers, the physical strength of teen vampires is generally camouflaged by their appearance, which is almost wimpy.

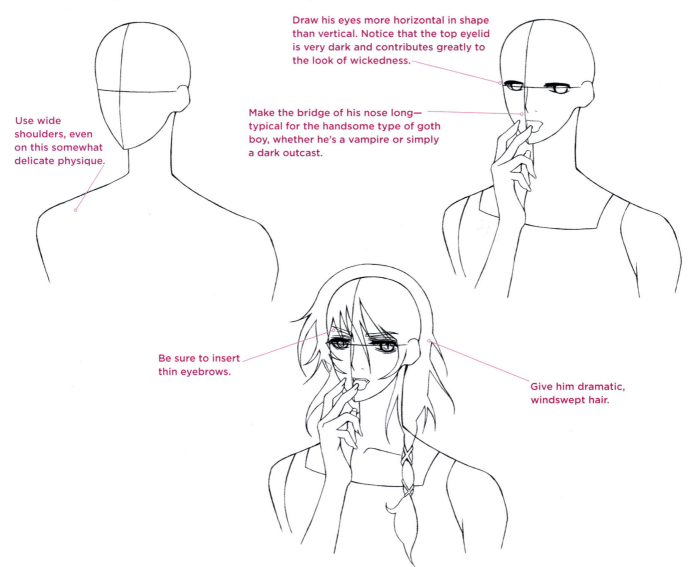

Use wide shoulders, even on this somewhat delicate physique.

Draw his eyes more horizontal in shape than vertical. Notice that the top eyelid is very dark and contributes greatly to the look of wickedness.

Make the bridge of his nose long—typical for the handsome type of goth boy, whether he's a vampire or simply a dark outcast.

Be sure to insert thin eyebrows.

Give him dramatic, windswept hair.

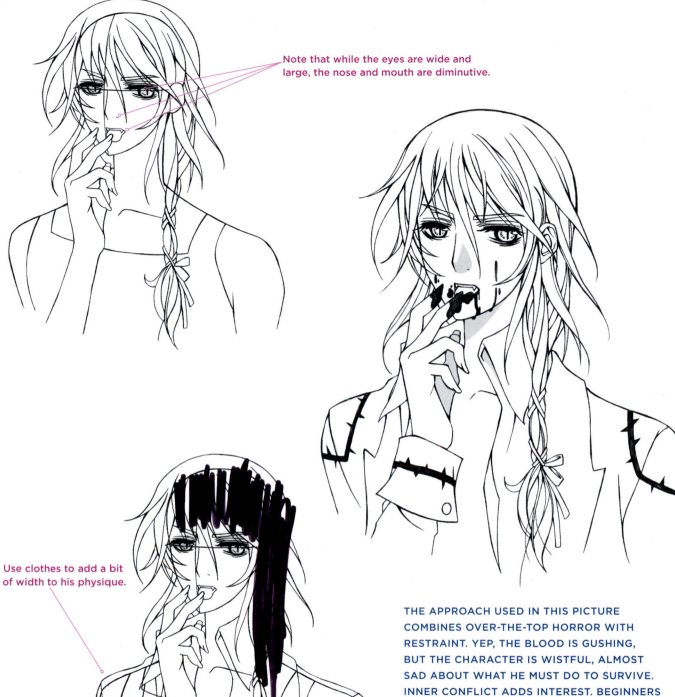

Note that while the eyes are wide and large, the nose and mouth are diminutive.

Use clothes to add a bit of width to his physique.

THE APPROACH USED IN THIS PICTURE COMBINES OVER-THE-TOP HORROR WITH RESTRAINT. YEP, THE BLOOD IS GUSHING, BUT THE CHARACTER IS WISTFUL, ALMOST SAD ABOUT WHAT HE MUST DO TO SURVIVE. INNER CONFLICT ADDS INTEREST. BEGINNERS DON'T ALWAYS RECOGNIZE THAT THEY HAVE THIS CHOICE AND, THEREFORE, TEND TO PORTRAY SCENES LIKE THESE BY DRAWING THE CHARACTER ENGAGED IN GLEEFUL GLUTTONY. BUT A MORE NUANCED APPROACH TO VIOLENCE MAKES THE VIOLENCE METAPHORICAL INSTEAD OF SIMPLY GORY.

Draw a vampire in the manner [...] In this scene, his torso tilts right, while the other handsome guy [...] with a [...] hips go left to counterbalance. Classic icons of willowy frame and long thin arms [...] ws the supernatural, namely rose petals and bats, are him to appear model-like [...] ses, which has been delicately strategically scattered about him. so [...] se of dynamism.

Give him a small [...] rough his shoulders are [...] ide.

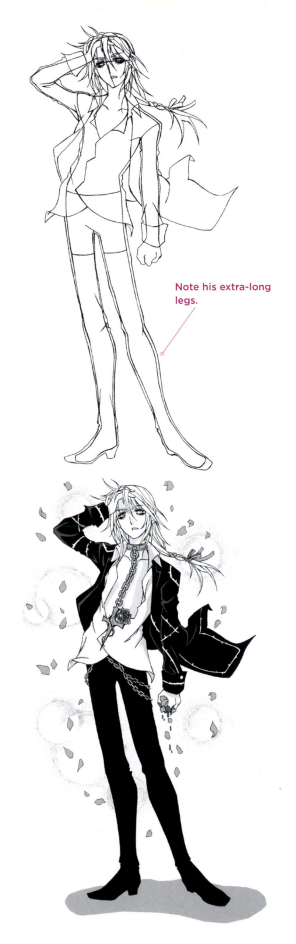

Note his extra-long legs.

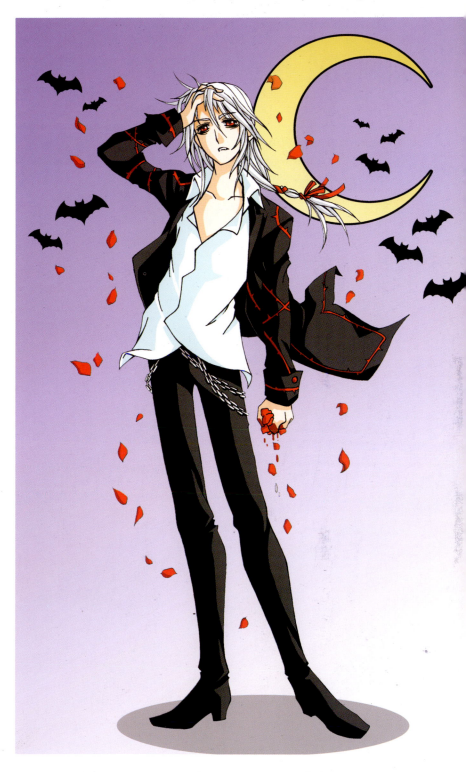

IN THE COLORED VERSION, THE RED ROSE PETALS CREATE AN EYE-CATCHING CONTRAST TO THE BLACK OF THE SILHOUETTED BATS. THE LACK OF A HORIZON LINE TO ANCHOR THE IMAGE ADDS AN ETHEREAL LOOK TO THE SCENE.

HUNTER OF VAMPIRES

When you've got bugs, you spray. When you've got vampires, you call this guy. But how does one go about killing a creature that's already dead?

Only two things are certain to kill a vampire: a stake through the heart and undercooked Buffalo wings. Though a dagger can't kill him, it will certainly slow him down.

This character must appear confident, with nerves of steel. What makes a person choose to go into this particular line of work instead of being, say, a hedge fund manager? Maybe he didn't like being stuck behind a desk all day, so why not hunt vampires? When you put it that way, it kind of makes sense, doesn't it?

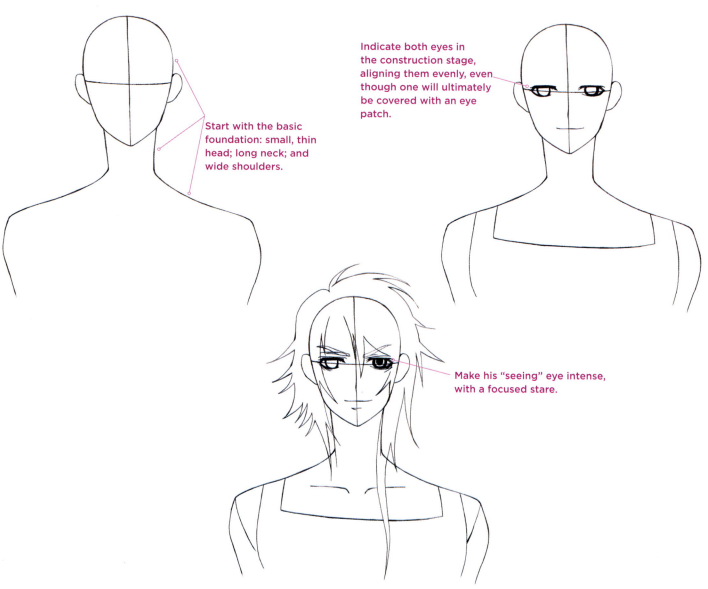

Start with the basic foundation: small, thin head; long neck; and wide shoulders.

Indicate both eyes in the construction stage, aligning them evenly, even though one will ultimately be covered with an eye patch.

Make his "seeing" eye intense, with a focused stare.

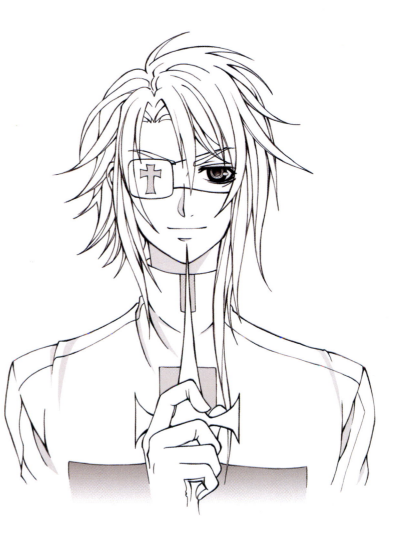

Add hair, rakishly drawn to look good but not coiffed.

DIRECT AND SIMPLE, THIS IS A HIGHLY EFFECTIVE POSE. WHY? THE BLADE LEADS THE READER'S EYE FROM THE HANDLE UP TO HIS FACE.

FULL BODY

You thought the dagger was the only weapon this hunter carried? Vampires tend not to go down without a fight; ergo, the big sword. True, it might not actually "kill" a vampire—legend requires a stake through the heart—but then, how many headless vampires do you see causing trouble?

Vampire hunters usually look like they've been run through the mill. Note the raggedness of his clothing, the bandages around his legs, and his eye patch.

Notice how his long, lean torso is mirrored by his long, lean limbs.

Observe that in this front pose, the foot appears slender, due in part to perspective. The bridge of the foot obscures the heel, which you can't see from this angle.

When drawing a character in a cape or flowing jacket, be sure to indicate the inner folds as well as the exterior of the garment.

ON A BLACK-AND-WHITE DRAWING, THE DISCRETE USE OF POOLS OF BLACK MAKES THE CHARACTER STAND OUT. GRAY ADDS VARIETY. WHEN SOME ARTISTS TURN TO COLOR, THEY ABANDON GRAY AND BLACK, AS IF THEY WON'T WORK WITH A COLORFUL PALETTE. OH YE OF LITTLE FAITH! YOU CAN ALSO USE COLORS AS HIGHLIGHTS ON A GRAY-BLACK IMAGE LIKE THIS ONE.

SORCERER

The sorcerer is a master conjurer. He can turn his enemies into toads with the tap of a wand. I would like to have that power for just five minutes. Tell me that wouldn't be sweet at a high school reunion.

Today's manga sorcerer is unlikely to be a bearded man in a conical hat. Instead, he's more likely to be a

teen with superpowers. He's neither all good nor all evil. His origins are more complex. The original legend of Merlin, for example, held that he was half-devil. Therefore, maintain some devilry in the character design, as well as in his wardrobe.

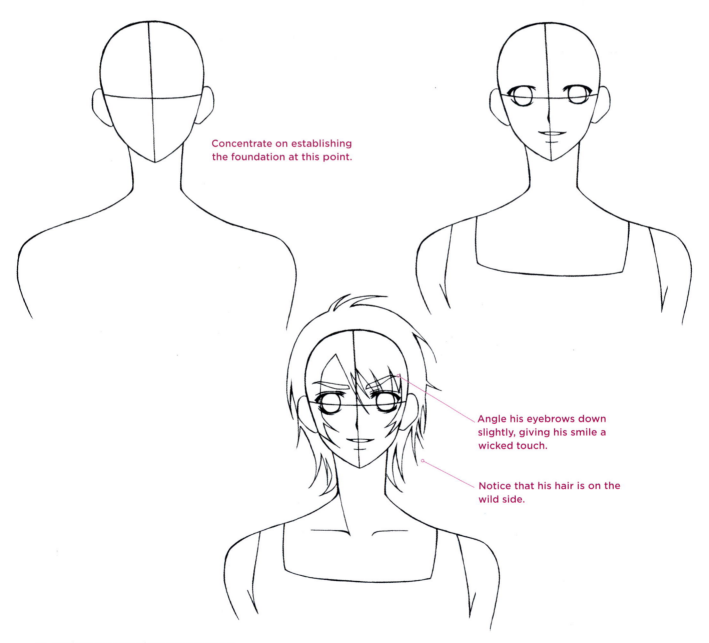

Concentrate on establishing the foundation at this point.

Angle his eyebrows down slightly, giving his smile a wicked touch.

Notice that his hair is on the wild side.

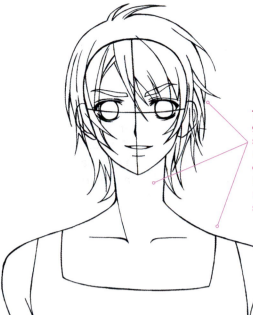

To create glamorous supernatural manga characters, combine a tiny head, super-long neck, and wide shoulders.

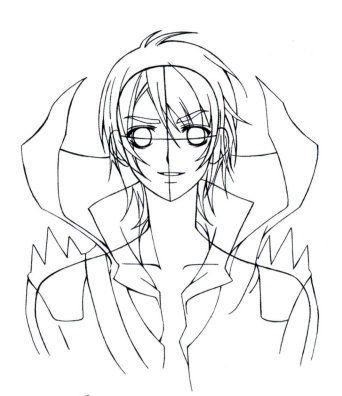

WHAT'S UP WITH HIS EYE BUSINESS? THE LEFT ONE HAS A ROUND PUPIL, BUT THE RIGHT PUPIL IS DIAMOND-SHAPED. THIS IS A POPULAR TECHNIQUE, USED TO INDICATE CHARACTERS THAT ARE MENTALLY UNBALANCED. YET HE BELIEVES HE'S SANER THAN ANYONE ELSE.

FULL BODY

Usually, when a character walks forward (toward the viewer) and out of the panel, he or she does so to the left or to the right, but rarely straight at the observer. Walking directly up to the viewer is confrontational. That's why you rarely see it. Not many characters can pull it off with aplomb. It takes a character with confidence and power. Oh, and a good rule of thumb: Never provoke a manga character whose hand is glowing.

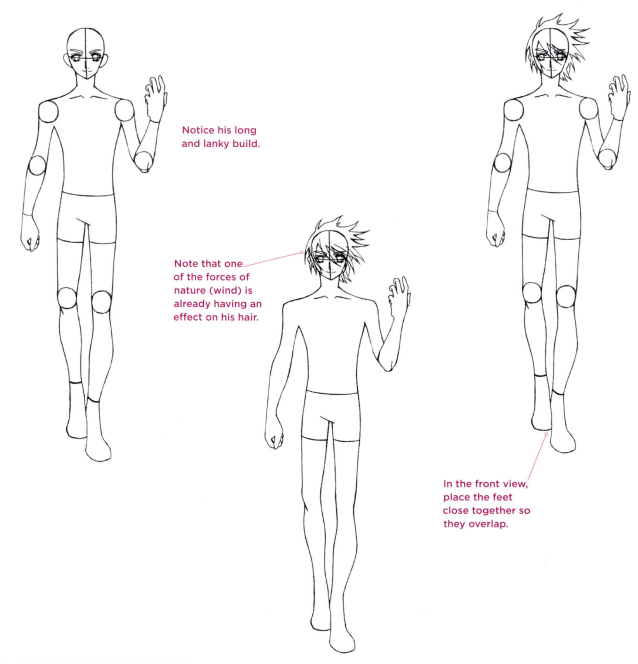

Notice his long and lanky build.

Note that one of the forces of nature (wind) is already having an effect on his hair.

In the front view, place the feet close together so they overlap.

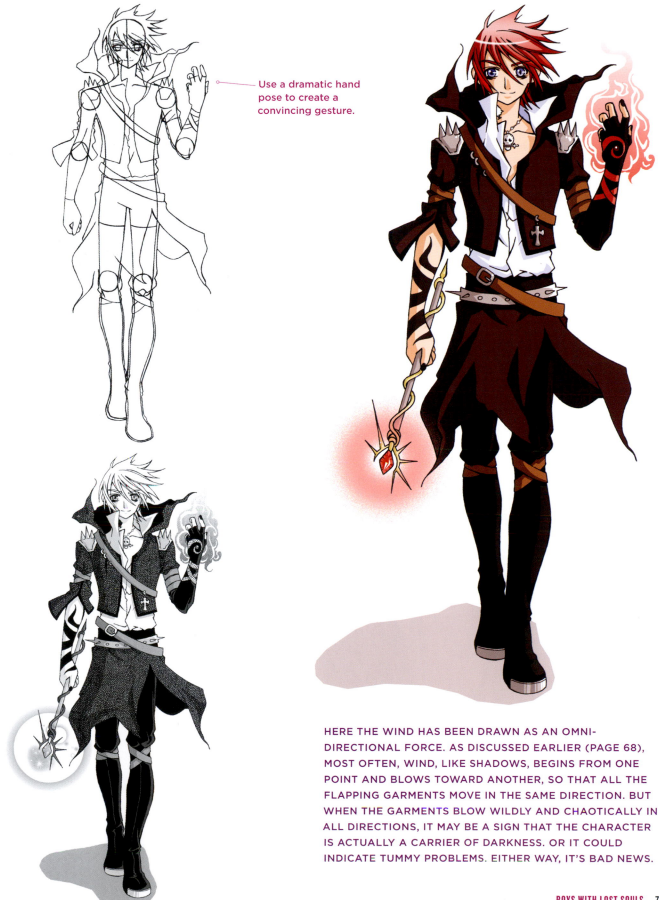

Use a dramatic hand pose to create a convincing gesture.

HERE THE WIND HAS BEEN DRAWN AS AN OMNI-DIRECTIONAL FORCE. AS DISCUSSED EARLIER (PAGE 68), MOST OFTEN, WIND, LIKE SHADOWS, BEGINS FROM ONE POINT AND BLOWS TOWARD ANOTHER, SO THAT ALL THE FLAPPING GARMENTS MOVE IN THE SAME DIRECTION. BUT WHEN THE GARMENTS BLOW WILDLY AND CHAOTICALLY IN ALL DIRECTIONS, IT MAY BE A SIGN THAT THE CHARACTER IS ACTUALLY A CARRIER OF DARKNESS. OR IT COULD INDICATE TUMMY PROBLEMS. EITHER WAY, IT'S BAD NEWS.

FALLEN ANGEL

When angels fall, they fall hard. Here's another exciting, tragic figure of the underworld. Tragic heroes have an excellent, built-in conflict: They're at odds with themselves and the world in which they exist. Battling inner demons, they are tortured souls; yet, there's often something poetic in the way that they are drawn. We call them "sensitive bad guys" or "bad guys with a conscience." Just don't rely too heavily on that conscience.

Note this character's tattoos. They're used as a metaphor, not a skin decoration. They show how deep a curse has been cast upon him: He has literally been branded by it. A man so marked, for all to see, cannot hope to ever again return to the light, but will live the rest of his life in darkness and shadows. You can come up with visual metaphors just as effective as this one, if you dig for them. First, decide on a theme you would like to convey about your character. Then literalize it, visually. For example, if you wanted to show that a particular character was a serial killer, you could give him a series of markings on his arm—one for each of his victims.

Note the glance out of the corner of this character's eyes. It's a suspicious look.

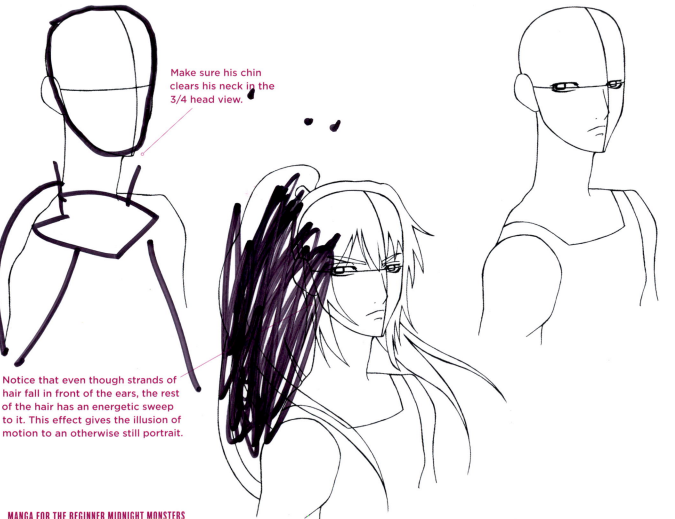

Make sure his chin clears his neck in the 3/4 head view.

Notice that even though strands of hair fall in front of the ears, the rest of the hair has an energetic sweep to it. This effect gives the illusion of motion to an otherwise still portrait.

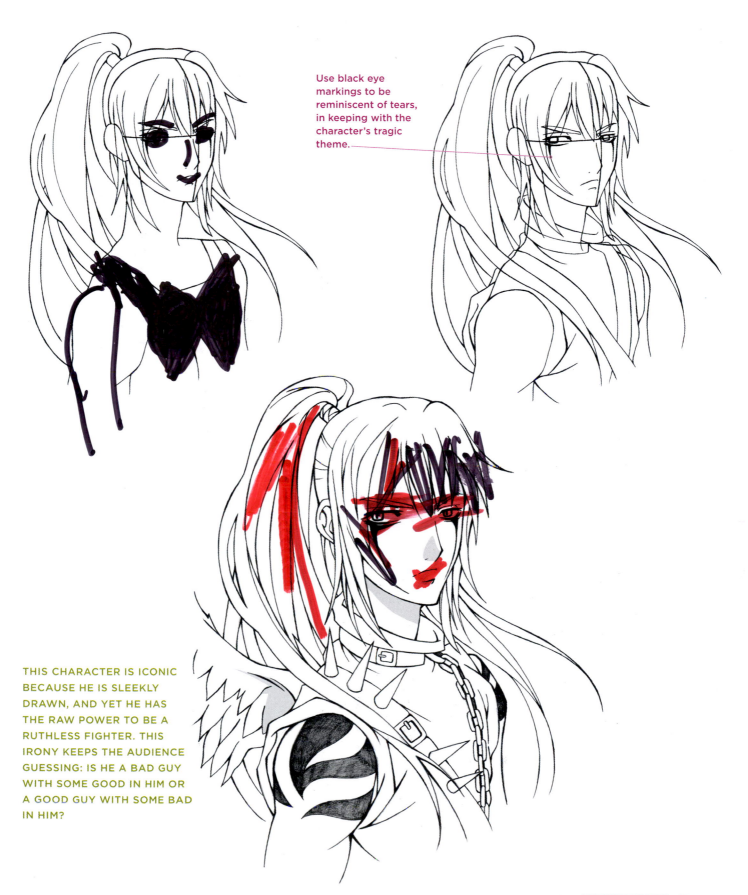

Use black eye markings to be reminiscent of tears, in keeping with the character's tragic theme.

THIS CHARACTER IS ICONIC BECAUSE HE IS SLEEKLY DRAWN, AND YET HE HAS THE RAW POWER TO BE A RUTHLESS FIGHTER. THIS IRONY KEEPS THE AUDIENCE GUESSING: IS HE A BAD GUY WITH SOME GOOD IN HIM OR A GOOD GUY WITH SOME BAD IN HIM?

FULL BODY

Here's another way to literalize a curse: Give the character an iconic symbol. A symbol of hope and light, such as this character's cross, makes the hopelessness of the character's accursed condition even more poignant. Readers feel for characters that face extreme hardship. It evokes their empathy.

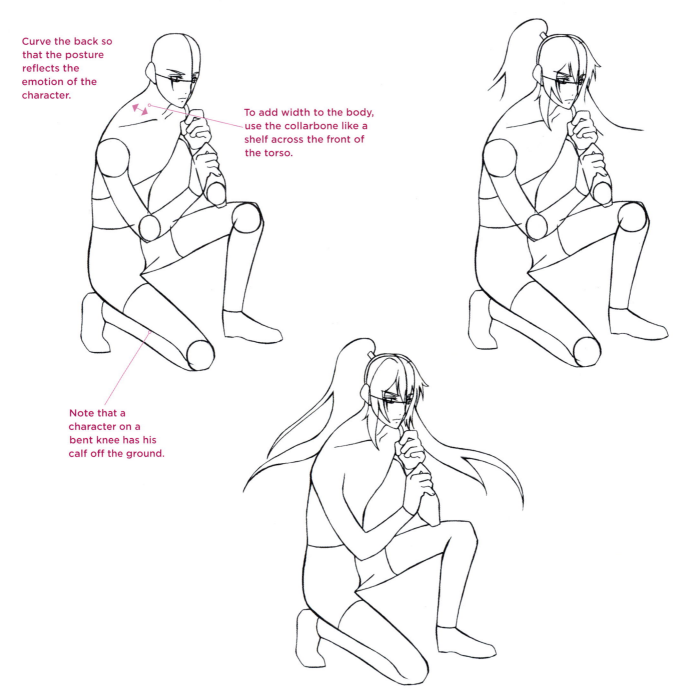

Curve the back so that the posture reflects the emotion of the character.

To add width to the body, use the collarbone like a shelf across the front of the torso.

Note that a character on a bent knee has his calf off the ground.

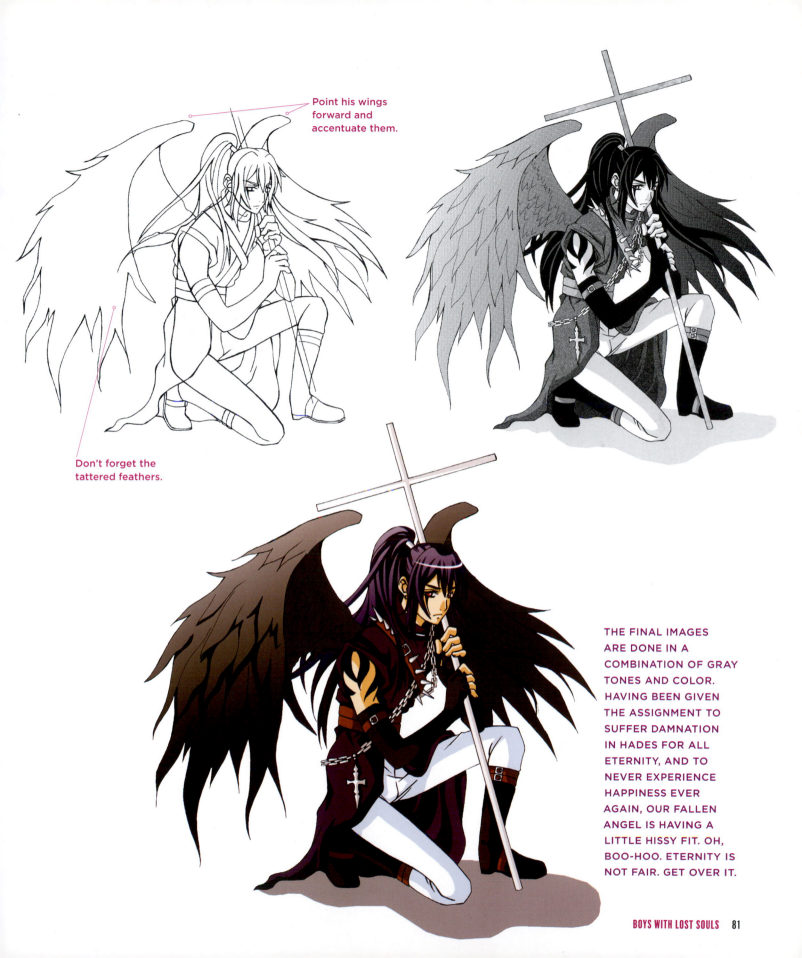

Point his wings forward and accentuate them.

Don't forget the tattered feathers.

THE FINAL IMAGES ARE DONE IN A COMBINATION OF GRAY TONES AND COLOR. HAVING BEEN GIVEN THE ASSIGNMENT TO SUFFER DAMNATION IN HADES FOR ALL ETERNITY, AND TO NEVER EXPERIENCE HAPPINESS EVER AGAIN, OUR FALLEN ANGEL IS HAVING A LITTLE HISSY FIT. OH, BOO-HOO. ETERNITY IS NOT FAIR. GET OVER IT.

VAMPIRES
RULERS OF THE UNDERWORLD

Vampires are featured in all forms of entertainment, from manga to movies. Your humble author, in fact, wrote a manga graphic novel, with illustrations by Anzu, called *The Reformed*, which was published by Del Rey, a division of Random House.

The vampire used to be thought of as a popular monster in the horror genre. But with vampire mania running so high, vampire fiction has become a full-fledged genre in its own right.

What accounts for their popularity? Besides the matinee good looks of the characters, it's the retelling of the human condition through a darkly lyrical allegory. The vampire's existence is heartbreaking. For this antihero to live, others must die. He has everlasting life; but it must be forever spent in darkness. He wants to belong, but guards his secret nature. Poor vampy—so misunderstood!

THE EVER-POPULAR VICTORIAN-STYLE VAMPIRES

No matter how many times Hollywood tries to reinvent and redefine the character, vampires in the Victorian style continue to remain popular. And it's no wonder. The nineteenth century produced classic horror stories thick with mood and atmosphere, such as *Dr. Jekyll and Mr. Hyde*, the works of Edgar Allan Poe, and, of course, the number one story of horror and pathos, *Frankenstein*.

It's time for us to meet our main player—the man of the hour, a great entertainer, a super-evil character, and the only creature to give dentures a bad name: *Nosferatu!*

THE VAMPIRE AS MATINEE IDOL

This soulless, tragic figure is a refined young man, physically mature for his age, and in possession of piercing eyes, which some might even call hypnotic, especially to people who take one glance at them, and then blurt out, "Yes, master!"

The vampire has a delicate face, composed of androgynous, severe eyebrows, with morally corrupt eyes. His nose is long and thin, and punctuated by a subtle mouth. He is often portrayed with a full head of long, flowing hair, which is pretty remarkable, since he's more than three hundred years old.

The vampire's appearance is deceptive, because he has almost unfathomable power. But you can feel it seep out in the form of his animal magnetism.

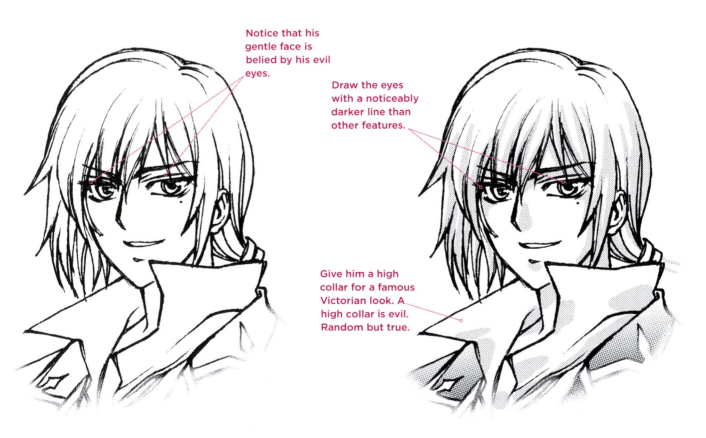

Notice that his gentle face is belied by his evil eyes.

Draw the eyes with a noticeably darker line than other features.

Give him a high collar for a famous Victorian look. A high collar is evil. Random but true.

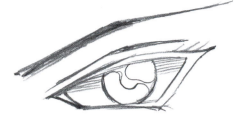

DIAGRAM OF A VAMPIRE-TYPE EYE

CONSTRUCTION OF A VAMPIRE-TYPE EYE

Shadow, cast by the eyelid, blends into the pupil.

VICTORIAN VAMPIRE FASHIONS

If I had to put on all those layers of frilly clothes each morning just to slide down the banister, trek to the dining hall of my estate, ring the bell, and wait until my manservant brought me a cold, crisp glass of corpuscles, I'd shoot myself.

Vampires have been barons, dukes, and princes. If not actual royalty, then they're often portrayed as aristocracy. But unlike the fops and popinjays of the time, these guys can fight. You can suggest power by drawing wide shoulders on the character, which will also make his chest and back appear broader.

Here's another effective technique that suggests power without bodybuilder-type muscles: reducing the head size. By reducing it just slightly on a tall body with wide shoulders, the resulting contrast makes the body appear even more powerful.

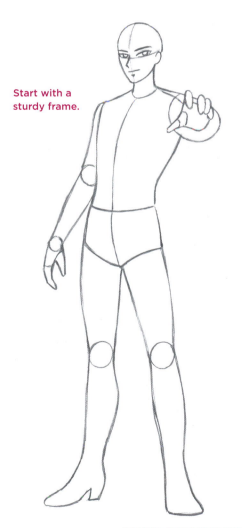

Start with a sturdy frame.

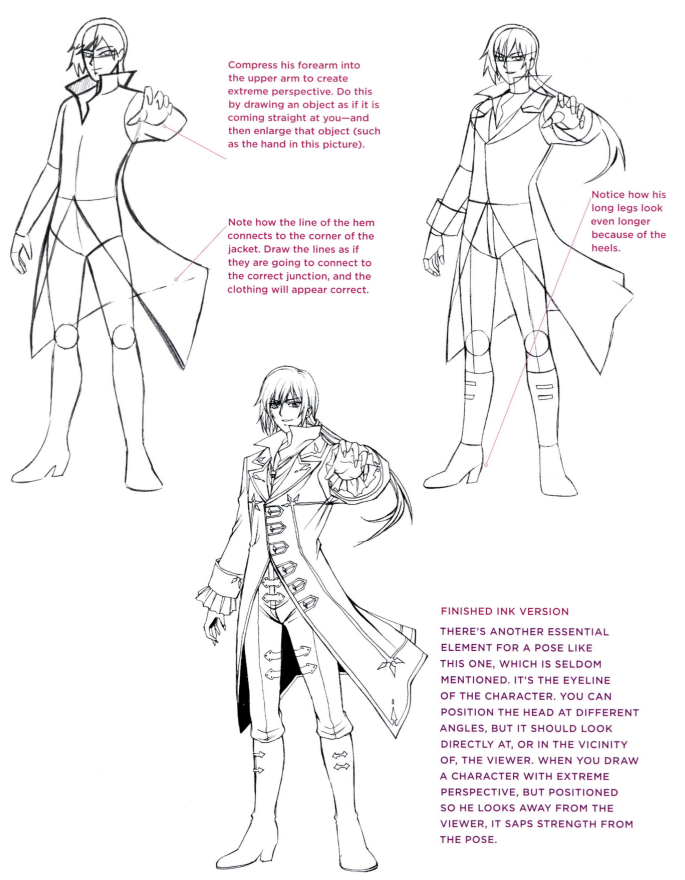

Compress his forearm into the upper arm to create extreme perspective. Do this by drawing an object as if it is coming straight at you—and then enlarge that object (such as the hand in this picture).

Note how the line of the hem connects to the corner of the jacket. Draw the lines as if they are going to connect to the correct junction, and the clothing will appear correct.

Notice how his long legs look even longer because of the heels.

FINISHED INK VERSION

THERE'S ANOTHER ESSENTIAL ELEMENT FOR A POSE LIKE THIS ONE, WHICH IS SELDOM MENTIONED. IT'S THE EYELINE OF THE CHARACTER. YOU CAN POSITION THE HEAD AT DIFFERENT ANGLES, BUT IT SHOULD LOOK DIRECTLY AT, OR IN THE VICINITY OF, THE VIEWER. WHEN YOU DRAW A CHARACTER WITH EXTREME PERSPECTIVE, BUT POSITIONED SO HE LOOKS AWAY FROM THE VIEWER, IT SAPS STRENGTH FROM THE POSE.

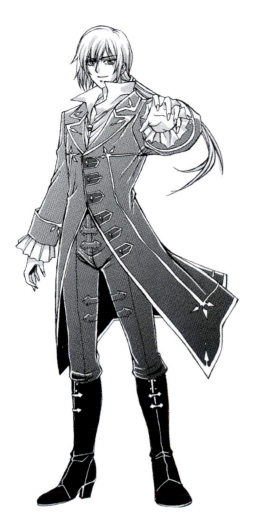

INKED VERSION WITH GRAY TONE
TRY TO USE DIFFERENT DEGREES
OF DARKNESS TO SUGGEST TONES.
HIS BOOTS ARE DARKER THAN HIS
JACKET. THE JACKET IS DARKER
THAN HIS WHITE SHIRT.

COLOR VERSION
THE COLORFUL TRIMMING ADDS
AN ORNATE TOUCH AND MAKES
HIM LOOK WEALTHY.

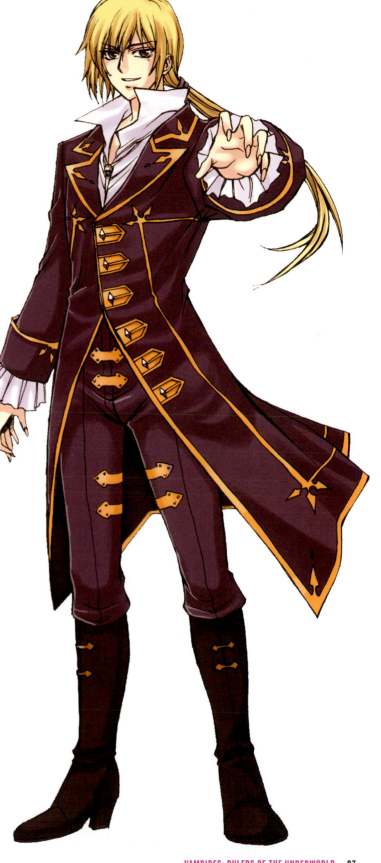

THE ARISTOCRAT

Never trust anyone who keeps a raven as a pet and lives in a castle. These are telltale signs of a bad guy.

When drawing the wardrobe of the aristocratic vampire, just remember the three Cs—Collar, Cuffs, and Cape. Or, if that's too difficult to remember, then go with the three Bs—Bats, Bangs, and Boots. Of course, there's always my personal favorite, the three Fs—Formal Flounces and Folds. Stop me before I alliterate again!

Any way you look at it, vampire duds in the Victorian age were fancy-dancy, with extra emphasis on the *dancy*. Lots of layers comprised most outfits.

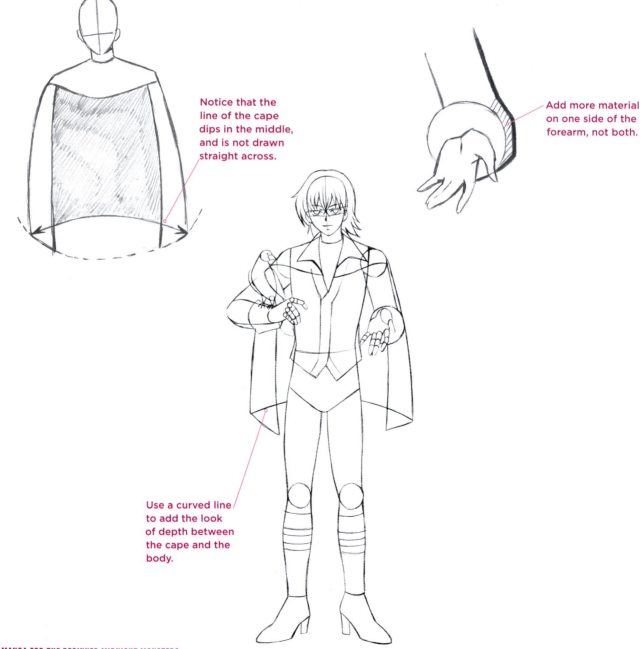

Notice that the line of the cape dips in the middle, and is not drawn straight across.

Add more material on one side of the forearm, not both.

Use a curved line to add the look of depth between the cape and the body.

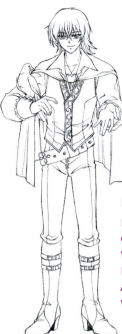

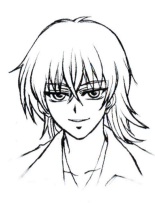

FINISHED INK VERSION

HE'S JUST YOUR TYPICAL, GOOD-NATURED TEENAGER, WHO HAPPENS TO SUCK BLOOD INSTEAD OF EATING AT BURGER JOINTS. IS THAT WRONG?

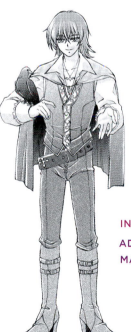

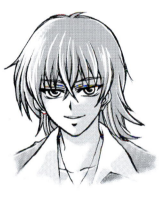

INKED VERSION WITH GRAY TONE

ADDING HIGHLIGHTS TO THE HAIR MAKES THE IMAGE LIVELIER.

COLOR VERSION

SOME PEOPLE WILL TELL YOU THAT PURPLE AND BLACK DO NOT GO TOGETHER BECAUSE THEY LACK CONTRAST. HA! THOSE PEOPLE ARE YOUR ENEMIES. THEY'RE FILLING YOUR HEAD WITH ARTISTIC MISINFORMATION. NEXT TIME THEY TRY TO HELP, JUST SCOFF!

SCHEMING VAMPIRE

The vampire doesn't have to strike a dramatic silhouette every time you draw him. Underplaying the moment can give it just as much suspense and serves to add pacing between big emotions, actions, and expressions. You can create the look of power with restraint.

I learned a wonderful lesson about storytelling from one of my favorite movie directors, my friend Michael Ritchie. Michael directed several classics, such as one of my all-time favorite films, *The Candidate*, with Robert Redford, and comedies like *Bad News Bears*.

When we collaborated on a script, he would always gently guide the story into uneasy areas, where there was no black-and-white, just shades of gray. And he'd allow the moment to linger there, unexplained. Michael was a master at letting the audience feel

unsettled in their view toward a character, rather than labeling the character simply "good" or "bad." These "gray" moments are much more powerful and intense than the over-the-top moments.

And so it is with vampires. Their very existence is a contradiction. Don't shy away from it; use it. The vampire may not want to do what he does in order to survive, and yet he always succumbs to the hunger. He may love "the girl," but she is never safe in his presence.

You can use those shades of gray in your poses as well. When drawing the vampire in a scheming pose, try underplaying the moment, and see if that works better for you. Therefore, don't telegraph what he's thinking; instead, make the audience guess. When you've got them curious, you've got them hooked.

LOOSE CLOTHING

Loose clothing is most effectively portrayed with small folds or wrinkles. Don't overdo it.

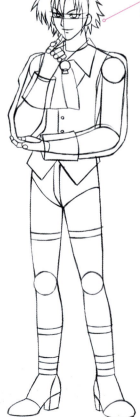

Make him look a little wild by hiding his hairbrush from him.

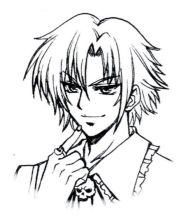

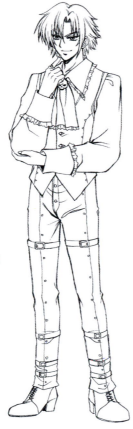

FINISHED INK VERSION
HE'S DECIDING WHAT HE'D LIKE
TO HAVE FOR LUNCH.

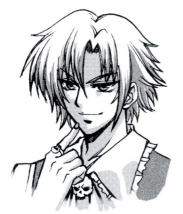

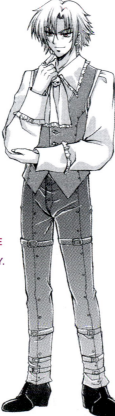

INKED VERSION WITH GRAY TONE
VICTORIAN SHIRTS WERE BILLOWY.
NO TANK TOPS BACK IN THE DAY.

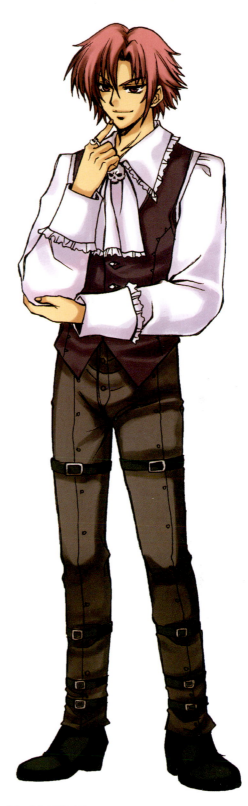

COLOR VERSION
AN INTROSPECTIVE LOOK BRINGS THE ARMS
CLOSE, WHEREAS AN EXTROVERTED POSE HAS
MORE OF A CAREFREE APPROACH TO ARM
PLACEMENT.

MODERN VAMPIRES: THE NEW STARS OF GRAPHIC NOVELS

Modern vampires suffer, and we pity them. They feel just terrible about the whole "suck-blood-and-kill" thing. Of course, some of their victims feel terrible about it, too, but no one's losing sleep over *them*.

The modern undead represent a progression in a long line of antiheroes, dating back to the classic James Dean flick *Rebel Without a Cause.* On a grand scale, antiheroes represent the loneliness of the human condition.

THE UNDEAD HEARTTHROB

Cool, intense, and more handsome than the other guys, who seem like youngsters by comparison, he's a worldly and wealthy character. He uses his position and possessions to sweep women off their feet before taking advantage of them. No, wait, I was thinking of single film producers in their early thirties. Well, he's pretty much the same thing, but with fangs.

His features are subtle. His expression is subtle. His lawn ornaments are a bit over the top, but the interior of his mansion is subtle, too. His expression often reflects thinly veiled hunger. He has the eyes of a predatory beast surveying his prey. This makes people wary, but his refined ways prove to be a useful and disarming distraction.

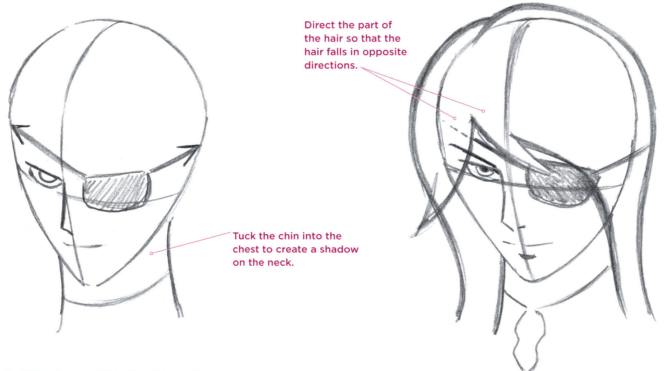

Direct the part of the hair so that the hair falls in opposite directions.

Tuck the chin into the chest to create a shadow on the neck.

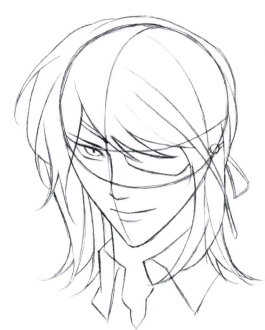

Note that the eye patch is held in place by a strap that is drawn at a diagonal—not straight across.

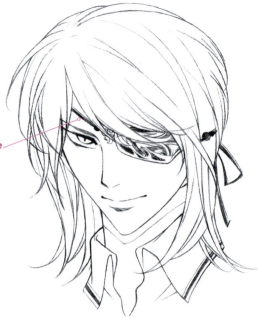

TIP

Drawing every single hair on a character's head is an incredible pain in the neck. Instead, draw the strands bunched together. By articulating groupings of hair rather than drawing each individual strand, you give the hair a fuller look, without the monotony of a person rolling pennies into a coin cylinder.

THE EYE PATCH GIVES HIM A SLIGHTLY SINISTER BUT CHIC LOOK.

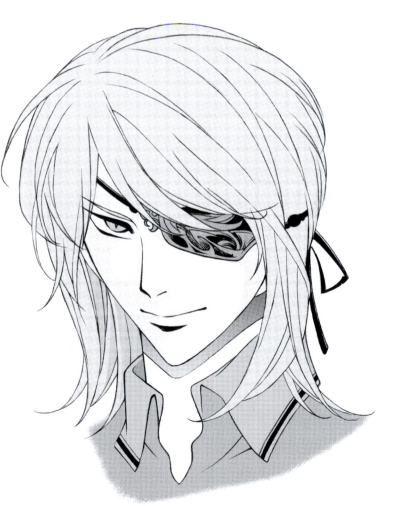

THE TEENAGE VAMPIRE

This self-absorbed string bean is a very popular type. The more he anguishes, the more the girls want to comfort him. Teenage girls in graphic novels really go for these bad boys, in part because they act more mature than human teenage boys. For example, you'll never catch a teen vampire opening his mouth wide, with half-chewed food in it, to gross out the girl he likes. Why anyone would think this is a good idea, science has yet to reveal.

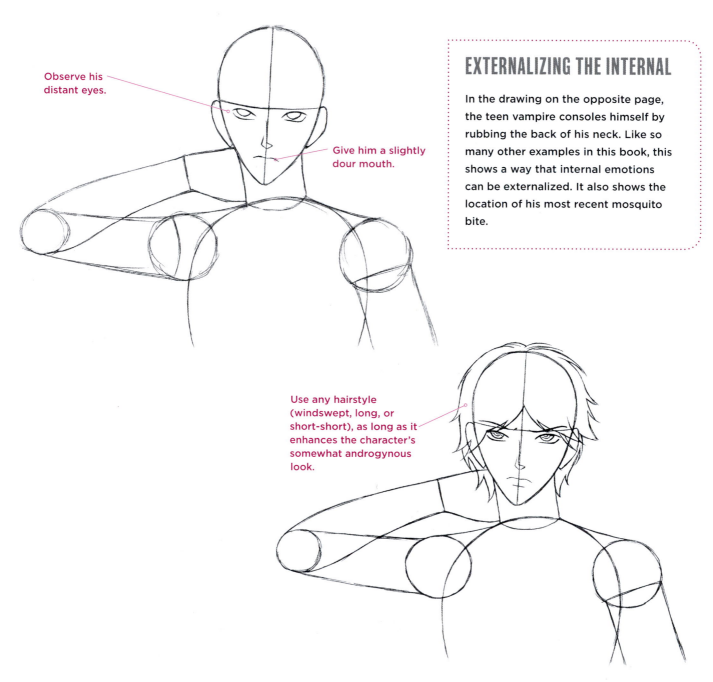

Observe his distant eyes.

Give him a slightly dour mouth.

EXTERNALIZING THE INTERNAL

In the drawing on the opposite page, the teen vampire consoles himself by rubbing the back of his neck. Like so many other examples in this book, this shows a way that internal emotions can be externalized. It also shows the location of his most recent mosquito bite.

Use any hairstyle (windswept, long, or short-short), as long as it enhances the character's somewhat androgynous look.

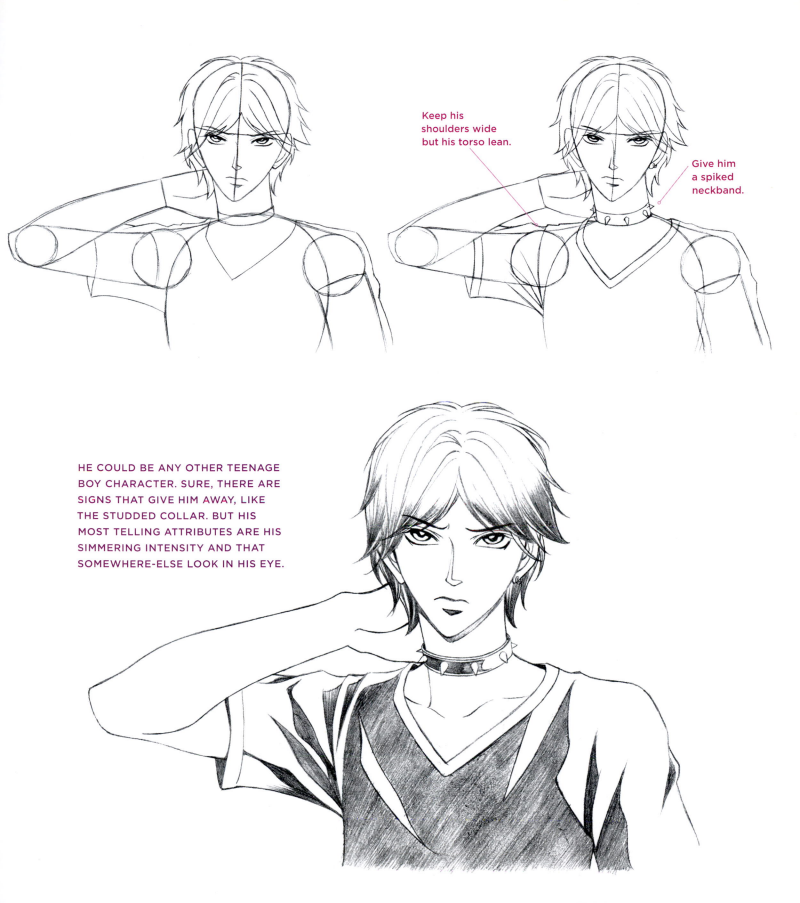

Keep his shoulders wide but his torso lean.

Give him a spiked neckband.

HE COULD BE ANY OTHER TEENAGE BOY CHARACTER. SURE, THERE ARE SIGNS THAT GIVE HIM AWAY, LIKE THE STUDDED COLLAR. BUT HIS MOST TELLING ATTRIBUTES ARE HIS SIMMERING INTENSITY AND THAT SOMEWHERE-ELSE LOOK IN HIS EYE.

FULL-FIGURE TEEN VAMP

The teen vampire is a modern invention. He personifies a tangle of emotions, ranging from yearning to sorrow, grief to fury. That adds up to a whole lot of whining. Could a visit to the school shrink help? I'm afraid the answer is no. No, my friends. First of all, the vampire, lonely to the extreme, doesn't open up to anyone. Second, he hates to talk about his mother. And so it matches his personality to show him as a loner, off by himself, ruminating darkly.

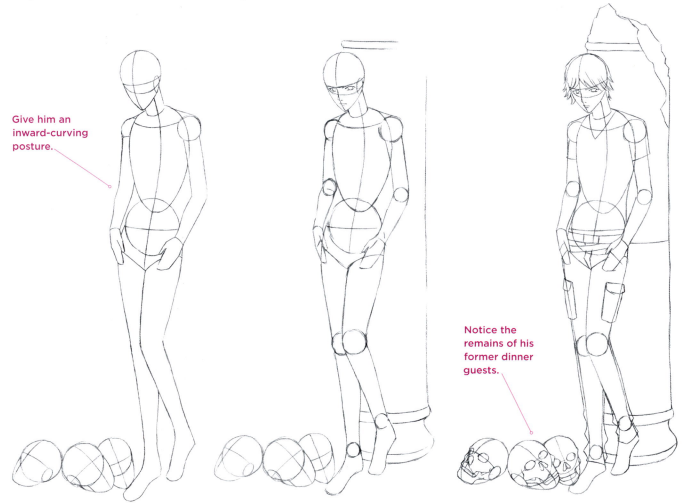

Give him an inward-curving posture.

Notice the remains of his former dinner guests.

STANCES AND POSES

A stance is utilitarian. For example, a character drawn with his legs shoulder-width apart exudes sturdiness and balance, and maybe even power. Poses, on the other hand, indicate mood. For example, drawing him with knees together gives him an introspective look.

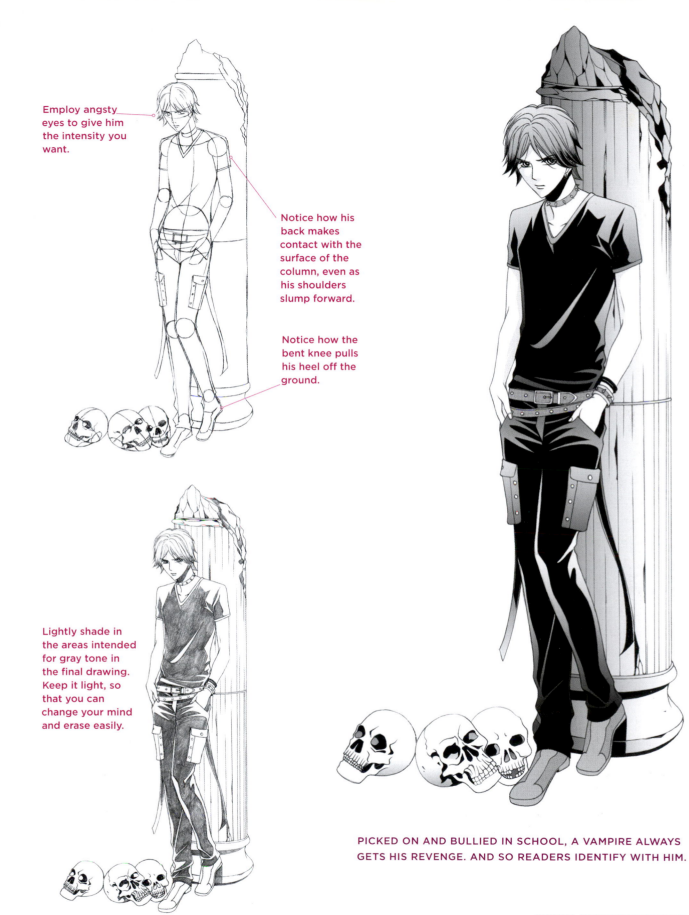

Employ angsty eyes to give him the intensity you want.

Notice how his back makes contact with the surface of the column, even as his shoulders slump forward.

Notice how the bent knee pulls his heel off the ground.

Lightly shade in the areas intended for gray tone in the final drawing. Keep it light, so that you can change your mind and erase easily.

PICKED ON AND BULLIED IN SCHOOL, A VAMPIRE ALWAYS GETS HIS REVENGE. AND SO READERS IDENTIFY WITH HIM.

THE SEDUCER

The vampire's gaze is hypnotic. His teenage victim cannot turn away. She cannot run; she cannot hide; and she cannot spell words that begin with the letters *pn*. As the Evil One draws closer, she's in terrible danger. "Run!" you cry out. Just then, the guy seated next to you on the train asks why you just yelled at a how-to-draw book. (As if it's any of his business.)

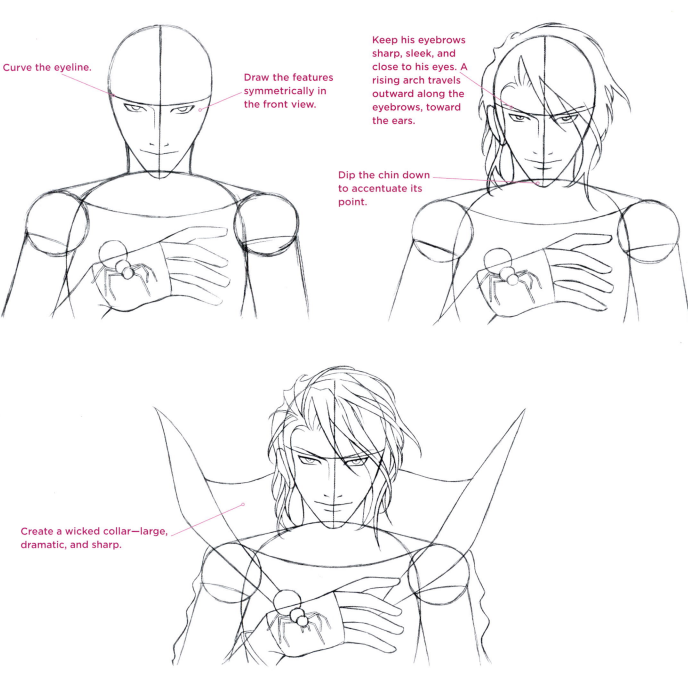

Curve the eyeline.

Draw the features symmetrically in the front view.

Keep his eyebrows sharp, sleek, and close to his eyes. A rising arch travels outward along the eyebrows, toward the ears.

Dip the chin down to accentuate its point.

Create a wicked collar—large, dramatic, and sharp.

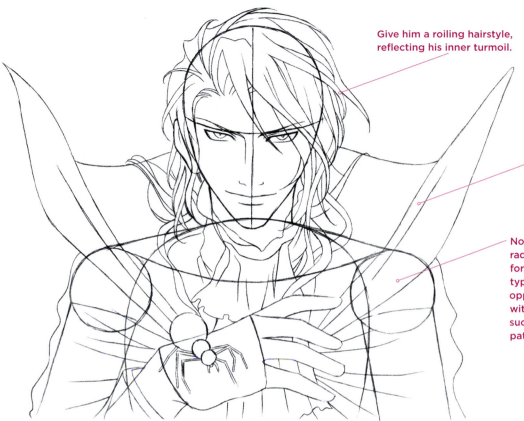

Give him a roiling hairstyle, reflecting his inner turmoil.

Indicate thickness at the edge of the collar.

Note how the creases in his cape radiate outward from the center, forming a pleasing wagon-wheel type of design. Look for the opportunity to do the same thing with other interpretive elements, such as shadows and repeated patterns.

THE UNDERSIDE OF THE COLLAR IS DARK AND IN SHADOW AS A RESULT OF MOONLIGHT HITTING IT FROM OVERHEAD. HE'S NOT AFRAID OF THAT BLACK WIDOW SPIDER. HE'LL MAKE HER HIS PET. AND NAME HER SPARKY.

EXTRAVAGANCE, ELEGANCE, AND EVIL

I'd like to meet the personal shopper who sold this vampire his getup. This is as over-the-top as a goth outfit can get. And yet it works. "But wait!" you intone. "You've always taught us to simplify, but now you hit us with this elaborate image. I am so confused that my head is whirring like a banshee. A banshee with a whirring head. Oh, darn you, cruel instructor, thy name is Christopher!"

Um, okay. Anyhow, for most images, *busy* means unfocused, cluttered, and distracting. However, sometimes a character is meant to be detailed, and it works better when it's packed with stuff. For example, a teenager's cluttered room is funnier than one where everything has been neatly put into drawers. Wait, bad example. There is no teenager's room where everything has been straightened up.

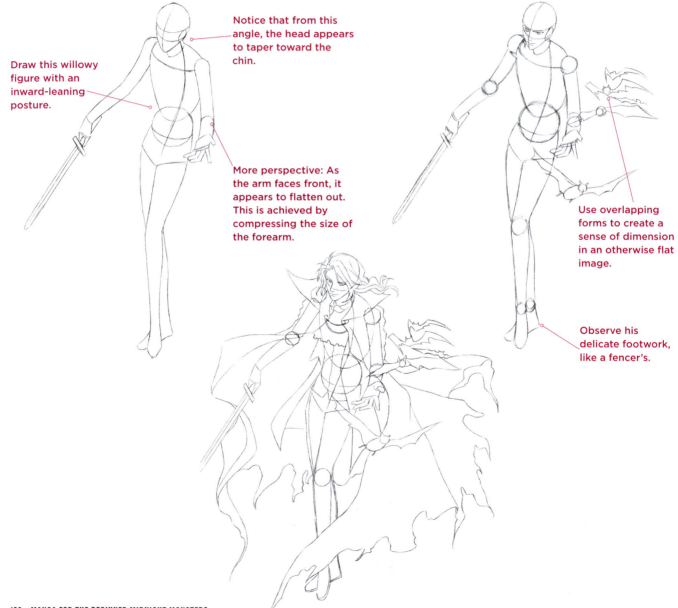

Draw this willowy figure with an inward-leaning posture.

Notice that from this angle, the head appears to taper toward the chin.

More perspective: As the arm faces front, it appears to flatten out. This is achieved by compressing the size of the forearm.

Use overlapping forms to create a sense of dimension in an otherwise flat image.

Observe his delicate footwork, like a fencer's.

Give his cape tons of folds, which add interest to the picture.

Use silhouettes to turn this colony of bats into a series of evil, faceless creatures.

Whip the cape in front of the figure for more overlapping.

CAN YOU IMAGINE WHAT THE SIZE OF HIS CLOTHES CLOSET MUST BE? MY WIFE WOULD BE SO JEALOUS.

THE BEWITCHING BEAUTY OF FEMALE VAMPIRES

Surprisingly, although male vampires are the more common of the hemoglobin gourmets, female vampires often appear to be the more dangerous of the two. While the male may just be seductive, she's seductive and deceptive in her villainy—a potent combination.

If she's a modern vampire, her outfit may be a darker version of casual chic. If she's of the Victorian genre, her clothes are probably as cheery as a recurrence of plague.

TAROT CARD READER

If she pulls the wrong card, your future is black. This game is like an evil version of "eenie-meanie-minie-moe." Note the head angle—she casts a glance from a 3/4 pose. That turn to the side indicates that a character is hiding something, which may be nothing more than her true feelings. Conversely, the front view is more open, more honest.

Note her cute hat. At the same time, she's been loaded up with symbols of mysticism, from the ornate tattoo to the veil and her pet bird, which is sort of an avian version of a golden retriever.

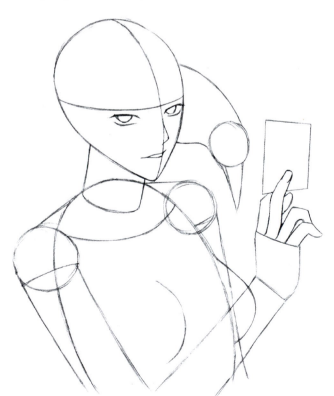

"Layer" your drawing of the body by overlapping various parts. The front arm overlaps the torso. The torso overlaps the far shoulder. And the head overlaps the bird.

TIP

Layering doesn't require much more effort than drawing a flat pose; it just takes a little advance thought.

In manga, let the hair flow as freely as water, paying little attention to the garments in its way.

Crane the raven's neck around toward the card, keeping the viewer's eye circling back to that element.

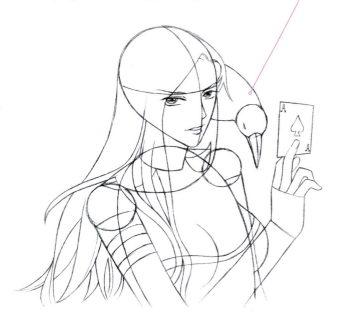

Bump up the accessories to clearly spell out her evil intentions.

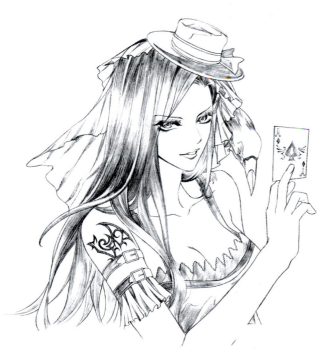

VAMPIRE WOMEN ONLY NEED THE SUGGESTION OF EVIL IN THEIR EXPRESSIONS IN ORDER TO LOOK WICKED. TRY UNDERPLAYING IT AT FIRST, AND SEE IF THAT WORKS FOR YOU. IF NOT, YOU CAN RATCHET UP THE INTENSITY BY STAGES TO GET WHERE YOU WANT TO BE WITHOUT OVERSHOOTING THE MARK.

EVIL IN FULL REGALIA

Is her outfit too extravagant? Nah. It's a new look: casual death. Okay, so maybe it's over the top. What's the alternative? A pretty blouse and jeans? It wouldn't go with the raven. Here's what you should keep in mind: She'll look weird if her outfit makes her stand out like a sore thumb. But if she stands out like a sore thumb *and* looks flamboyant at the same time, she'll steal the scene. Fans love villains. Hey, it's not as if the reader is living vicariously through the evil character as she commits all sorts of atrocious deeds without any consequences. No, wait. Actually, that is the reason fans love villains.

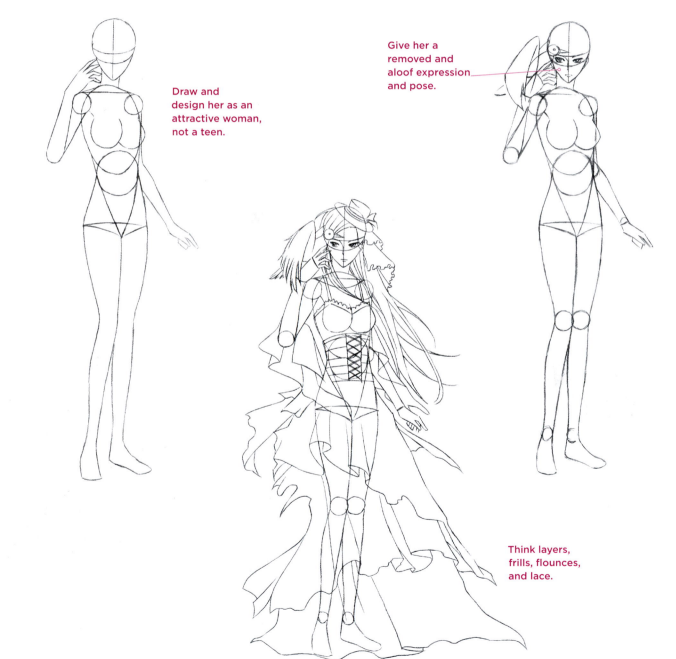

Draw and design her as an attractive woman, not a teen.

Give her a removed and aloof expression and pose.

Think layers, frills, flounces, and lace.

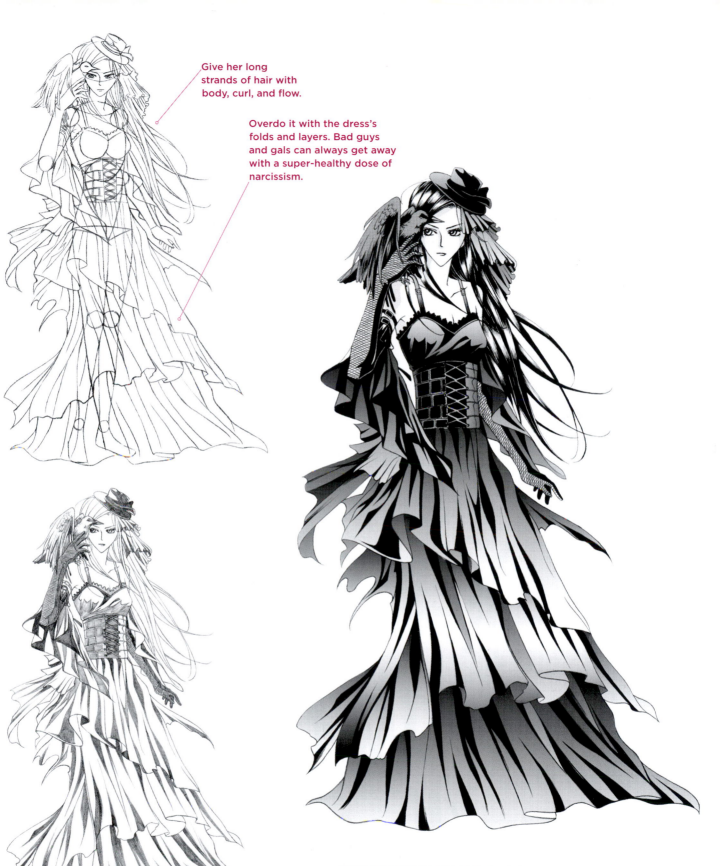

Give her long strands of hair with body, curl, and flow.

Overdo it with the dress's folds and layers. Bad guys and gals can always get away with a super-healthy dose of narcissism.

SOMEBODY PLEASE LEND THIS CHARACTER AN IRON.

THE VAMPIRE NEXT DOOR

She's so sweet that she could be the teacher's pet. But underneath that sugary veneer lies evil. The kind of evil that never fails to remind the teacher that he forgot to pass out the homework. Yes, my friends. We're talking the deepest depths of depravity. And as if it couldn't get any worse, she's also a vampire. She sneaks into the cemetery on Friday nights to terrorize and murder the local teens who are partying there. What I want to know is, who thought that partying in a cemetery was a good idea? It must be Darwin's way of culling the herd.

Rest her heavy eyelids directly on the eyeballs for a dreamy, sweet look.

Draw the chin so it clears the neck.

Give her a bow in her hair, in case, for some reason, the viewer didn't notice how innocent she was. I hope this does the trick, or you may have to add a halo.

Give her a bob haircut.

Draw her hair so it falls just above her eyes. Even though it covers her eyebrows, draw them anyway so they still show up.

Remember: You can never have enough skulls.

Notice that her sharp eyebrows naturally slope downward toward her nose, giving her eyes a slightly wicked glint in almost every expression.

A SWEET LOOK, BUT PAIRED WITH MOODY EYES, MAKES HER APPEAR MUCH OLDER THAN HER YEARS. STILL, HINTING THAT SHE'S A VAMPIRE IS A BIG TASK TO ACCOMPLISH WITH EXPRESSIONS ALONE. INCLUDE A FEW VISUAL CUES, SUCH AS THE CUTE LITTLE COLLECTION OF SKULLS ON HER HEADBAND AND BACKPACK.

HOME SWEET HOME

It may not have a white picket fence, but to her, it's home. This is where she can kick off her heels, relax in her casket, and watch TV as she nibbles on a box of scabs.

Parents usually don't understand their kids' fascination with these supernatural characters. Don't try to explain it to them. It would only become another painful experience with them, like "bonding."

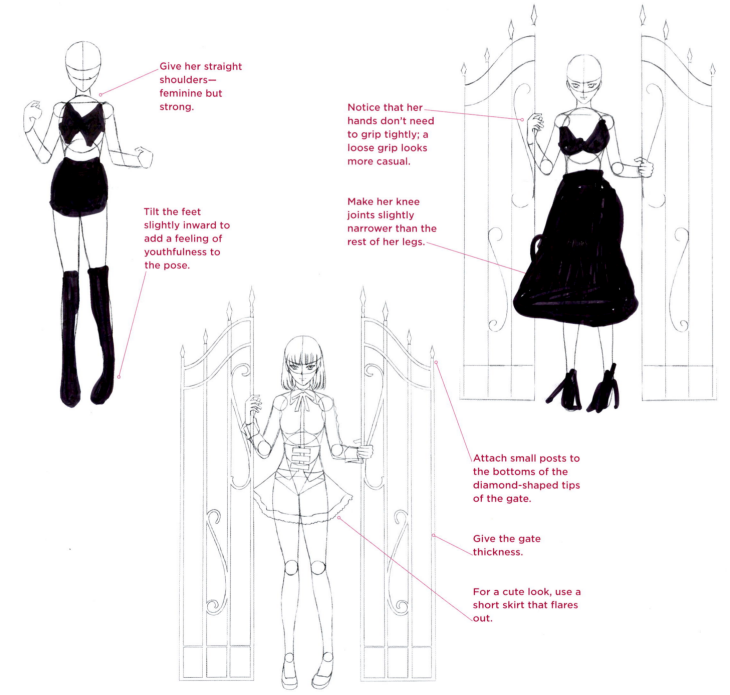

Give her straight shoulders—feminine but strong.

Tilt the feet slightly inward to add a feeling of youthfulness to the pose.

Notice that her hands don't need to grip tightly; a loose grip looks more casual.

Make her knee joints slightly narrower than the rest of her legs.

Attach small posts to the bottoms of the diamond-shaped tips of the gate.

Give the gate thickness.

For a cute look, use a short skirt that flares out.

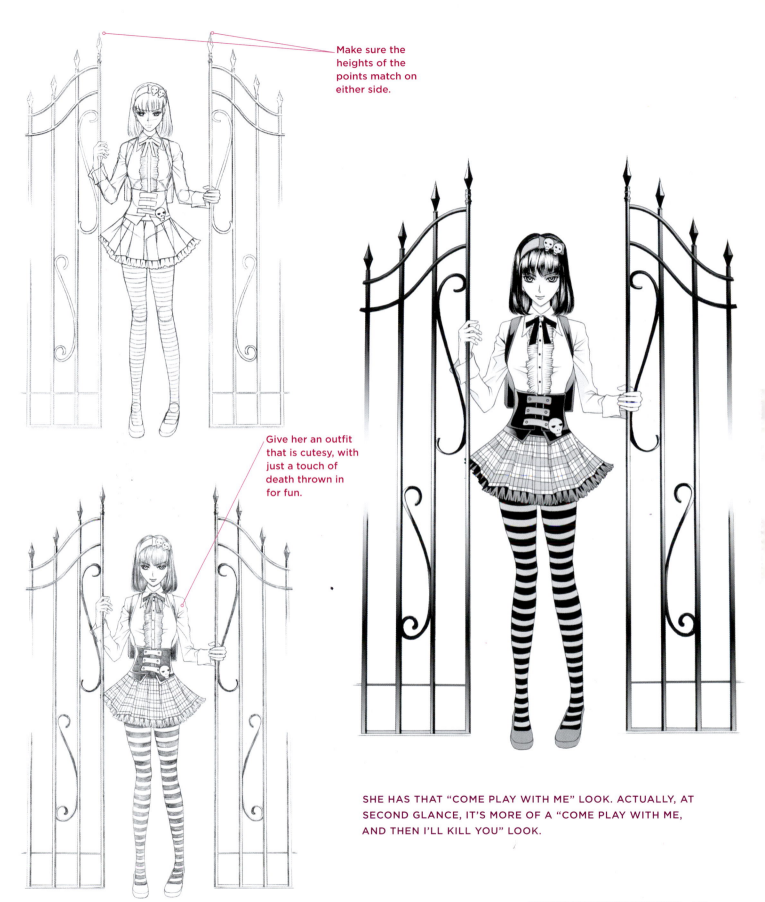

Make sure the heights of the points match on either side.

Give her an outfit that is cutesy, with just a touch of death thrown in for fun.

SHE HAS THAT "COME PLAY WITH ME" LOOK. ACTUALLY, AT SECOND GLANCE, IT'S MORE OF A "COME PLAY WITH ME, AND THEN I'LL KILL YOU" LOOK.

MAGICAL BEASTS

Supernatural beasts include creatures from mythology, as well as original, invented characters. In this chapter, you will learn how to create and draw both types. There are a handful of famous beasts that have become closely associated with the supernatural. The dragon is a great example. It's the big kahuna of beasts. How can you top an enormous creature that not only flies but also breathes fire?

I'll also cover the topic of anthropomorphism, which means attributing human characteristics to an animal. The premier example is the werewolf, which is half-wolf and half-human. You can anthropomorphize other animals as well. I'll explore this option later on.

DRAGON

The most ferocious supernatural beast is the dragon. From an artist's point of view, you can think of the dragon as a cross between a lizard and a dinosaur with a skin problem that can't be fixed by simply laying off the chocolate. The head is usually small compared to the body, which, by the way, does not appear terribly aerodynamic to me. And I say that with confidence, as an expert, who happens to have no experience flying anything.

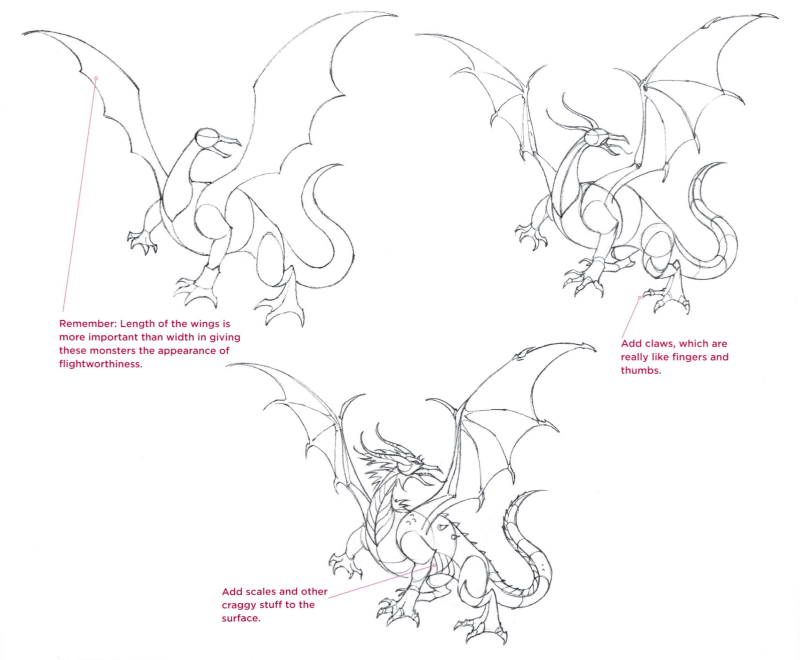

Remember: Length of the wings is more important than width in giving these monsters the appearance of flightworthiness.

Add claws, which are really like fingers and thumbs.

Add scales and other craggy stuff to the surface.

THE NECK AND TAIL
GIVE THIS BIG BEAST
A PARADOXICALLY
SLINKY AND SERPENTINE
QUALITY. BETWEEN THEM
LIES A BODY THAT IS
ALMOST ALWAYS LARGE
AND CUMBERSOME DUE
TO ITS GIRTH. I HAD AN
AUNT WHO WAS BUILT
THAT WAY.

WEREWOLF

Picture yourself on a moonlit night, in some Eastern European town in the countryside. The narrow cobblestone streets all look the same, and you've gotten lost. As the fog settles in, you look for a bed-and-breakfast—someplace warm, where you can stay for the night. But just then, from the stillness of the night comes the sound of a dog howling. It's distant, and you pay it no mind. But it happens again. You decide you had better get going. You pick up the pace as the howling grows nearer. You are by the riverbank. It's so dark, you can't see in front of your face. You look behind you—there's nothing there. You heave a huge

sigh of relief, turn back around, and—suddenly let out a blood-curdling scream!

Okay, folks, I'm going to have to stop at this point. Why? To point out what just happened. You didn't have to guess what was making that howling noise or what was going to happen to our victim. In fact, all the drama happened in the buildup, the anxious anticipation, before the werewolf even appeared. Pretty cool technique, eh? Remember it when laying out your graphic novel. The excitement starts to happen *before* the action begins.

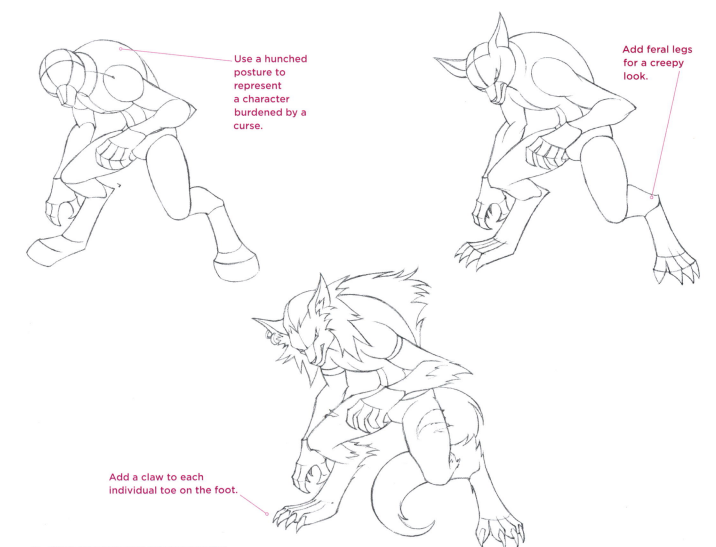

Use a hunched posture to represent a character burdened by a curse.

Add feral legs for a creepy look.

Add a claw to each individual toe on the foot.

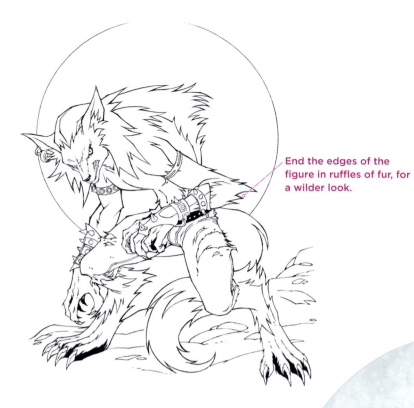

End the edges of the figure in ruffles of fur, for a wilder look.

NO SHIRT, TORN PANTS, AND MISSING SHOES. WHEN HE MAKES IT BACK HOME TOMORROW MORNING, HE'S GOING TO HAVE SOME EXPLAINING TO DO.

HUMAN-CREATURE HYBRID

Everyone fears the scorpion. There's nothing warm and fuzzy about a scorpion. Even scorpion mothers are freaked out by their offspring's looks. No one is ever going to pinch the cheek of a baby scorpion or coo-coo it.

Exotic animals produce the weirdest monsters when combined with humans.

In this approach, the human still retains his original head and features, but they sit atop the scorpion's body, like the scorpion's mutated spawn. This type of creature is so creepy, so scary, that it's almost impossible to resist showing it to your kid brother just before he goes to bed. Sleep tight, Billy.

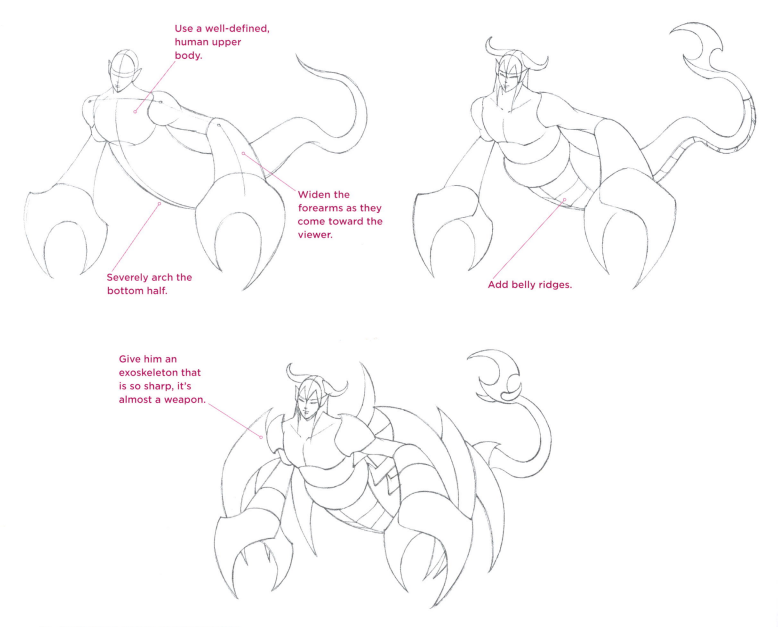

Use a well-defined, human upper body.

Widen the forearms as they come toward the viewer.

Severely arch the bottom half.

Add belly ridges.

Give him an exoskeleton that is so sharp, it's almost a weapon.

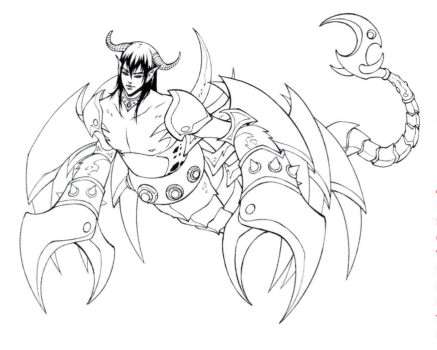

A RED-HOT COLOR WORKS WELL TO IMPLY THE RED-HOT STINGER. IF YOU SHOULD EVER COME ACROSS THIS GUY IN YOUR TRAVELS, AND HE ASKS YOU TO GIVE HIM A LIFT ON YOUR BACK AS YOU SWIM ACROSS A RIVER, I WOULD SAY TO GO AHEAD AND DO IT, BUT ONLY IF HE PROMISES NOT TO STING YOU AND LOOKS LIKE HE REALLY MEANS IT.

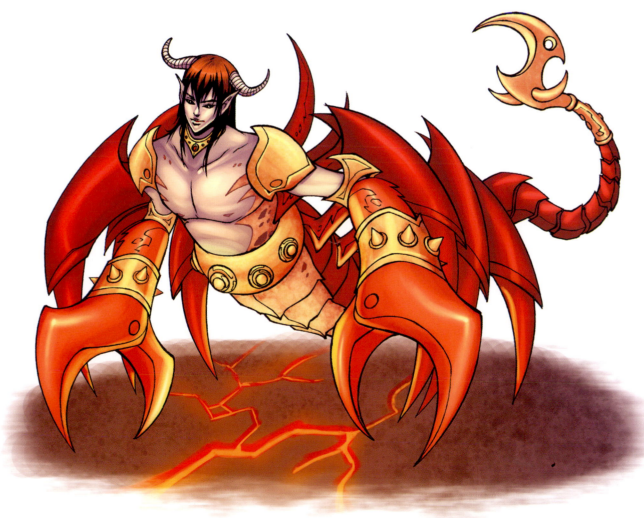

MAGICAL WHITE TIGER

Completely invented, mythology-based animals are among the most compelling monsters. That's because they're fresh, unlike traditional characters out of myth, which have been kicking around forever.

For newly minted monsters, begin with a visually dynamic animal. In other words, a panther would make an excellent choice, whereas readers are lukewarm to the concept of a fighting llama.

Tigers are associated with strength, ferocity, and stunning visual appeal. It's a real tragedy that the species is so close to extinction. No more soapbox speeches from me, but that had to be said.

You don't need to hide the fact that this is really a tiger with added motifs. That's part of the approach; don't apologize for it. Apologize to your mom instead. Why? I don't know, but she has probably made you feel guilty about something.

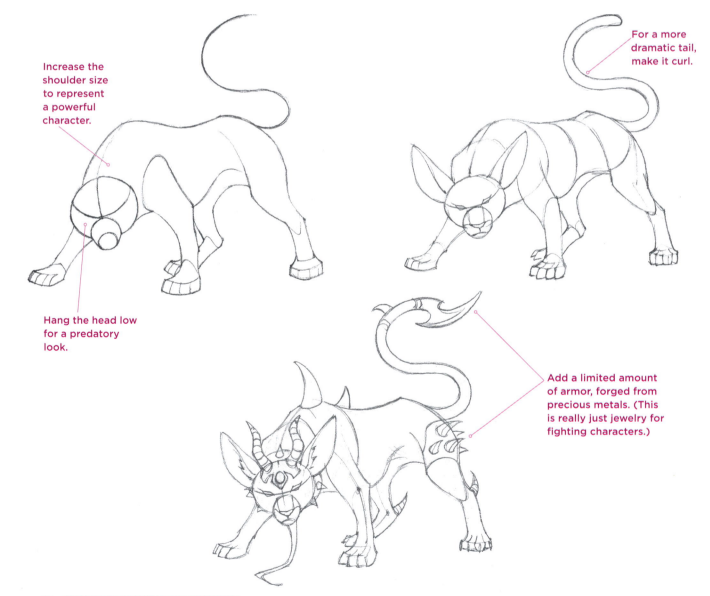

Increase the shoulder size to represent a powerful character.

Hang the head low for a predatory look.

For a more dramatic tail, make it curl.

Add a limited amount of armor, forged from precious metals. (This is really just jewelry for fighting characters.)

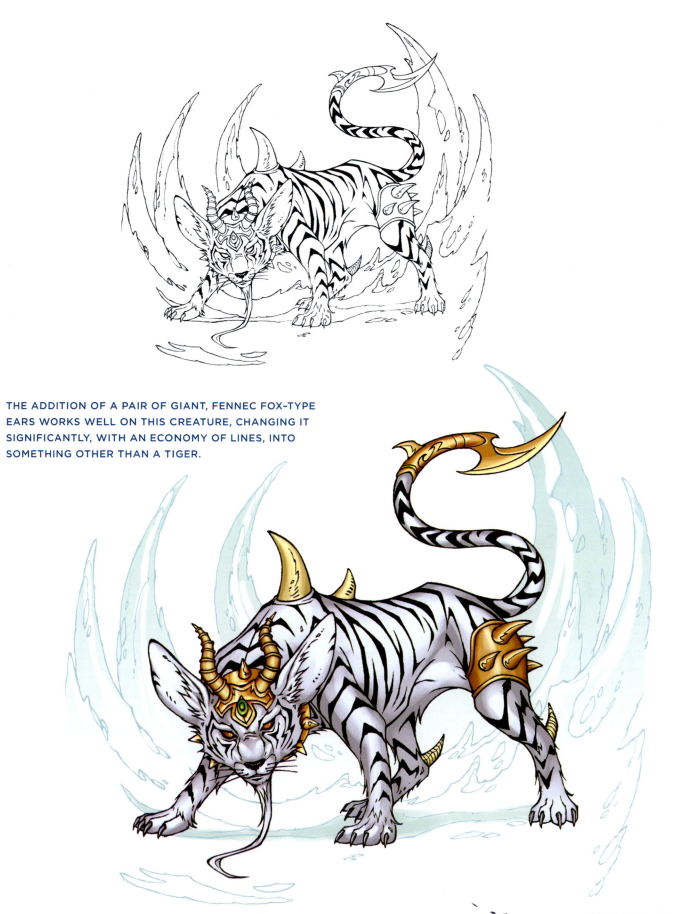

THE ADDITION OF A PAIR OF GIANT, FENNEC FOX-TYPE EARS WORKS WELL ON THIS CREATURE, CHANGING IT SIGNIFICANTLY, WITH AN ECONOMY OF LINES, INTO SOMETHING OTHER THAN A TIGER.

ELK MONSTER

When an animal already has a prominent feature, such as these antlers, you don't have far to go to make it appear magical. Customize them so that they turn into a dazzling display. This approach not only captivates viewers, but it's also attractive to other elk.

With the addition of monster-antlers, the elk, normally a peaceful creature, is transformed into an aggressive beast. Widen its stance to give it a tough look. By leaving the eyes blank, you create the aura of evil.

An overhead angle highlights the size of the magical elk's natural weaponry. At this high-angle approach to drawing this creature, the far limbs aren't even visible, because they are blocked from view by the monster's torso.

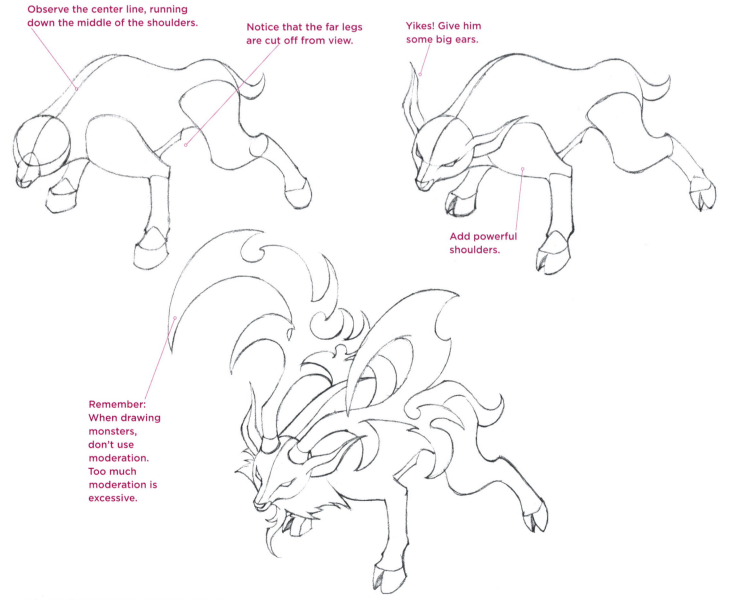

Observe the center line, running down the middle of the shoulders.

Notice that the far legs are cut off from view.

Yikes! Give him some big ears.

Add powerful shoulders.

Remember: When drawing monsters, don't use moderation. Too much moderation is excessive.

Blacken the outline of his blank eyes to make them look very wicked.

DID YOU THINK THAT EVIL ALWAYS COMES IN SHADES OF RED OR BLACK OR MAYBE GREEN? DID YOU THINK THAT? DID YOU?? ADMIT IT!! HA, THAT WAS A TRICK QUESTION. WELL, YOU ARE WRONG. HOW WRONG? SO WRONG THAT IF YOU ASKED A STRANGER HOW WRONG IT WAS, HE'D HAVE TO ANSWER, "REALLY WRONG." DARK FANTASY HAS NO RESTRICTIONS. EXCEPT PUCE. IT CAN'T BE PUCE.

FLYING SNOW FOX

Most snow foxes don't come with wings as standard features. You have to special-order them. Let's see, you've got your bat wings, your feathered wings, and your dragonfly wings. And if you decide to purchase a set of wings from us today, I might be able to talk my manager into throwing in one of those giant tails at no additional charge. Now, what do I have to do to get you to fly off the lot in a set of brand-new creature wings?

Note how the wings reach out, then double back. This is a pro technique that you can use.

Remember: When you get down to its basics, you're really drawing a dog's body.

Make sure the curve of the chest leads into the neck without a shift in the line.

Overlap the rear legs, but not the front ones.

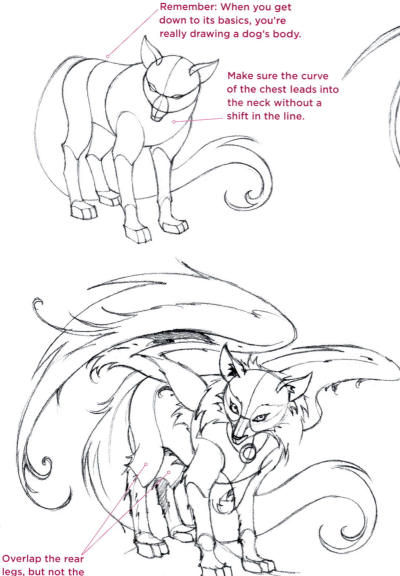

WING TYPES

* Bat wings: Great for demonic characters.

* Feathered wings: Excellent choice for magical characters.

* Butterfly wings: Again, perfect for magical characters—but tiny ones, like fairies.

* Titanium wings: Mostly used on airplanes and mecha-based creatures.

* Wooden wings: Mainly used by Orville and Wilbur Wright.

Add a shield, not a bib. When's the last time you saw a snow fox eating lobster?

GIVING A CHARACTER A SPECIAL POWER, LIKE THE ABILITY TO FLY, MAKES IT UNNECESSARY TO DO A LOT OF EMBELLISHING OR ALTERING OF THE UNDERLYING ANIMAL. THE WINGS ARE SO PROMINENT THAT ANY MORE ADDED STUFF, LIKE HORNS OR CLAWS, WOULD SIMPLY SAP IT OF IMPACT.

UNICORN

Who among us doesn't love unicorns? This mythological creature is extremely popular. The unicorn has a magical presence. What do I mean by *presence*? It's the ability to enter a scene and stun everyone with your awesomeness. Unicorns have that. This awesomeness is often accompanied by a blast of light. The transcendent power of the character spares the good and destroys the evil. I'm not sure about those in between, like kids who act out during class. Maybe the awesomeness causes them some really uncomfortable itching.

The unicorn is a powerfully built horse, and yet it is graceful, or, in some variations, super-feminine. Either way, it should be an idealized character. Don't forget to add the horn to the unicorn; otherwise, you've just drawn a "horsey." The horn is always drawn on the upper forehead, not farther down on the bridge of the nose.

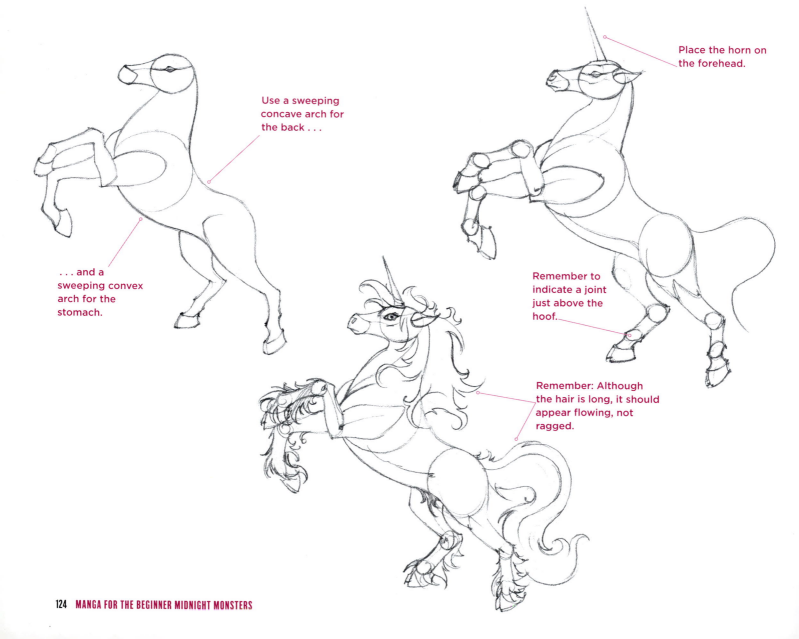

Use a sweeping concave arch for the back . . .

. . . and a sweeping convex arch for the stomach.

Place the horn on the forehead.

Remember to indicate a joint just above the hoof.

Remember: Although the hair is long, it should appear flowing, not ragged.

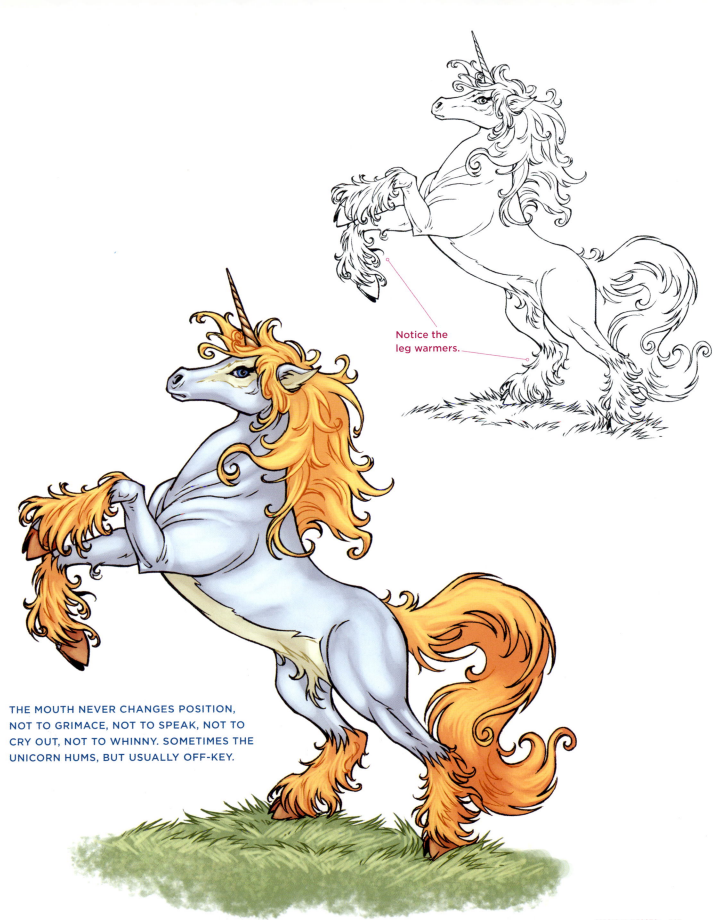

Notice the leg warmers.

THE MOUTH NEVER CHANGES POSITION, NOT TO GRIMACE, NOT TO SPEAK, NOT TO CRY OUT, NOT TO WHINNY. SOMETIMES THE UNICORN HUMS, BUT USUALLY OFF-KEY.

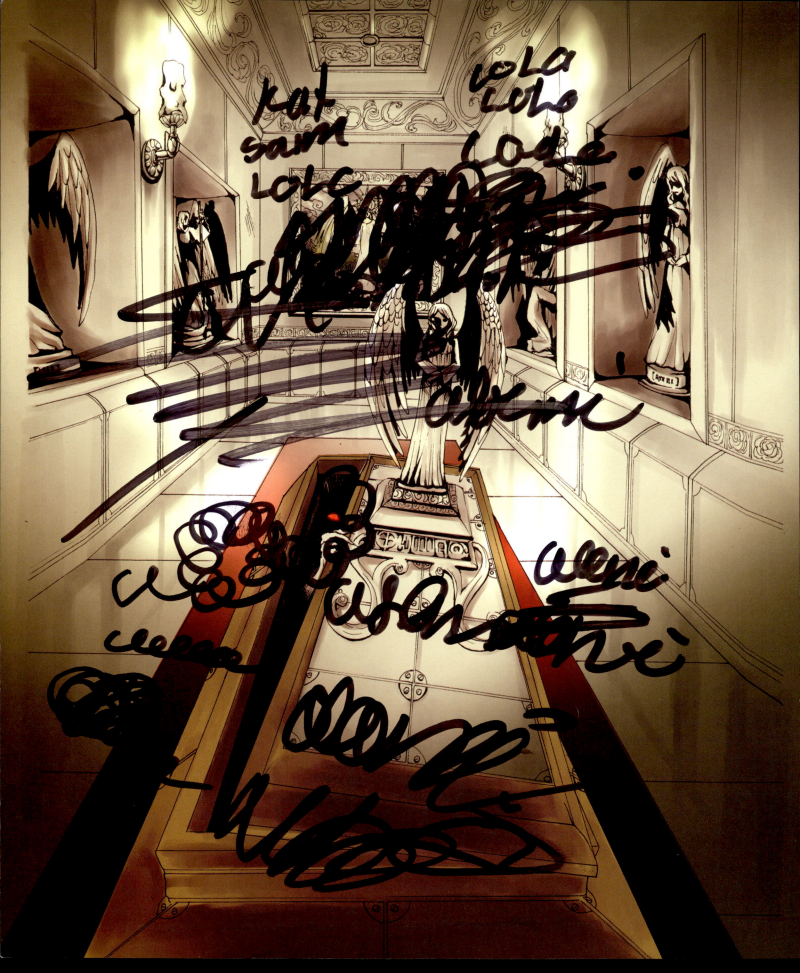

BACKGROUNDS

No style has backgrounds as evocative as goth. The keyword for these supernatural backgrounds is *ominous*. When something is ominous, it foretells evil things to come. That being the case, one of the goals when drawing backgrounds is to provoke an uneasy feeling in the viewer— a nervous sense that, although things may appear calm for the moment, something or someone nefarious is about to enter the picture. Now let's explore the chapter. If you dare.

IN THE GARDEN OF DEATH

The cemetery makes an excellent background. It's a place where gothic characters go to think things over when they're most angst-ridden. Normal people prefer a walk along the beach to a stroll through a graveyard. They don't know what they're missing. There is a peaceful calm in a cemetery, and nobody to bother you, at least not the ones who stay put. As to composition, note the layering of the gravestones, with some nearer ones overlapping farther ones. This adds depth to the scene. The farther back a gravestone appears, the less detail it requires.

SUPERNATURAL BACKGROUND CHARACTERICS

* A desolate setting, empty of people, as if an uneasy calm is hovering over the scene. Maybe a stray dog wanders through town.

* The panel may be drawn on a diagonal, or tilt, indicating that something is not quite right.

* Objects and props with strong gothic associations are placed in the scene. It's the same principle as product placement, only instead of a can of a popular soda, it's a pentagram.

* The location may be in disrepair; the bushes and plantings may be overgrown and unattended; and it may look abandoned.

* It has an association with death.

* The weather is ominous.

* If a formerly popular gathering place, like a playground, it is empty, and the only sign of people is an innocuous object in motion, such as an empty swing that creaks back and forth.

THIS QUINTESSENTIAL SUPERNATURAL BACKGROUND GOES THROUGH THREE STAGES BEFORE IT IS COMPLETE:

- PENCIL
- GRAY TONES
- BLACK AREAS

THE BARON'S CASTLE

Also known as the vampire's frat house, the castle is a good location to stage banquets, parties, and hazings. Actually, the first form of hazing was developed right here, but they had a different name for it back then: torture. There was the rack, the wheel, the garrote. You have to admire their inventiveness.

The thorny vines in the foreground say, "Stay Out." Sort of an early version of the "Beware of Dog" sign. Look at the size of that moon. Artistic liberty allows us to greatly exaggerate things in order to produce a lingering sense of doom. Any time is a bad time to knock on a vampire's castle door and ask for directions, but a full moon is a really, really bad time.

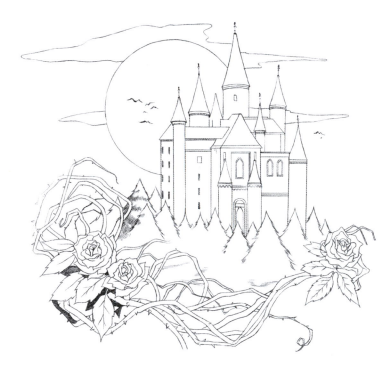

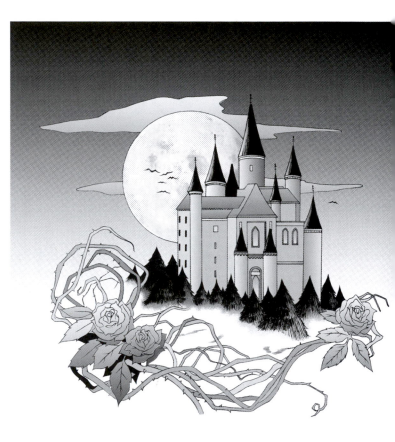

CASTLE FEATURES

Those pointy tips on castle columns have a name: turrets. They come in a variety of shapes and sizes.

Take a look at some of the more popular artistic choices.

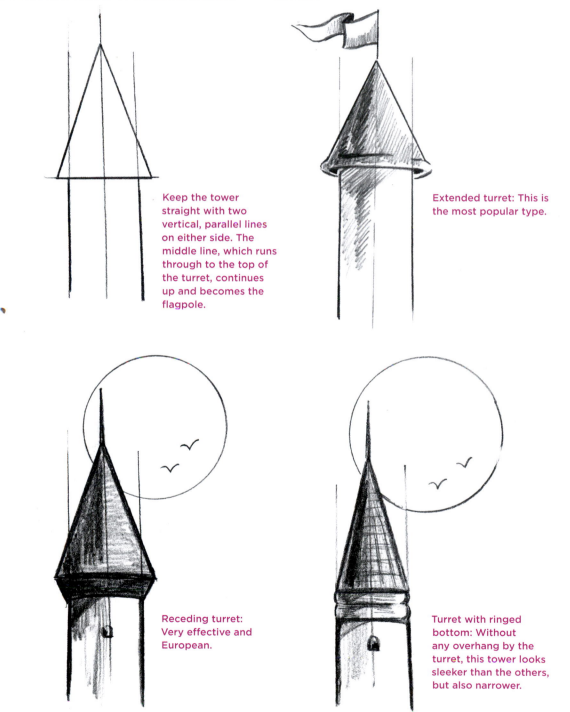

Keep the tower straight with two vertical, parallel lines on either side. The middle line, which runs through to the top of the turret, continues up and becomes the flagpole.

Extended turret: This is the most popular type.

Receding turret: Very effective and European.

Turret with ringed bottom: Without any overhang by the turret, this tower looks sleeker than the others, but also narrower.

CHURCH STEEPLE

The church holds an eternal place in vampire lore. Tension comes from the never-ending battle between good and evil. So we need a visual icon. The presence of the church makes the evil seem even more sinister in contrast.

The layout is more than just a design. A good layout tells and implies a story, visually. First, let's look at the tilted perspective of the scene. This signifies to the reader, on a subliminal level, that he's not in Kansas anymore. Next, the church appears empty. Everyone has fled in anticipation that something evil will soon be coming to town. Those bats hovering around the steeple are scouts—they report back everything they see to their master.

However, it's the juxtaposition of bats circling a cross that is the true metaphor for the story as a whole: darkness and light.

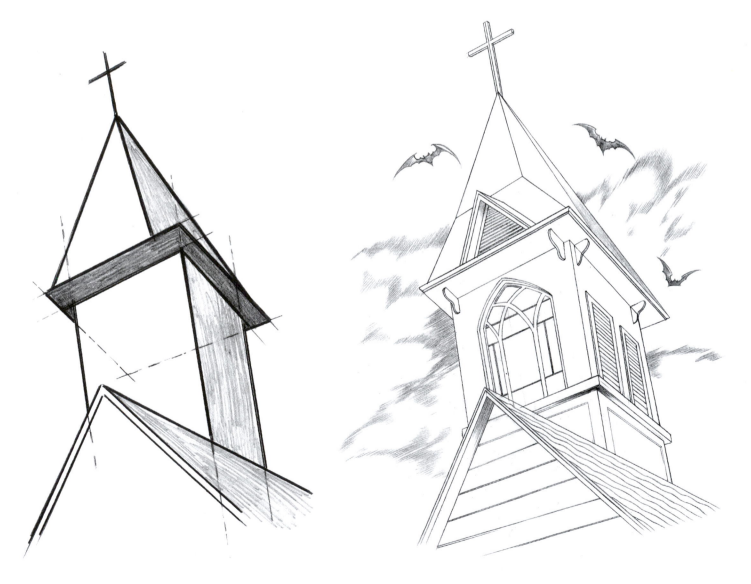

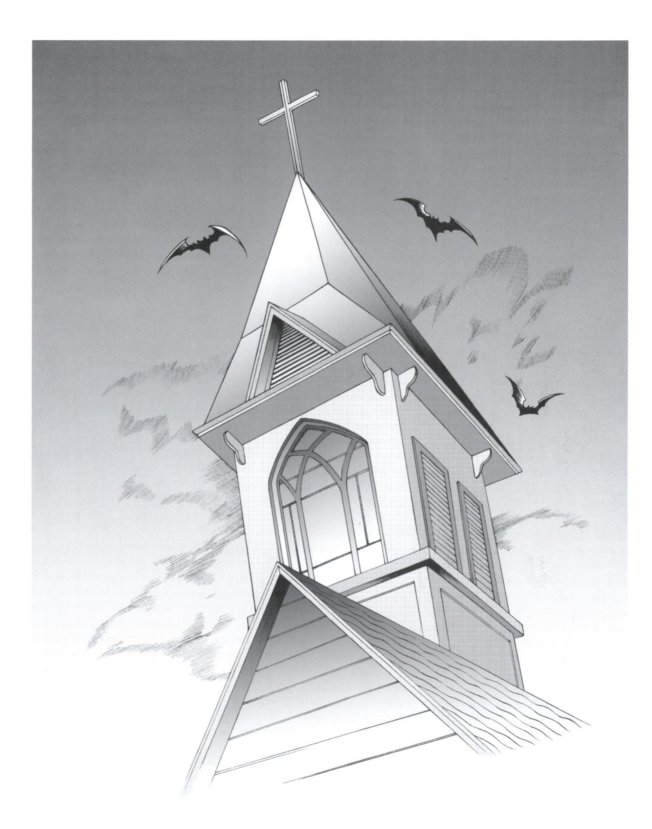

YEP, GET OUT THOSE RULERS. YOU'LL NEED THEM TO DRAW THE STRAIGHT LINES THAT DOMINATE THE PICTURE. FREEHAND DRAWING DOES NOT WORK WELL ON SOLID, GEOMETRIC STRUCTURES LIKE THIS ONE.

LOST IN THE WOODS

Remember what happened to Little Red Riding Hood when she went walking through the woods to Grandma's house? She didn't listen to her mom's warning! The howl of wolves is not English for "Be my friend." She also warned Red that she should never, ever invest in anything with someone who wears a toupee.

Since we all have a fear of baying wolves, you can use it to terrify your audience. Go on, be evil!

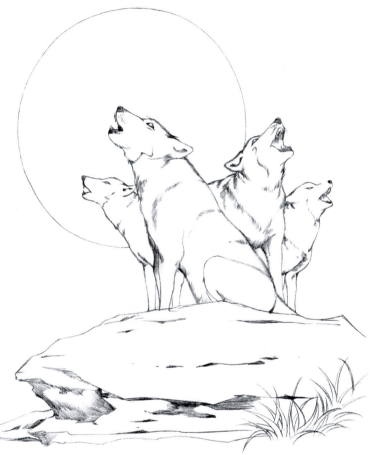

OTHER PLACES TO ADD WOLVES

* Around a campsite
* Marshes
* As guards for something valuable
* A deserted town
* A dream sequence

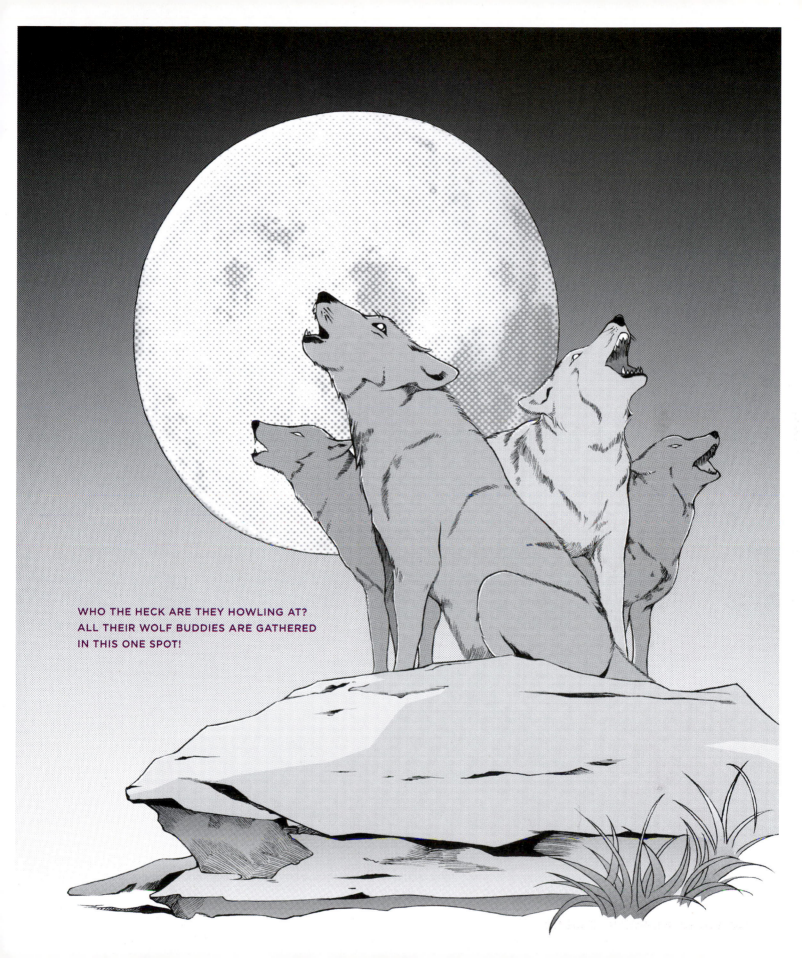

WHO THE HECK ARE THEY HOWLING AT?
ALL THEIR WOLF BUDDIES ARE GATHERED
IN THIS ONE SPOT!

ABANDONED FARMHOUSE

Why do teenagers always decide to sleep overnight in an abandoned farmhouse when they're lost in the woods? Haven't any of them seen a horror movie before? I mean, look at it. What about this farmhouse says, "You'll be safe here"?

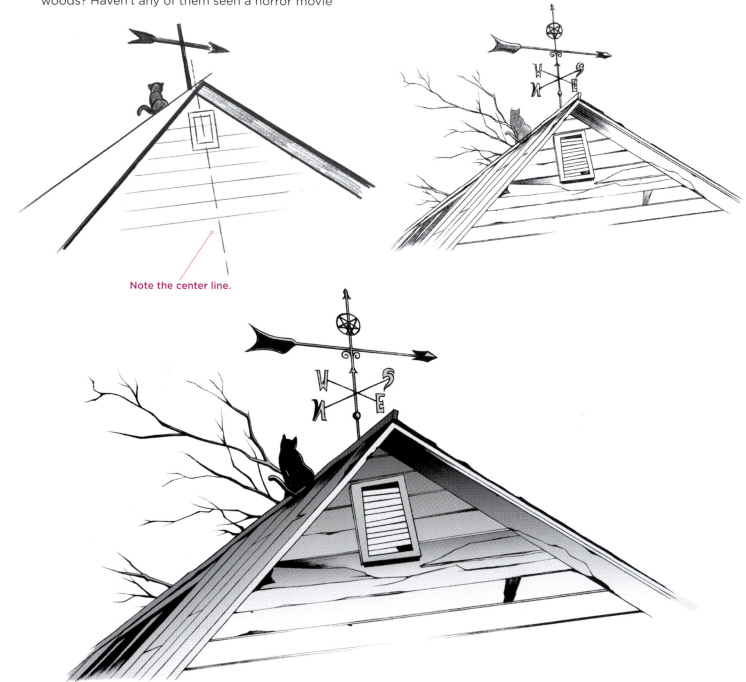

Note the center line.

CREATING AN EERIE, ISOLATED CABIN IN THE WOODS

When creating a spooky look, use accents that are derived from our primal fears: bats, isolation, things falling apart, and darkness. Also, contractors who fail to give estimates. Wow, can those guys be nightmares!

Why is it so creepy?

* It's abandoned.
* It's in disrepair.
* It's late afternoon, with only about half an hour of sunlight left.
* Omens abound, which our lost troop of honor students somehow failed to see. For example, tree branches that seem to reach out like hands, or eyes that appear out of the mist, or a small cemetery just outside the property's perimeter.

Avoid strictly parallel lines vertically and horizontally to give backgrounds an eerie effect.

Vary shades from light to dark to darkest, which represents going from purity to evil.

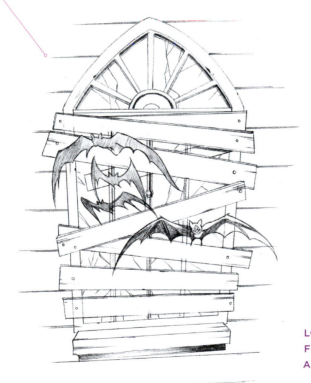

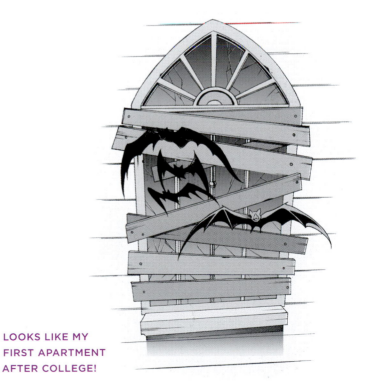

LOOKS LIKE MY FIRST APARTMENT AFTER COLLEGE!

THINGS THAT GO BUMP IN THE NIGHT

On these pages, you'll find powerful, classic super-natural props and objects that are lodged in the dark recesses of the brain. In fact, they're lodged so deep that it takes two hands just to yank them out. And what a mess that makes. There is simply no way to get your shirt completely white again once you've gotten cerebral cortex splattered on it.

Evil icons serve varied but essential purposes to set a scene:

* To decorate
* To underscore a mood
* To warn
* To create tension
* To fill empty spaces
* To change a nondescript location into an evil one (for example, by changing a doorknocker from a brass handle to a brass skull)

BLACK CAT

It works best to avoid giving a black cat personality. It's really just there as a symbol, like those shiny round things on a drum set, only it and doesn't give off that much-desired "ping" sound.

RAVEN

Ravens are great. Just their appearance is enough to scare people, except for Edgar Allan Poe. They often fly away as soon as they are noticed, giving the distinct impression that they are bringing information about what they just observed back to the Evil One.

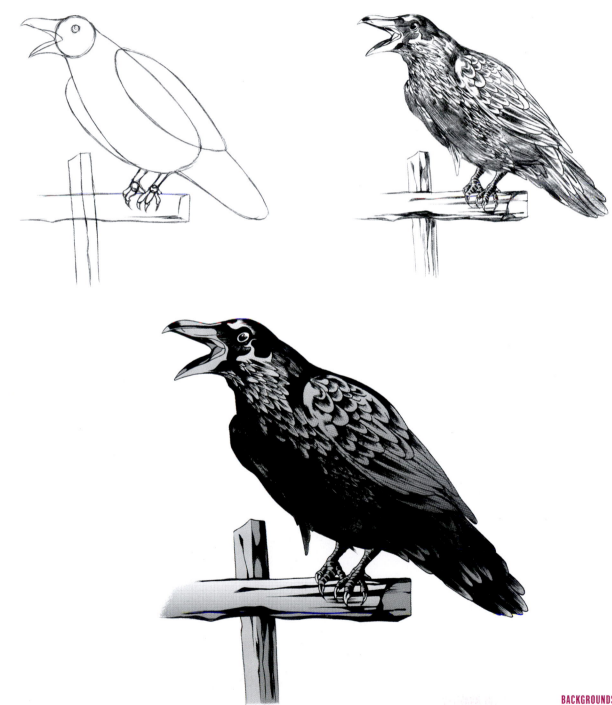

JACK-IN-THE-BOX

Although clowns are supposed to be funny, many people find them creepy. And not just because they're really grown men in clown suits with their faces painted to appear overjoyed at all times. Come to think of it, that's exactly why they're creepy. As an artist, you'll want to bring out that nightmarish quality.

One approach is by drawing the smile really, really wide to make the clown appear disturbingly happy. Another technique that ratchets up the creep-o-meter is adding black starbursts over the eyes. The spring at the base of the head makes the icon look like a human-serpent hybrid.

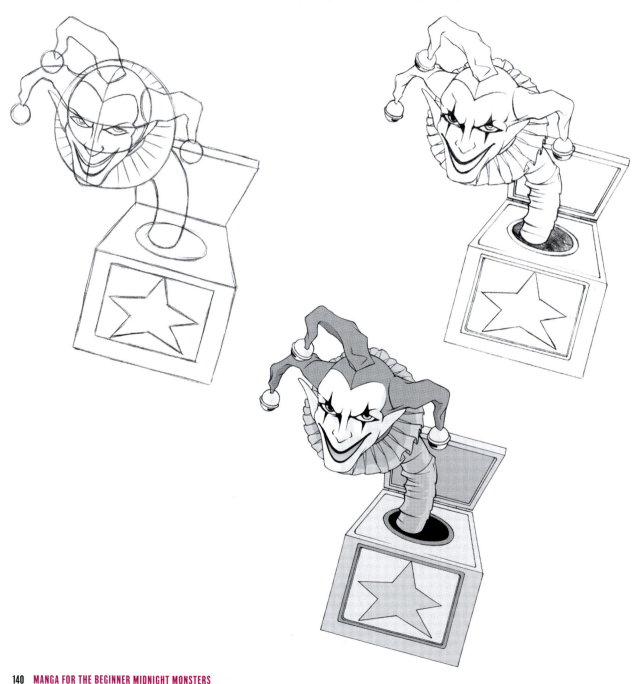

MARIONETTE

She should be drawn to appear less like a puppet and more like a victim who has been stripped of her free will. Her soul is enslaved by those who would control her. Even her mind is not her own. She's told what to do, what to think, and even when to think it. It's like school on steroids.

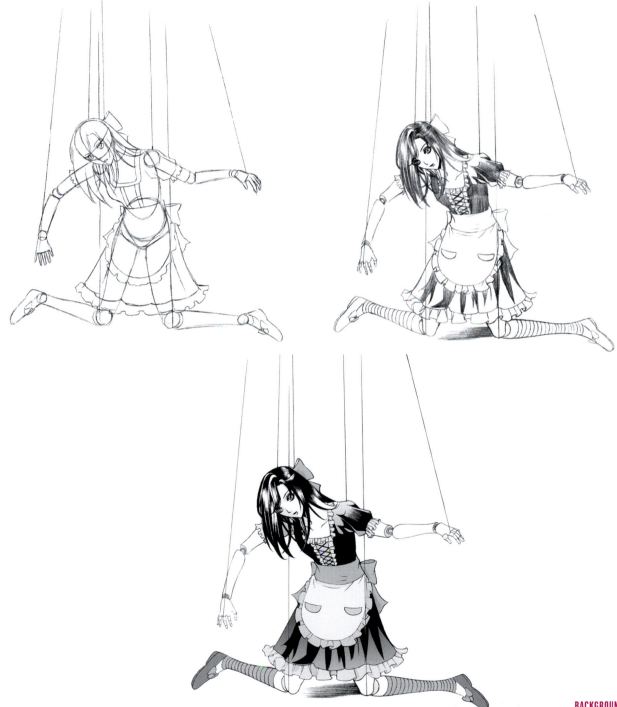

BLACK WIDOW

Spiders, especially black widows, stir primal fears in people. As everyone knows, this is the species where the female kills its mate. Therefore, any male black widow stupid enough to date a female black widow deserves whatever is coming to him. It's like people who marry other people who have been divorced four times. What do they expect? That this time it'll be different?

Black widows are distinctive because of their bulbous torso and long, thin legs. They're especially useful in gothic scenes as "fillers." In other words, if you've drawn a scene that looks too empty in places, you can add these nasty little predators to a web, and they will effectively fill up the scene.

SCORPIONS

These are aggressive little creatures. Do not try to make friends with one by rubbing its tummy. Whatever possessed you to want to try that anyway? They find it annoying. Scorpions look like elongated crabs, with three major differences: Scorpions have giant claws, have a forward-curling tail, and will never be served in a salad at brunch.

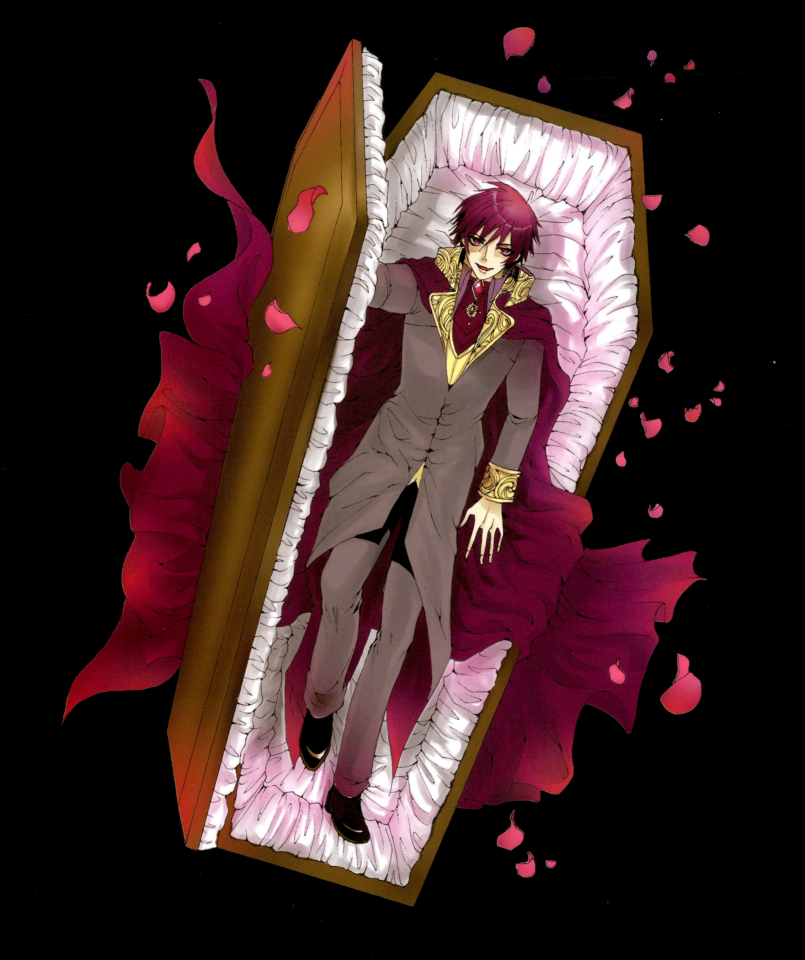

COLOR THEORY

This entire book is filled with guidelines and suggestions, all based on sound principles of art. But remember that you're the artist. If you come up with color combinations different from what's recommended in this chapter, follow your instincts. New ground is always being broken in art. If, after a few attempts, certain choices that you've made don't appear to be working, you can always return to the popular tried-and-true approaches covered in this chapter.

The color media available to manga artists are considerable. They include colored markers, of which there is a gigantic selection, such as Copic and Prismacolor, which come in 150 colors. Colored pencils are popular and can be used effectively as an adjunct to other media. For example, some people add highlights and shading over colored markers to create a vibrant look. Anyone who has ever tried to shade using markers over markers can tell you how poorly it works. Colored pencils come in more than a hundred different colors. There are also variations of colored pencils, such as watercolor pencil.

COLOR PALETTES FOR SUPERNATURAL CHARACTERS

Give yourself the freedom to experiment with a variety of color combinations. First do a few preliminary color combos—on three or four copies of the exact same drawing. Then select the one you like best, and use it as a guide from which to create the final, colored drawing. But don't ignore the other versions. Although you may not like the overall color schemes of the discarded attempts, you very well may like some things about them. Borrow color themes from the discarded examples, rather than tossing out the baby with the bathwater. Apply whatever works, in your opinion, to the final version.

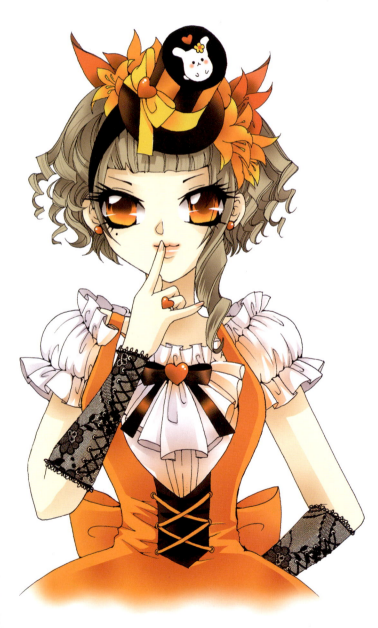

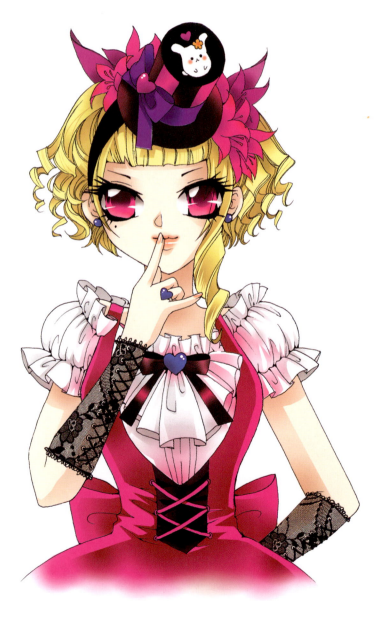

THESE ARE ALL EFFECTIVE APPROACHES, EACH OF WHICH EMPHASIZES A DOMINANT COLOR THEME.

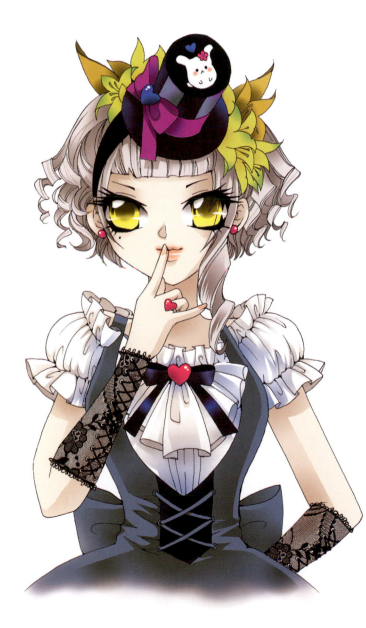
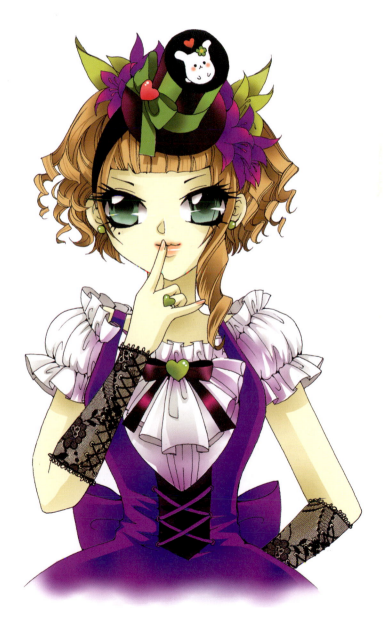

KEEP WITHIN THE THEME

Goth is a strong style, with a recognizable, consistent look. Viewers come to it with expectations. If you don't meet the more basic expectations, the genre may not appear to be correct. Color is a good example of this, which is why you see very few vampires, in manga, wearing plaid. Another example:

The classic vampire is a creature of the night; in fact, he can't be out in the sunlight at all, even if he were to apply number 3,419 sunblock.

Now let's take a look at a few color schemes and make some observations about what works, what doesn't, and why.

VAMPIRE DARK

IN MY VIEW OF THINGS, THIS IS THE BEST CHOICE. THE CLOTHES ARE DARK—MAINLY A CHARCOAL GRAY. THIS POPS AGAINST THE WHITE, COZY LINING IN THE COFFIN. GREEN, THE SECONDARY COLOR, IS A GOOD CHOICE TO DEPICT ANYTHING THAT'S UNDEAD, OR HAS BEEN IN THE REFRIGERATOR TOO LONG.

VAMPIRE GLAMOUR

NOT A BAD CHOICE. MAGENTA IS FREQUENTLY USED IN FANTASY. IT TENDS TO GIVE A MAGICAL QUALITY TO A CHARACTER. NOTICE THAT THE COLOR OF THE CAPE BLEEDS ONTO THE WHITE, SILKY LINING OF THE COFFIN AS RED "BOUNCE LIGHT." THIS SUBTLE GLOW EFFECT FURTHER ADDS TO THE EVIL, ENCHANTED LOOK.

LEISURE SUIT TIME

THIS IS A GREAT COLOR COMBO, IF YOUR VAMPIRE IS
ATTENDING AN INSURANCE CONVENTION. AVOID BROWN.
NO ONE LOVES BROWN. IF A CLIENT WANTS YOU TO
COLOR SOMETHING BROWN, SAY NO! BY GOD, YOU DON'T
HAVE TO TAKE THAT FROM ANYONE!

VAMPIRE DJ

YOU SEE, THIS IS EXACTLY WHY WOMEN SHOULD NEVER
ALLOW THEIR MEN TO SHOP BY THEMSELVES, EVEN
VAMPIRES.

COLOR TIE-INS

What do you do if your color scheme works (that is, the colors you've selected are the correct ones to represent the thing you colored), but the overall impression is that of a hodgepodge? Run to the refrigerator and grab a quick snack? Me too. However, there's a better solution:

Add a color highlight, like golden trim, that runs through the entire figure. Therefore, it acts as a unifying element. For example, look at the vampire images. Look at them!!

You see?

Alternatively, suppose you have a cool color idea. Perhaps you want to give your bloodsucker an unlikely color for the eyes, such as blue or magenta. The problem is that the eyes are small, and with everything else going on in the picture, the viewer might easily overlook it. The solution is to repeat that eye color on a larger area, creating visual color redundancy. To see what I mean, look at the examples of the eyes of the vampire.

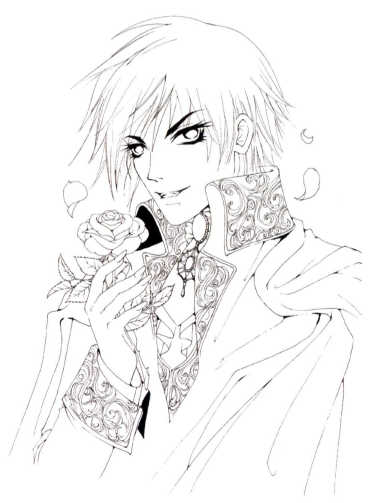

BLACK-AND-WHITE

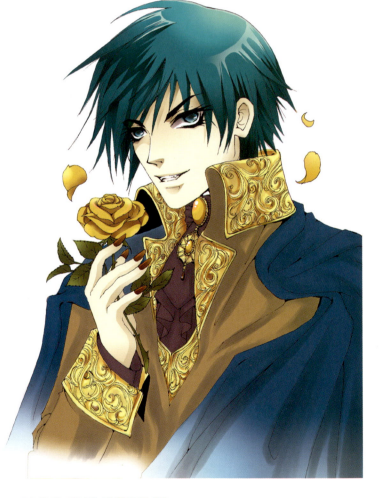

BLUES TIED IN TO EYE COLOR

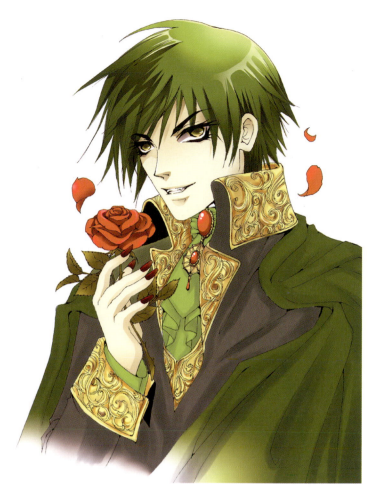

GREENS TIED IN TO EYE COLOR

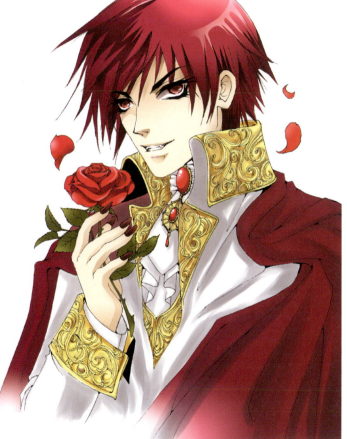

MAGENTAS TIED IN TO EYE COLOR

COLOR BACKGROUNDS

Most people choose colors as if they were at a buffet: a little of this color, a little of that color, a little more of this, a little less of that, and a Swedish meatball.

And while instinct often serves you well in the buffet style of coloring, you can go only so far with it. Some strategic thinking will create a scene with more impact that better supports the overall concept.

When deciding on a color scheme, you might begin by closing your eyes briefly. Daydream about what the color version of your drawing might look like. Now, as you're imagining, ask yourself these questions:

* What main color comes to mind for the overall scene?
* If it's outdoors, what time of day is it? (This will help you visualize the color of the light.)
* If it's inside, are the walls painted a color or are they left white?
* Is the scene dreamy (magenta), creepy (green), or violent (red)?
* Can the Mummy beat Dracula in a cage-fighting contest? (Sorry, lost a little focus after the first four questions.)

WARM COLORS

The color wheel is an art tool that has given rise to several theories of color. You can use the color wheel to distinguish warm from cool colors. Warm colors are, in order of their intensity: red, orange, and yellow. The cool colors are green, blue, and violet. Gray is not technically a color; it is a tone. However, I refer to it as a color because we use it in much the same way, except that it can be incorporated into black-and-white drawings, too.

By using predominantly warm colors, you can make the reader feel as if you've raised the thermostat in the room. But what purpose would that serve? Let's have a look at the example and find out.

In this scene, the viewer is in a mansion. The room is large and elegant, like a museum without the coat check. The vampire and his dog, Tinky, are calmly awaiting their first guest's arrival. Nosferatu sits calmly and purposefully, as Tinky, who appears to know what's coming, bares her fangs. Bad Tinky!

The intensity of the flames from the fireplace and candelabra are a "tell," in that they give away the burning rage that seethes within the vampire and suffuse the room with a red-yellow tone that appears to radiate heat. As the room temperature appears to rise, so does the emotional state of the reader, who is keyed into the scene with anxious anticipation. Color, therefore, can be used to enhance the moment and build suspense.

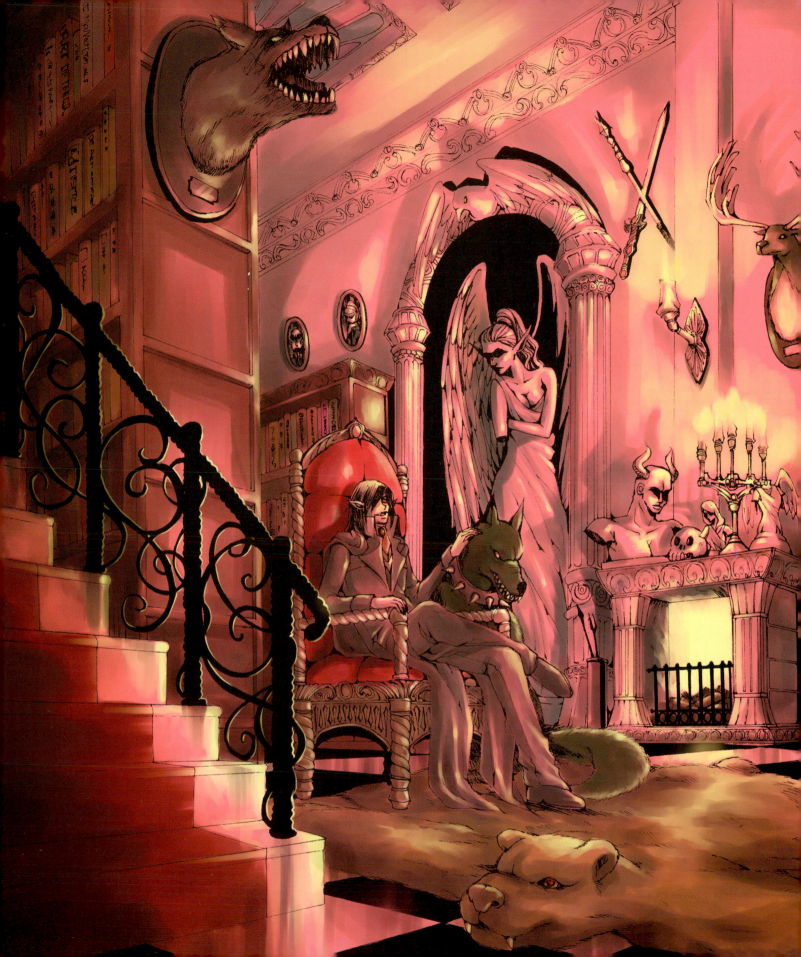

COOL COLORS

By *cool colors* I don't mean to say, "Colors rock!" I'm talking about colors that appear on the cool spectrum of the color wheel. Shift your focus to the scene: home sweet home. Drained of life, the room is a whitish gray. It is pale and anemic, with an overall funereal look. You can almost feel the chill as you imagine touching the marble walls.

But there's also evil in this room. Angry, violent, primitive evil, which is suggested by the color of deep red. Notice that gray (a cool color) is mixed with a touch of yellow—a warm color. There's cool and warm in the same picture, which supports the theme of the scene: The chill of death is in the air, but so is the hunger of the vampire.

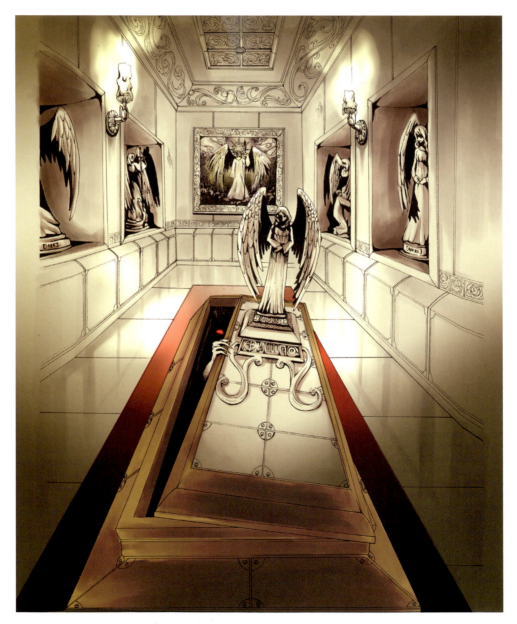

BLUE WASH

Vampires like hanging out. Yes, this scene is a little decadent, but what did you expect vampires to do, play mah-jongg? The decadence of vampirism is nothing new. It's been, and continues to be, popularized in graphic novels and movies. It's actually a metaphor, in that it represents humanity's carnal sinfulness, which must be destroyed.

The blue wash (with highlights) is a personal favorite of mine for creating mood and atmosphere.

Here's how it works: Instead of coloring each person, object, and thing in the picture, the entire image is bathed in a midnight blue. The color can be allowed to vary a bit, which adds interest. Three elements are often present in a blue wash: First, it's usually a nighttime scene. Second, the color is never opaque. It needs to be weak enough to allow the characters to easily be seen. And third, it's usually a large scene, not a single panel within a page of a graphic novel.

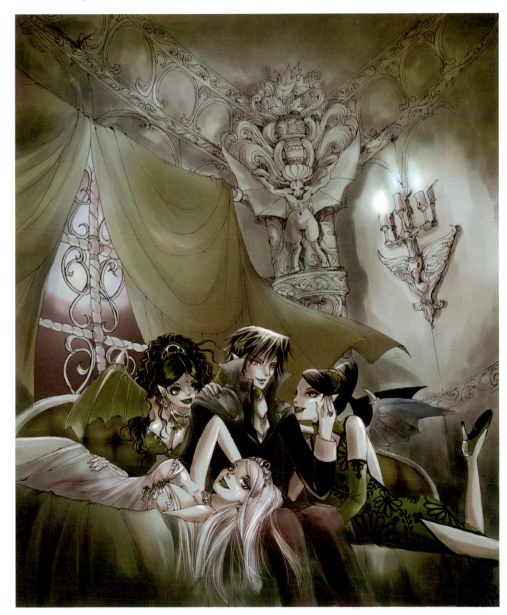

INTERPRETIVE COLORS

Not every color background is a literal representation of a scene. Color can be used to externalize an emotional state. For example, the intense and hot orange sky reflects urgency rather than the time of day. Though each character in these three examples has an identical facial expression, the one against a hot orange background seems to have a slightly more intense expression. That's the effectiveness of color.

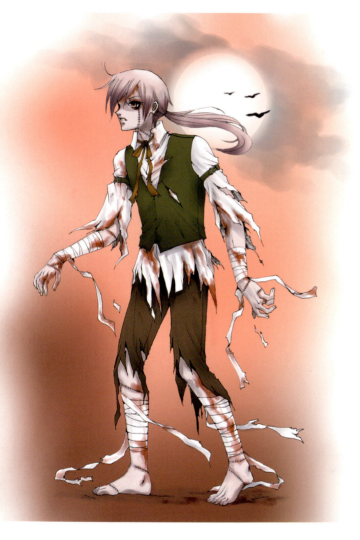

ORANGE: THE INTENSITY OF THIS COLOR CONVEYS A SENSE OF URGENCY.

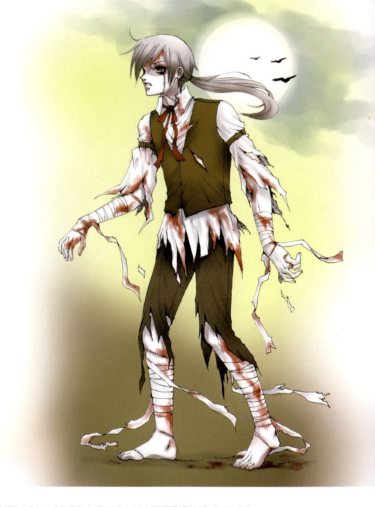

YELLOW-GREEN: THIS UNAPPETIZING COLOR ALLUDES TO RIGOR MORTIS AND A REALLY UNPOPULAR FLAVOR OF JELLY BEAN.

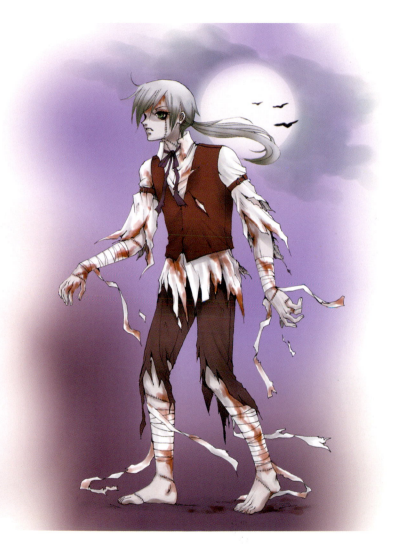

VIOLET: THE SKY CAN SERVE AS AN OMEN. THIS STRANGE VIOLET SKY MEANS THAT A STORM IS BREWING, OR THAT IT'S FOGGING UP. BOTH ARE BAD SIGNS.

NIGHT AND DAY

Classic scenes are extremely effective—that's why they've become classics.

The granddaddy of them all is probably the castle high atop a cliff, overlooking an angry sea. This is a nighttime scene. At night, an otherwise pleasant-looking castle takes on an unholy appearance. The colors of night provide a tint of danger. Realtors love the view.

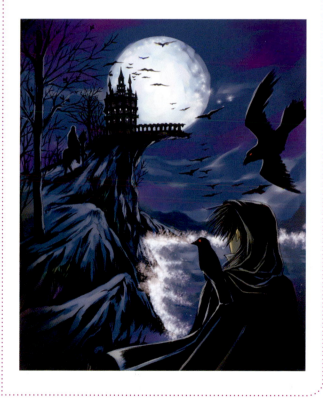

BLACK-AND-WHITE VERSUS COLOR

Some people swear by this axiom: "Color is better than black-and-white." However, many things look just as dramatic in black-and-white. (And sometimes better.) Black-and-white emphasizes starkness and bleakness.

WHEN TO CHOOSE BLACK-AND-WHITE

* The image is high contrast.
* The scene is bleak or desolate.
* Many areas of the scene are filled with pools of black or shadow.

* The picture contains many naturally dark elements, such as a forest at night, and you need lots of white for contrast.
* It features the effects of weather, such as wind or rain.
* You want the details of the scene to be noticed.

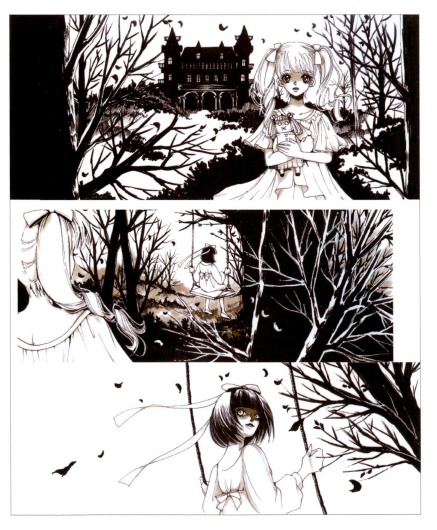

WHEN TO CHOOSE COLOR

* The emotions in a scene drive the choice of colors.
* You want the scene to appear sumptuous.
* There's a large, uncluttered area in the image, which would look empty in black-and-white, such as the sea, a sky, or a meadow.
* You want to add a feeling that something in the scene is terribly wrong by using an unusual color choice.

* You want to show a glow.
* You want to help to define the character, such as a zombie with green skin.
* You want to liven up a scene.

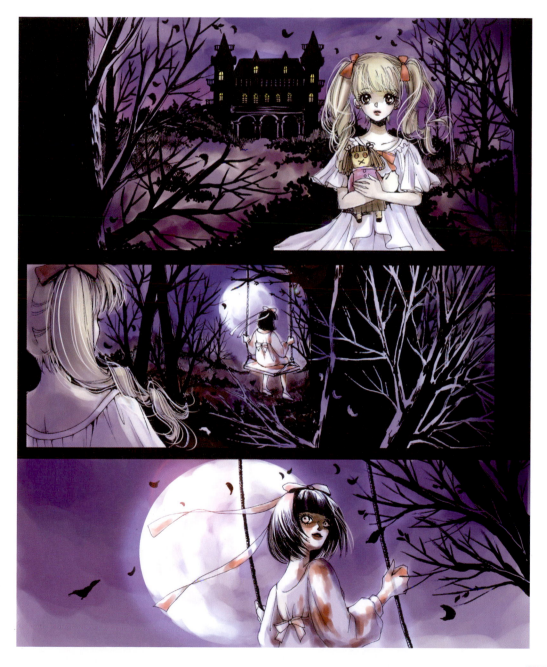

ADDING MONSTROUS ELEMENTS AND EXPANDING YOUR ART

Manga creators and publishers are always looking for an edge to their stories and characters. They do this to make a property stand out from the pack, so that it's not just another "This boarding school is really haunted" teen adventure. Creative, fresh ideas, even reinventions of standard oldies, often strike a chord with readers.

To be clear, I'm not talking about mixing similar types, like goth with punk, because they're not different enough from each other to create a new style when combined. You want to combine genres that seem to have nothing in common or are, in some cases, opposites of each other. Now that's a cool effect!

SPORTS AND SUPERNATURAL

Sports is a popular category of manga, especially in Japan. In this example, you've got a shoujo-style boy in a goth baseball uniform. How many possibilities can you think up for stories about a ballplayer from the underworld? I'd run out of fingers and toes, and then I'd have to borrow yours and, believe me, that ain't gonna happen. Can you imagine the fun of reading a story with a cast of these ghoulish creatures taking on the humans in a World Series of the souls versus the soulless?

Notice the juxtaposition of a healthy-looking face on one of the undead.

Give him a sturdy build, rather than the skinny physique of goth characters.

A WORD OF CAUTION

Try not to veer too far in the direction of one genre over the other, or the character may become all about that primary genre, with the secondary one lacking impact.

Use small bat wings to identify the character's monstrous influence, so as not to overpower his typical teen boy-next-door good looks.

Observe that, by adding evil conventions and icons, he's no longer the clean-cut boy he started out as.

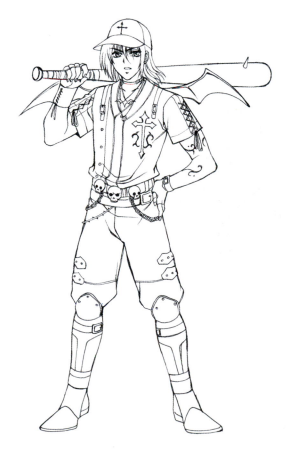

Here's where the uniform takes a left turn, as if it ran into a psychotic tailor. A small dose of powerful icons, like skulls, adds a lot of impact.

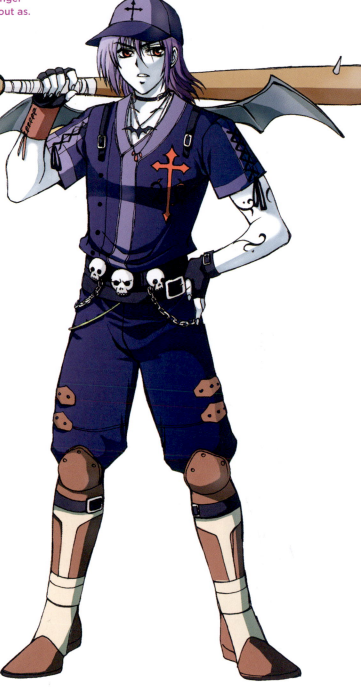

TURNING A COSTUME "SEMI-SUPERNATURAL" MEANS USING LOTS OF ACCESSORIES. WHY MUST YOU INSERT SO MANY ACCESSORIES INSTEAD OF SIMPLY CHANGING THE ENTIRE UNIFORM? THE ANSWER IS THAT CHANGING THE ENTIRE UNIFORM WOULD EVISCERATE THE ORIGINAL GENRE.

TRADITIONAL JAPANESE CHARACTERS AND GOTH

Traditional Japanese characters, like princesses, geishas, tea servers, and other characters in kimonos, appear to have little in common with the goth genre. But that's exactly what you're looking for in deciding which genres to combine. Two genres that are totally different produce a fresh spark when combined. The difference can astonish and captivate readers.

Traditional characters dress conservatively. Toss a dollop of the supernatural onto them, and it's like putting a drop of milk into a cup of black coffee—the entire tone changes. It's the same with genres.

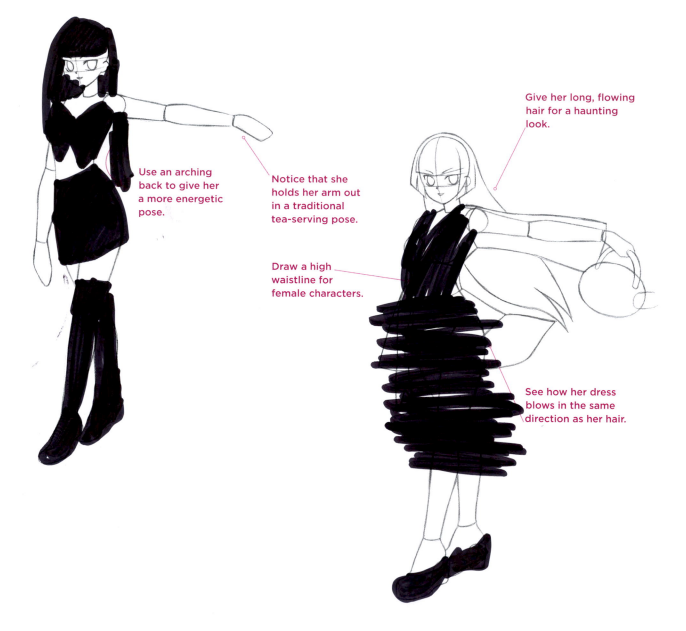

Give her long, flowing hair for a haunting look.

Use an arching back to give her a more energetic pose.

Notice that she holds her arm out in a traditional tea-serving pose.

Draw a high waistline for female characters.

See how her dress blows in the same direction as her hair.

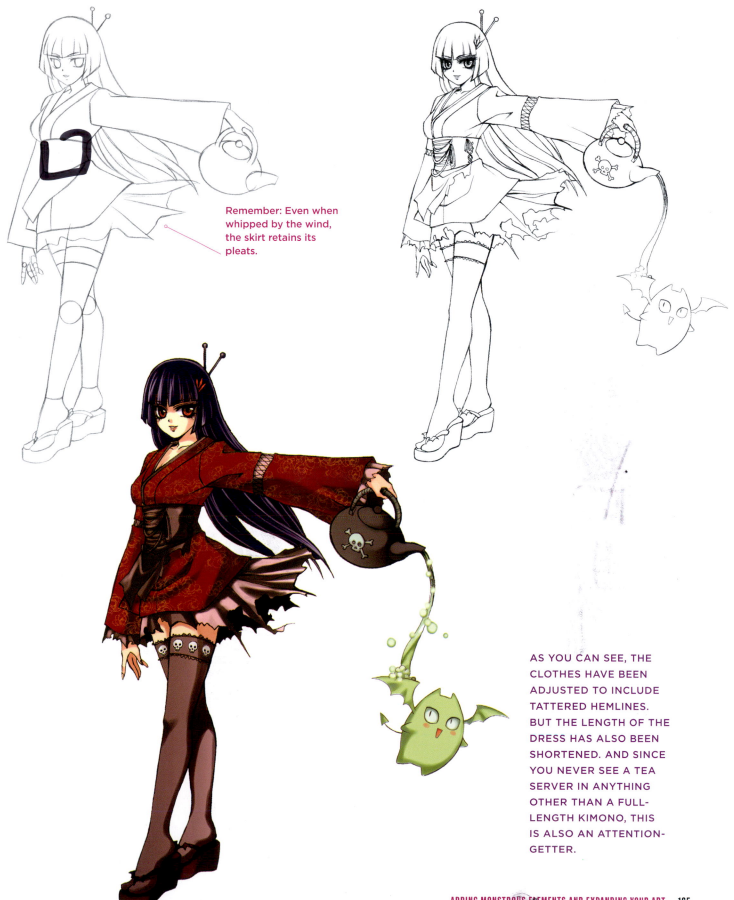

Remember: Even when whipped by the wind, the skirt retains its pleats.

AS YOU CAN SEE, THE CLOTHES HAVE BEEN ADJUSTED TO INCLUDE TATTERED HEMLINES. BUT THE LENGTH OF THE DRESS HAS ALSO BEEN SHORTENED. AND SINCE YOU NEVER SEE A TEA SERVER IN ANYTHING OTHER THAN A FULL-LENGTH KIMONO, THIS IS ALSO AN ATTENTION-GETTER.

FANTASY (FAIRIES) AND HORROR

Ordinary fairies are sweet and innocent characters, bringing joy and light wherever they go. A world filled with fairies is filled with smiles from ear to ear. So . . . let's trash it! All this talk of goodness and light makes me want to crush the fairy concept into a gelatinous ooze and feed it to the wolves.

Is that wrong?

This character is an example of a "good" goth. She can't help it if she's also evil. Don't ask me to explain. It works on this character. And on other characters. There are actually many gothic-horror characters that are cute and affable, but attired in evil outfits. Some are quite popular. The genre is wide-ranging, offering a good selection of character types.

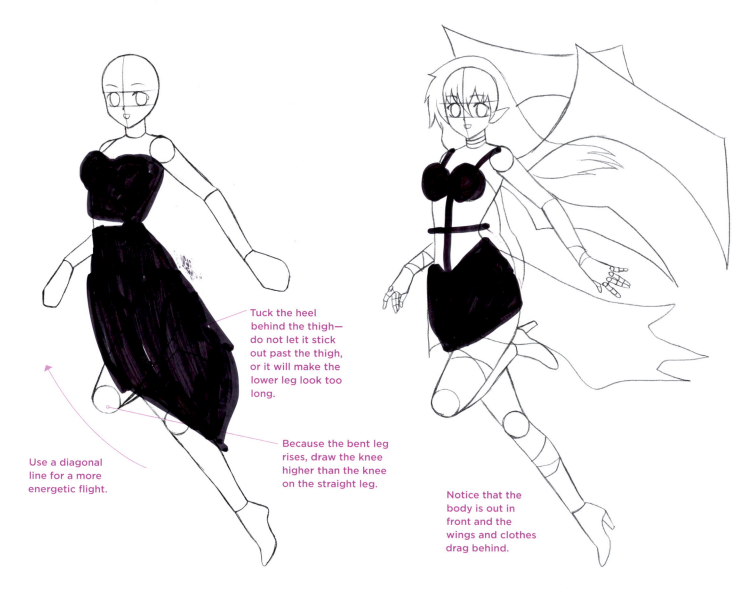

Tuck the heel behind the thigh— do not let it stick out past the thigh, or it will make the lower leg look too long.

Use a diagonal line for a more energetic flight.

Because the bent leg rises, draw the knee higher than the knee on the straight leg.

Notice that the body is out in front and the wings and clothes drag behind.

Tatter up the costume.

NOTHING HAS BEEN LEFT UNTOUCHED BY THE MIXING OF THE TWO GENRES—SUPERNATURAL AND FANTASY. BECAUSE FAIRY WINGS ARE MOST FREQUENTLY DEPICTED AS LIGHT OR TRANSLUCENT, HER RADICAL DEPARTURE MAKES AN INSTANT IMPRESSION. HER FAIRY CLOTHING IS FRAYED AND RIPPED (SHE MUST GO TO THE SAME DRY CLEANER AS I DO). AND HER COLORS, FAR FROM THE LYRICAL GREENS AND YELLOWS, ARE THE COLORS OF NIGHT.

SAMURAI AND GOTH

Samurai comics and graphic novels are very popular. These characters mainly come in two versions. The traditional samurai serves a master and gets an official warrior outfit with the job, plus a sword and a decoder ring. The second type is called a "ronin," and he serves no master. Here, you'll create a third: the Gothic Samurai. He wears ragtag, historical clothing. Like the vampire, the Gothic Samurai possesses a dark personality, with deadly intentions.

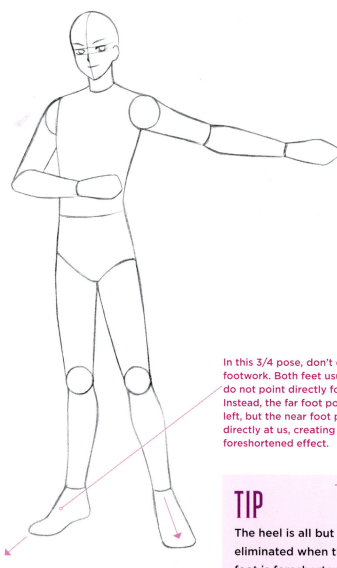

For a classic samurai blade, use a sword without a handguard.

Draw huge sleeves for martial arts tops.

Show the interior of jackets and capes to add a sense of depth and movement.

In this 3/4 pose, don't overlook footwork. Both feet usually do not point directly forward. Instead, the far foot points left, but the near foot points directly at us, creating a foreshortened effect.

TIP

The heel is all but eliminated when the foot is foreshortened in the front view.

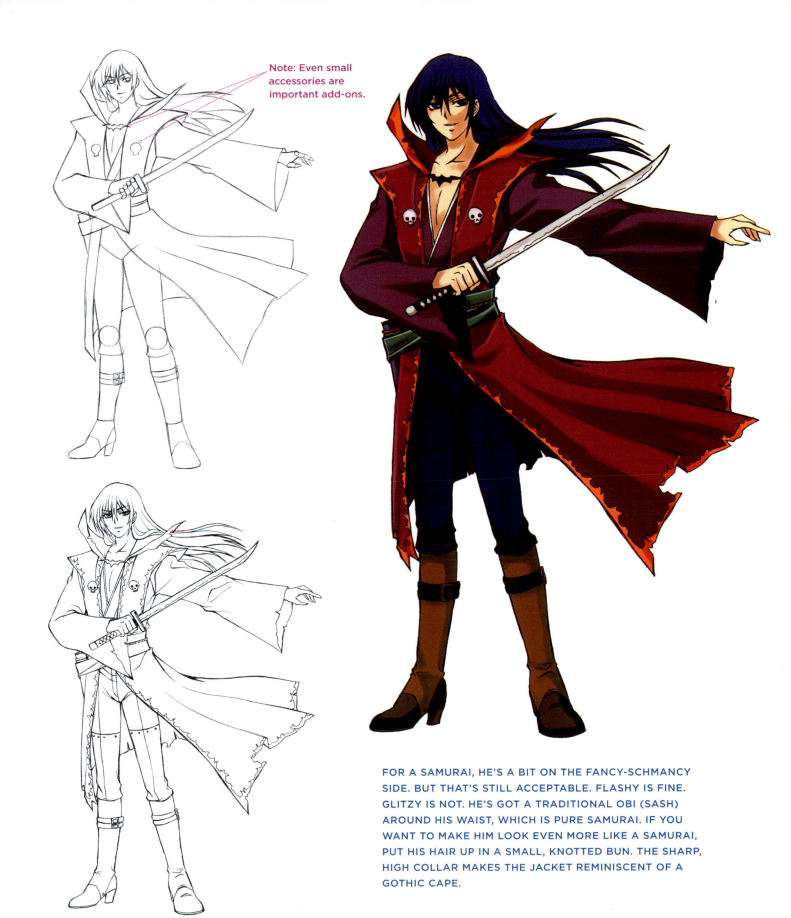

Note: Even small accessories are important add-ons.

FOR A SAMURAI, HE'S A BIT ON THE FANCY-SCHMANCY SIDE. BUT THAT'S STILL ACCEPTABLE. FLASHY IS FINE. GLITZY IS NOT. HE'S GOT A TRADITIONAL OBI (SASH) AROUND HIS WAIST, WHICH IS PURE SAMURAI. IF YOU WANT TO MAKE HIM LOOK EVEN MORE LIKE A SAMURAI, PUT HIS HAIR UP IN A SMALL, KNOTTED BUN. THE SHARP, HIGH COLLAR MAKES THE JACKET REMINISCENT OF A GOTHIC CAPE.

MAGICAL GIRL AND HORROR

You know them as those perky schoolgirls who can magically morph into glamorous heroines and idealized characters. They battle to save the Earth, which seems to be in constant danger anytime they appear. They're schoolgirls by day and warrior teens by night.

Most magical girls wear bold, primary colors and have their "perky" meters turned to the maximum. But if you were to change her look to one of darkness and villainy, she'd lose her most important qualities: earnestness and cheerfulness. You simply must find a

way to maintain her original look, while at the same time casting her as a denizen of darkness.

Here's one way to do it: Keep her cheerful expression and pink, curly hair. But add gothic elements on top of it, such as lace, a wand, a dark color scheme for the clothes, and gothic accessories. As a result of these additions, her cheery expression takes on an eerie quality. It begins to look as if she's using her charms to lure a love-struck man to her lair, where he'll live with her forever on the wall, as a trophy, like all the other guys before him.

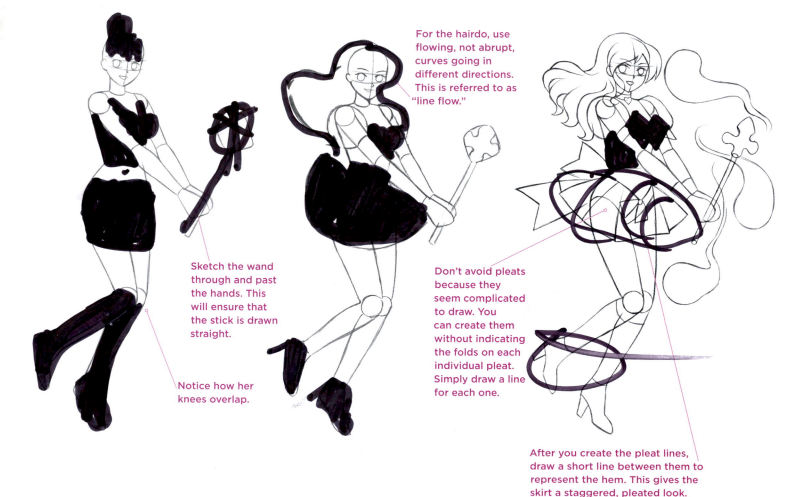

For the hairdo, use flowing, not abrupt, curves going in different directions. This is referred to as "line flow."

Sketch the wand through and past the hands. This will ensure that the stick is drawn straight.

Notice how her knees overlap.

Don't avoid pleats because they seem complicated to draw. You can create them without indicating the folds on each individual pleat. Simply draw a line for each one.

After you create the pleat lines, draw a short line between them to represent the hem. This gives the skirt a staggered, pleated look.

Use extra ribbons and cute stuff to create a dark irony for evil characters.

Add minor details. These details, taken together, enhance the impression your character makes.

TONE PLAYS A BIG ROLE IN THIS COLOR SCHEME. THE DOMINANT COLOR IS GRAY. LIGHT GRAY CAN BE CALMING AND SERENE. MEDIUM GRAY CAN MAKE SOMETHING APPEAR TO RECEDE INTO THE BACKGROUND. DARK GRAY IS OMINOUS AND STARK, AND IS USED FOR CAST SHADOWS AS WELL AS SHADOWS ON THE GROUND. NOTE HOW THE GREENISH-GRAY TIES TOGETHER THE GIRL (HER LEGGINGS) AND THE EVIL SPIRITS.

MOE AND GOTH

Moe (pronounced "moe-AY") is a very popular style of manga, especially in Japan. It features super-feminine, delicately drawn, emotive characters. Combining it with goth or the supernatural produces a darkly elegant quality, striking in its beauty.

Notice that the line connecting the shoulder muscles to the neck is gently sloping, which underscores her femininity.

Use layers to give the dress a formal look from the late-nineteenth-century upper class.

Use gentle curves for the torso.

Don't use an anorexic, model-type body to make her look cute. Unhealthy is not pretty or cute.

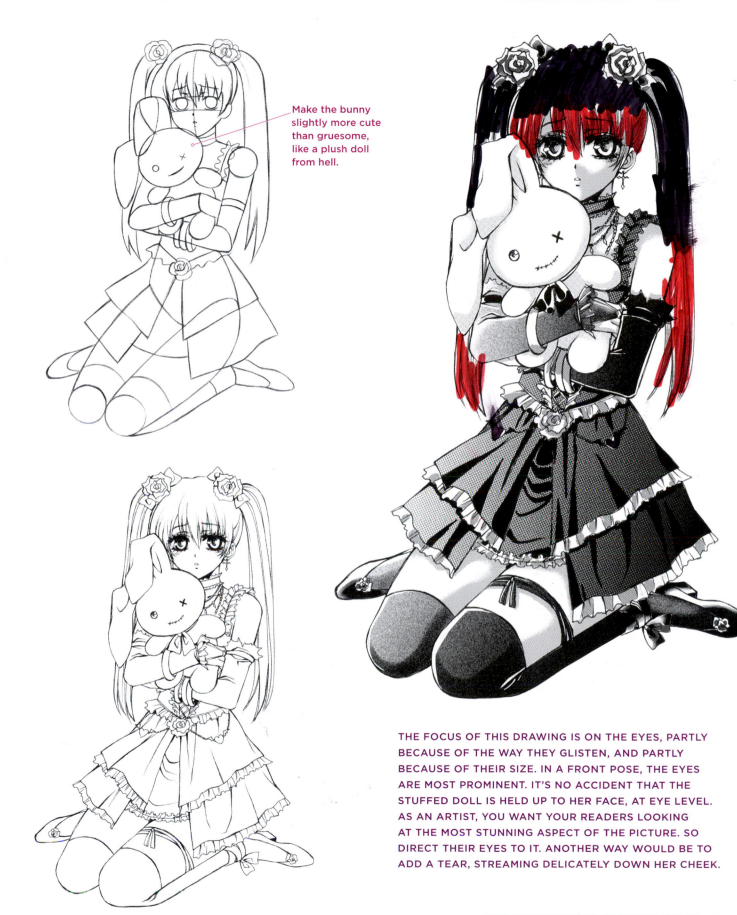

Make the bunny slightly more cute than gruesome, like a plush doll from hell.

THE FOCUS OF THIS DRAWING IS ON THE EYES, PARTLY BECAUSE OF THE WAY THEY GLISTEN, AND PARTLY BECAUSE OF THEIR SIZE. IN A FRONT POSE, THE EYES ARE MOST PROMINENT. IT'S NO ACCIDENT THAT THE STUFFED DOLL IS HELD UP TO HER FACE, AT EYE LEVEL. AS AN ARTIST, YOU WANT YOUR READERS LOOKING AT THE MOST STUNNING ASPECT OF THE PICTURE. SO DIRECT THEIR EYES TO IT. ANOTHER WAY WOULD BE TO ADD A TEAR, STREAMING DELICATELY DOWN HER CHEEK.

TAKING YOUR A.R.T. TO THE NEXT LEVEL

This isn't the end of our creative journey together, but the beginning. As you gain more experience, you'll undoubtedly discover many untapped parts of the book that you'll want to tackle.

I already know you're serious about improving your skills, or you wouldn't have purchased this book. And that shows drive and determination, which are, in my experience, a better predictor of artistic potential than even innate talent is. So at this point, please allow me to offer some words of encouragement, as well as a few suggestions, to further your skills as an artist.

All you have to do is remember these three letters: A.R.T.

A IS FOR "ADAPT"

In the wild, if an animal can't adapt to a cold climate, it perishes. In today's society, we might also find ourselves in a cold climate, which is why there's Florida. Wait while I locate my point. Oh, yes: It may be more comfortable to draw the same thing over and over again than to attempt to draw new and unfamiliar styles and trends. But even a good rut is still a rut.

Adapting to different styles challenges you to use all your skills and to grow as an artist. The look of manga is constantly evolving. New styles emerge and old ones are reinvented. Nothing stands still.

But what if you're trying to develop your own style? Are you worried that by adapting to other styles, you won't ever develop your own? Well, if you weren't worried about that before, you certainly are now. But have no fear. You can create your own style by adding your new, supernatural style to up-and-coming trends. For example, if the new trend was manga heroes with wings, you would know how to draw gothic versions of those wings. Add a few monstrous elements and you have developed a brand-new, combination-genre approach.

R IS FOR "REALITY CHECK"

Did you ever tell a joke over and over again until it no longer sounded funny? The same kind of thing can happen with drawing. You can spend so much time on a character that you can no longer tell if it's got the same spark that made you want to draw it in the first place.

So what do you do if you can't tell whether your drawing is still any good? Do you space out in front of the TV, hoping to avoid the issue? Do you get into an argument with your girlfriend to let off some steam? Maybe you take a bath and have a good cry. While those are all excellent options, I have a suggestion that may be even better:

Get an opinion from somebody with a fresh perspective.

But whom can you trust? I suggest enlisting the help of a few sympathetic friends who will nevertheless be candid with you. They may not be as well versed in your art form as you are, or maybe they aren't familiar with it at all. That can actually be to your advantage. They'll give you a gut reaction, without intellectualizing it. They'll either like it, or they won't, and then they'll tell you why. You should also feel free to ask a few leading questions, such as, "I had trouble drawing this arm in perspective, but now I think it works. What do you think? Does it look like

it's the right length to you?" They'll tell you what they think. But, it's always up to you to decide if they're right.

T IS FOR "TECHNIQUE"

Let's say that you want to learn to draw in the goth style. Let's say it all together. Let's hop as we say it in unison. Okay, knock it off.

Techniques are your tools. Tried-and-true art techniques help you produce the effects you seek. Few are so adept that they can teach themselves everything they need to know without any instruction. There's no shame in not knowing how to do something.

When you know which techniques to use for a given drawing problem, you don't have to reinvent the wheel. (Of course, if everyone suddenly forgot how to make a wheel, then you might have to reinvent one, but how likely is that, really?) The good news is that there is an ample supply of techniques available to you, and some are probably right under your nose.

* There are some excellent how-to-draw books. (There's this one series that covers a ton of great manga styles and subjects. But I forget the author's name.)

* Art lessons, even once a week for a few months, can drastically improve your craft. See if any are offered at a local arts center, college, or community college (in the form of continuing education classes, which you can take à la carte), or even at the local Y.

* Immerse yourself in the subject of your particular interest. If goth is your thing, read tons of goth graphic novels. Many of the techniques will sink in by osmosis.

* If you're in high school, make use of what the art teacher has to offer. Even if the teacher doesn't know how to draw manga, he or she can help to give your drawings a solid foundation. The style, however, will most likely remain your domain.

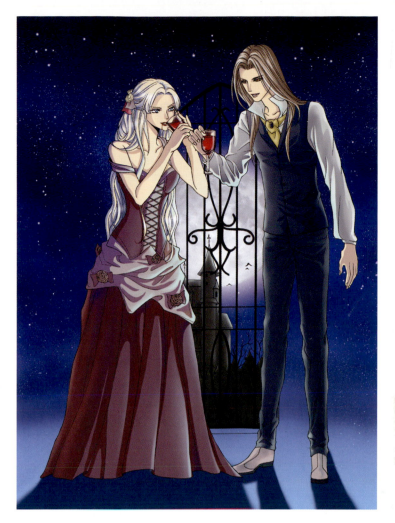

* Get a mentor. The relationship doesn't have to be anything official. Find someone whose drawing ability you admire, and strike up a dialog. Ask if you could show him or her a drawing or two, from time to time, to get some advice.

* Be careful about tutorials offered on social media networking sites. Anyone can post a tutorial. But you want to be sure you're getting good advice. Check out the credentials of the person who posted it.

I really enjoyed spending time with you, digging into the supernatural style of manga. Hopefully, you've gotten some nuggets of inspiration along the way, as well as a healthy helping of valuable art techniques. So until next time, keep drawing, and always remember: You deserve to succeed.

INDEX